MATISSE

MATISSE
THE CHAPEL AT VENCE

MARIE-THÉRÈSE PULVENIS DE SÉLIGNY

PHOTOGRAPHY BY
BAMS PHOTO – RODELLA

Royal Academy Publications
Beatrice Gullström
Alison Hissey
Elizabeth Horne
Carola Krueger
Peter Sawbridge
Nick Tite

Translated from the French by
Caroline Beamish

Selection of images and layout:
Pixel Studio, Milan

Typography:
Isambard Thomas, London

Printed and bound by
Grafiche Flaminia, Trevi (PG)
June 2013

British Library Cataloguing-
in-Publication Data
A catalogue record for this book is
available from the British Library

ISBN 978-1-907533-60-0

Distributed outside the United States
and Canada by Thames & Hudson
Ltd, London

Distributed in the United States and
Canada by Harry N. Abrams, Inc.,
New York

Photographic Credits

Photographs of the chapel, along
with the images on pages 77, 94, 98,
102, 110, 114, 126–127, 176–179
are by BAMS – Photo Rodella

Archives Henri Matisse: 209 (top),
210 (top).
© Centre Georges Pompidou,
MNAM-CCI, Dist RMN-Grand Palais /
Philippe Migeat: 213 (bottom).
Ville de Nice – Service photographique:
213 (top), 214 (top).
© Fonds Hélène Adant, Bibliothèque
Kandinsky, MNAM, Centre Pompidou,
Paris: 211 (top), 215.
François Fernandez: 173–175, 205,
206, 207, 208, 209 (middle), 210
(middle), 210–211 (bottom), 212,
213 (middle), 214 (bottom).
© Lucien Hervé, Paris: 211 (middle).
© Succession H. Matisse / Photo: Ville de
Nice – Service photographique: 34 (top),
66, 67, 96, 100, 104, 106, 108, 112,
116, 208 (top).

Plan of the chapel on page 34
by Daniela Blandino

Author's Acknowledgements

This book could never have been
produced without the support, advice,
skill and friendship of Sante Bagnoli,
Vera Minazzi, Georges Matisse,
Gwenaëlle Fossard, Sylvie Forestier,
Wanda de Guebriant, Michel Herrmann,
Nathalie Lavarenne, Giulia Valcamonica,
Valentina Vincenti, Nathalie Scholz
(French edition), Roberto Cassanelli
(Italian edition), Caroline Beamish and
Alison Hissey (English edition); to these,
and to all who have spoken to me about
the Chapel, including Claude and
Barbara Duthuit, Gérard, Évelyne
Matisse, René Percheron, Barbara Freed,
Sister Jacques, Sister Myriam, Sister
Magdalena, Sister Bernadette, Sister
Marie-Pierre, Father March Chauveau
and my brothers Jean-François and
Paul-Antoine I extend my heartfelt
thanks.

To the Dominican Sisters
of the Chapel of the Rosary, Vence,
and in memory of Sister Jacques-Marie

This chapel is for me the culmination of a lifetime of work, and the
fruit of immense effort, heartfelt but difficult
Henri Matisse[1]

In 1947, Henri Matisse undertook the design and construction of the
Chapel of the Rosary for the community of Dominican nuns in Vence; it was
inaugurated on 25 June 1951. Matisse worked on the project for four years,
delving deep into his emotions. The final result was the product of constant
hard work, and continuous thoughtful exchanges with the Dominican priests
and nuns. The chapel in Vence could well be considered the culmination
of Matisse's whole career; for the Dominican congregation it was the
embodiment of their desire to renew the Church's vision of its religious life
and worship. This peaceful place is home to the prayers of the Dominican
nuns, but it also welcomes visitors in their thousands from all over the world.

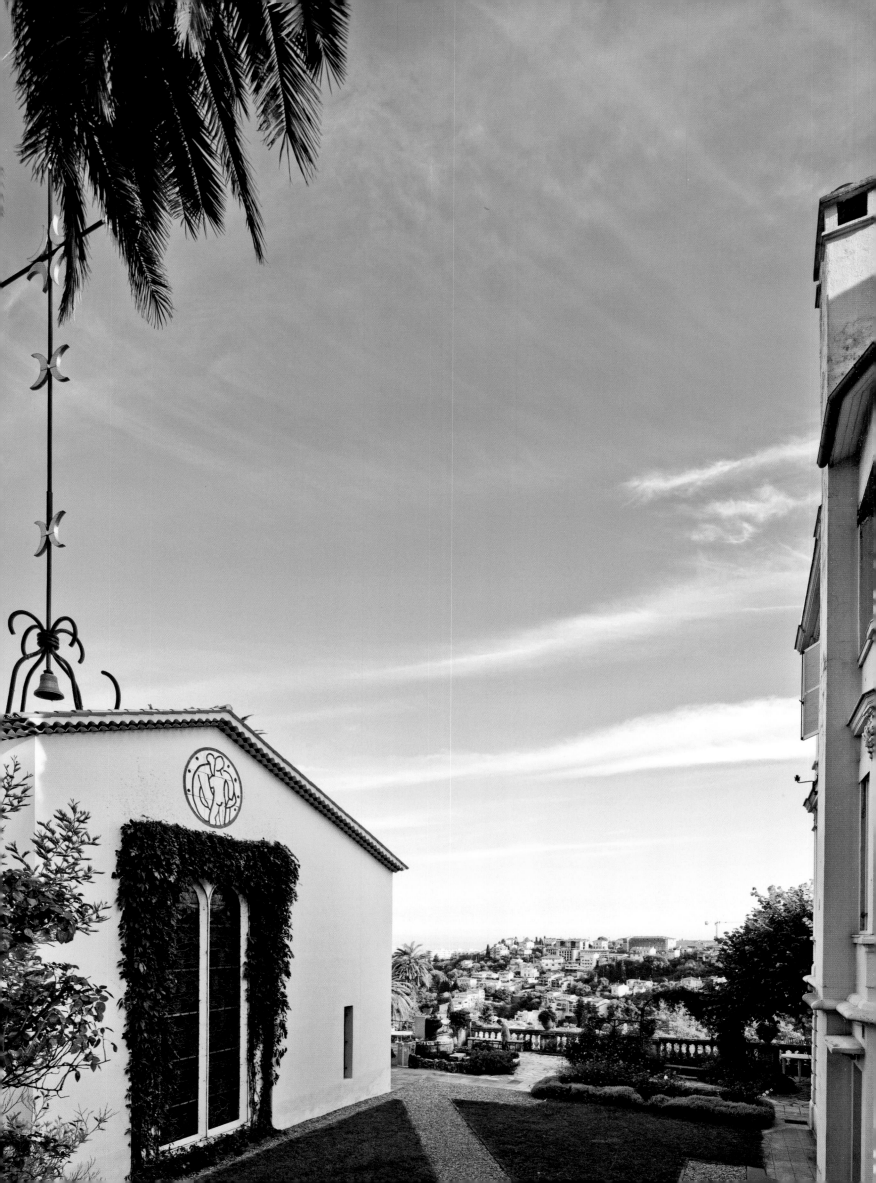

INTRODUCTION
The Chapel of the Rosary, Vence

The artist's conscience is a pure, faithful mirror in which he must be able to reflect his work every day … The abiding responsibility of the creator towards himself and towards others is not a hollow concept: by assisting the universe to construct itself the artist maintains his dignity.[1]

Matisse compared the Chapel of the Rosary in Vence to a book whose pages are to be inscribed using brushes and black Indian ink on white ceramic tiles, enhanced by the colour of the stained-glass windows. Beginning in 1932 with an edition of the poems of Mallarmé, Matisse illustrated a number of different books; their pages all share the same characteristic architectural space constructed through the artist's choice of typography and graphic design – pen and Indian ink, or sepia and cut paper coloured with gouache. As in the chapel, the pages of these books are overlaid with patterns and this serves to accentuate their luminous quality and their presence.

In creating the chapel, Matisse went beyond the specific religious ritual for which it is the framework: he was also motivated by his personal view of the archetypes represented by light and space. The boundless white inside the chapel represented the infinite, as well as man's spiritual dimension and mystical nature. The chapel is an enclosèd space built around the idea of man's potential salvation; this is symbolised by the disproportionate height and verticality of the chapel's bell tower, which extends upwards towards the sky, and by the brightness from the sky that enters the chapel through its windows. The building represents an embodied metaphor for our efforts to escape from material and spiritual constraints and return to a state of transcendence; it does this without destroying the identity of the person who comes to it to pray or to visit – instead it assuages their suffering.

[opposite]
The northwest façade of the Chapel of the Rosary and the *Tree of Life* window

9

Vence

In March 1943 an area of Nice was destroyed by bombing. Fearing that some
of the city's blocks of flats would be taken over by the Germans, Matisse
temporarily abandoned his studio apartment in the Régina building in Nice's
Cimiez neighbourhood and moved to Vence, a village in the countryside just
outside the city. There he occupied a villa named Le Rêve, in which he
remained until the end of 1948. As he did with all his homes, Matisse also
used the villa as a studio. He produced a large body of work there, work that
was noteworthy for the originality of the technique used, and in particular
Matisse's method of composing his image by laying out the colour in flat
planes. This technique characterises the so-called 'Vence period' in Matisse's
work. As usual, Matisse was completely dedicated to his work at this time,
and organised his day around sessions of drawing and painting. The garden
of Le Rêve was a major source of inspiration. The artist filled many notebooks
with drawings of plant forms, and he would work on a pattern and its
structure until it became a part of the fabric of his visual language. Through
the simplification of their graphic forms, leaves and branches became 'signs'.
He said: 'An artist must take possession of Nature. He must identify himself
with Nature's rhythm through applied effort; this will help him acquire the
mastery which, later, will enable him to express himself in his own language.'[2]
Matisse viewed nature as the guardian of the secret of creation. He wished to
be penetrated by the beauty of nature so that his art might be lively yet at the
same time accessible to others.

In addition to his studies of nature, the serious operation Matisse had
undergone in 1941 and his encounter in 1942 with Monique Bourgeois, who
was at the time a nurse but was later to become a Dominican nun, added
spiritual depth to his art and inspiration while he was in Vence. 'At the
moment I go every morning to say my prayers, pencil in hand; I stand in front
of a pomegranate tree covered in blossom, each flower at a different stage,
and I watch their transformation. Not in fact in any spirit of scientific enquiry,
but filled with admiration for the work of God. Is this not a way of praying?
And I act in such a way (although basically I do nothing myself as it is God
who guides my hand) as to make the tenderness of my heart accessible to

others.'[3] The development of his drawing, and the amplification of his expressiveness through colour and design, created a new pictorial realm. Particularly during 1947, Matisse's interpretation of interiors that were open to the outside world via the window foreshadowed the approach he was to adopt within the chapel.[4] With their coloured motifs, the chapel's stained-glass windows use the contrast between transparency and opacity to mediate the relationship between the inner religious world and the world outside. Additionally, the representations of *St Dominic*, the *Virgin and Child* and the *Way of the Cross* are simplified to such a degree that their lines have become 'signs'. With the chapel, Matisse's work acquired a new dimension, infused with far greater awareness of the spiritual grandeur of artistic creation of all kinds. 'Most painters … look for an external light to see clearly into their own nature. Whereas the artist or the poet possesses an inner light that transforms objects, creating a new world with them, a sentient, organised and living world, a sure sign of divinity in itself, the reflection of divinity.'[5]

Matisse moved into the Villa Le Rêve in 1943. In February the historian of art and literature, Louis Gillet, recorded the artist's words, as reported above. During this wartime period, while recovering from his operation of 1941, Matisse was soothed and supported by the landscape of Vence and the plants in his garden. Destiny was to lead him to create the Chapel of the Rosary for the Dominican nuns at the nearby Foyer Lacordaire.

[following pages]
Panoramic views of Vence

Everything is as new and as fresh as if the world had just been born. A flower, a leaf, a pebble – all shining, sparkling; lustre, varnish, you cannot imagine how beautiful it is! I sometimes tell myself that we are desecrating life: the more we see things the less we see. We bring things only our dulled sensibilities.[6]

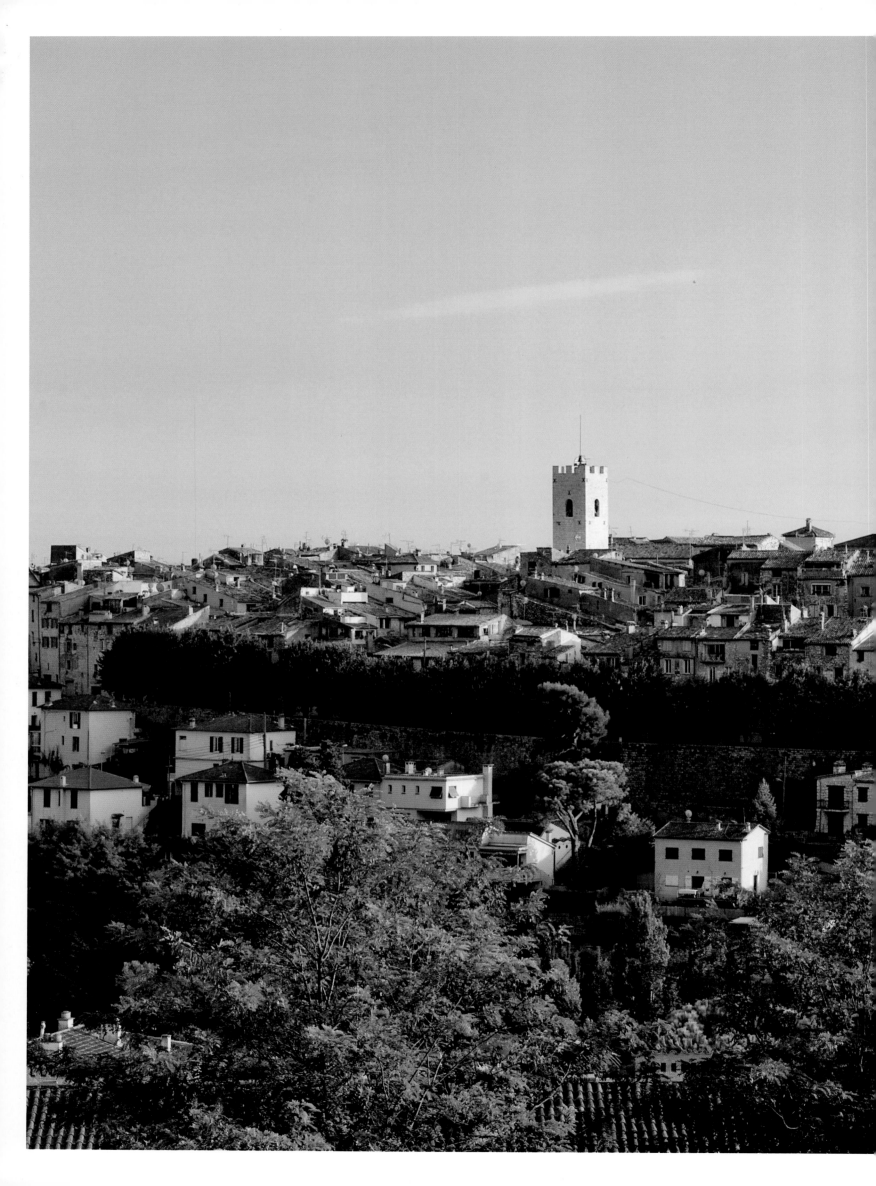

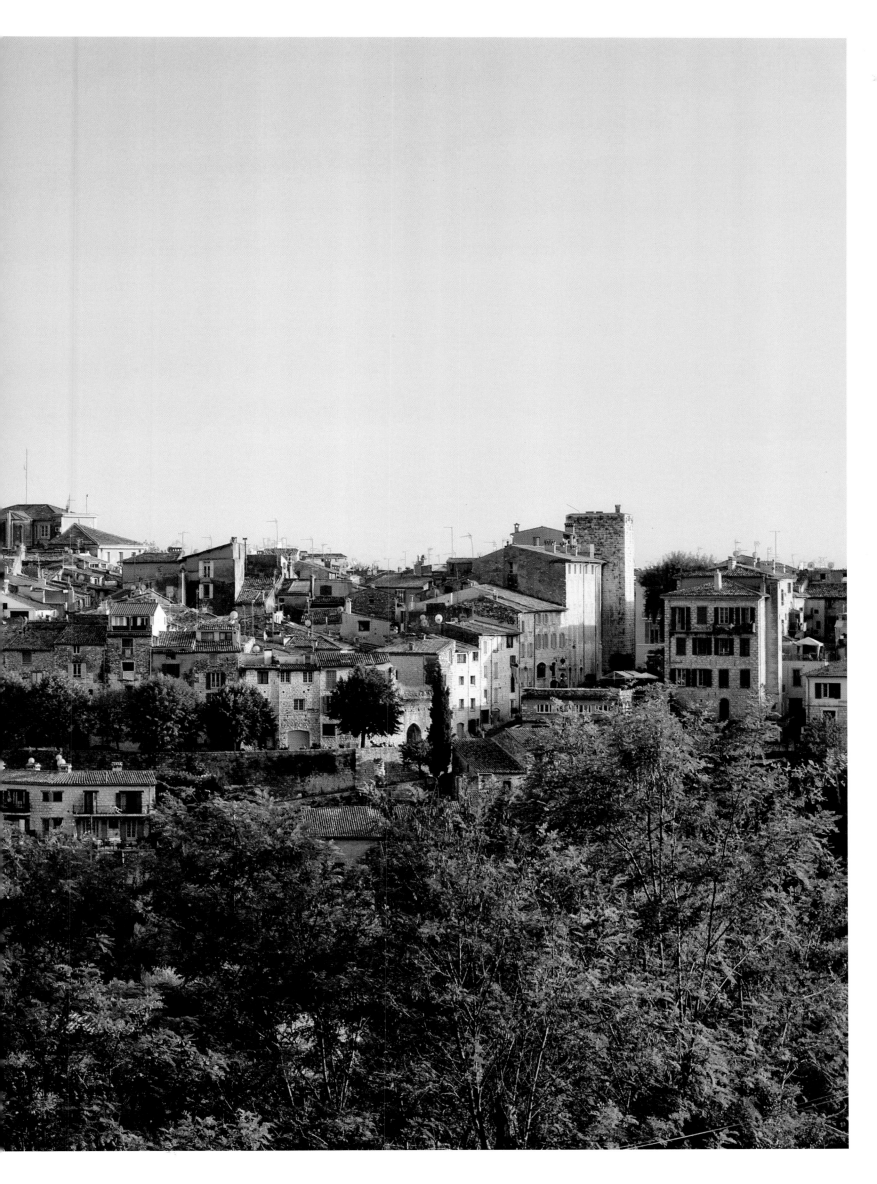

The Chapel of the Rosary seen
from Vence

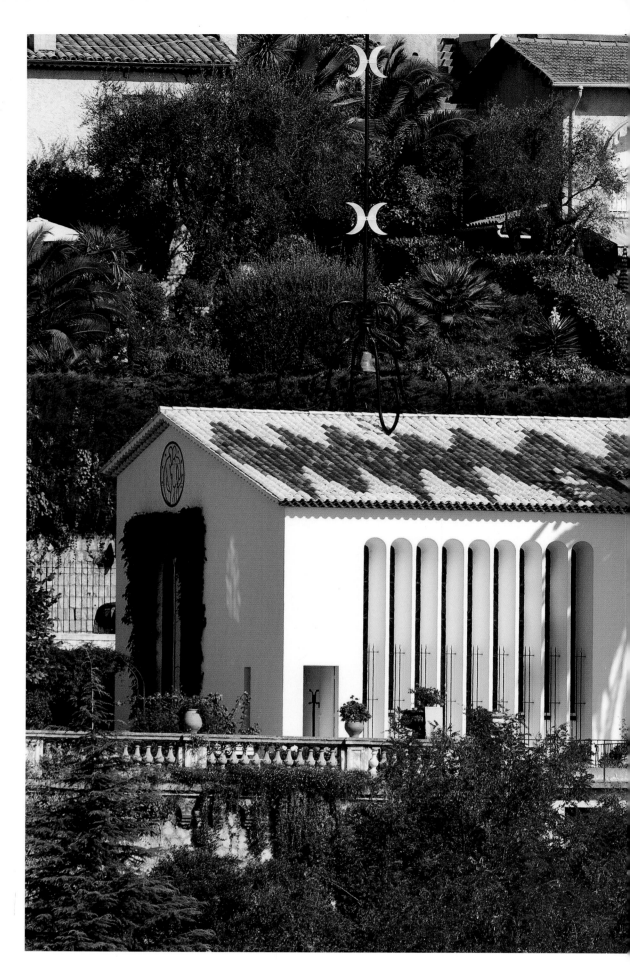

The exterior of the chapel

It is essential to be sincere, and a work of art only exists fully when it is heavy with human emotion and rendered in all sincerity, not rendered via the application of any of the conventional canons! This is why we can look at the pagan work of artists earlier than the Christian primitives without awkwardness. But sometimes when we are faced

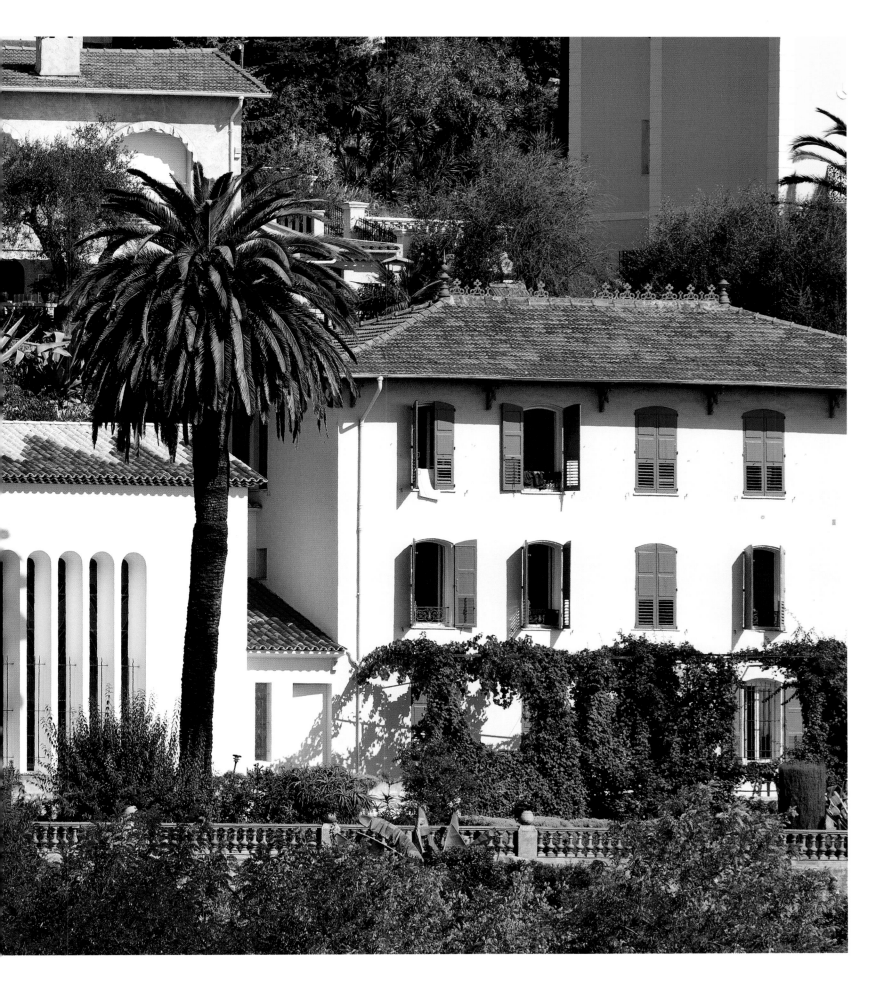

*with certain Renaissance works, with their over-rich materials,
sumptuous and provocative fabrics, we find ourselves rejecting the idea
that such sentiment could have any part in Christianity, with so much
pomp and circumstance.*[7]

1

The Birth of the Chapel of the Rosary

The Outcome of an Encounter

The combination of unexpected circumstances that presented Henri Matisse with the opportunity to design a chapel seems almost to have been sent by fate. In 1942, at the age of 73, the artist was living in a large block of flats, La Régina, situated on the Colline de Cimiez above Nice, looking down over the town and the Baie des Anges. He was still unwell after the serious operation he had undergone in Lyons the previous year, and his health required the constant presence of a nurse. The current nurse was about to go on holiday, and so a student nurse, Monique Bourgeois, arrived to replace her. Bourgeois recalled: 'It was on 26 September 1942. I rang the doorbell. A young woman, tall and fair-haired with a pale face, opened the door and gave me brief instructions.'[1] This was the beginning of a miracle of creation, the creation of the Chapel of the Rosary for the Dominican nuns in Vence.

Monique Bourgeois, a young woman of 20, had lost her father on 31 January 1942, and had herself been ill with lung trouble in 1940. In spite of her delicate state of health, she had presented herself at the nursing agency in Nice and had then taken the trolley bus up to Cimiez. She found the painter in bed: 'He seemed to be half asleep, but he was eyeing me through his gold-rimmed spectacles.'[2] Notwithstanding the artist's close scrutiny, and in spite of the awe he inspired in the young woman, an affectionate rapport was to develop between the two of them: 'M. Matisse was sometimes very cheerful, teasing and mocking me, but my playful nature easily adapted to this; we were soon friends.'[3] His light-hearted relationship with the young nurse gave Matisse a renewed burst of energy, which allowed him not only to endure his pain, but also, later, to confront the sizeable task of designing the Vence chapel.

Matisse supported the young woman in finding funds to finish her studies. They were more than 50 years apart in age, yet Matisse found in Monique's face the gaiety he wanted to portray, and from being his nurse she became his model. Sittings were often requested at odd times. 'One day, bored and irritated, I struck the most unlikely poses. Matisse grew angry and sent me away. Without realising it I had broken the artist's inspiration. The following day I had to make my excuses. He scolded me gently; I promised to sit quietly in future.'[4]

Matisse depicted her in four paintings: *Monique* (4 December 1942), *The Idol* (*L'Idole*, December 1942), *The Green Dress and the Oranges* (*La Robe verte et les oranges*) (January 1943) and *Royal Tobacconist* (*Tabac royal*, March 1943). Later, Monique Bourgeois had the opportunity to watch him at work

on the linocuts illustrating *Pasiphaé* by Montherlant.[5] The young nurse was deeply impressed by this experience and as a result she, too, began to draw and paint.

In February 1944 Monique Bourgeois entered the community of Dominican nuns in Monteils, in southwest France. In September she became a novice of the order, taking the name Sister Jacques-Marie. Matisse wrote to her frequently, sometimes pondering the significance of her vocation. In 1945 the young nun's health deteriorated and she was admitted to a convalescent home, the Foyer Lacordaire, in Vence. When she learnt that Matisse now lived only a short way away, she went to see him – her first visit to him as a nun. The following year, on 8 September, Sister Jacques-Marie returned to Vence having taken her vows, as a live-in nursing sister. Matisse described her in the following words: 'Although she is a Dominican nun, she is still a marvellous person. We talk about this and that in a particular tone of voice, with a bit of gentle teasing. When she had gone, Mme Lydia [Delectorskaya] expressed her surprise at our way of conversing.[6] I know what struck her: a certain tenderness can be detected, although none is intended. I expressed what was going through Lydia's mind by telling her it was a kind of flirtation. I should like to write "*fleur*tation", because it's rather as if we were throwing flowers at each other's faces, rose petals. And why not! This affection which needs no words yet which brims with meaning is not forbidden.'[7]

The encounter with Monique Bourgeois first as a nurse and then as a nun raised Matisse to new heights of reflection and creativity. In 1947 Sister Jacques-Marie told Matisse of her community's wish for the Foyer Lacordaire to build a chapel. She even handed him a sketch for a stained-glass window depicting the Assumption of the Virgin, painted by her in watercolour and executed on the evening of 7 August 1947 when she was at prayer, alone, keeping watch over the body of Sister Jeanne of the Holy Sacrament, the sacristine, who had just died. 'Why did I get out a piece of paper and start doodling? I've no idea', she said.[8] The freshness and simplicity of the sketch interested Matisse. 'I'd painted a picture of a stained-glass window. Matisse advised me to go ahead with it. One plan for the chapel had already been abandoned: he wanted me to do the drawing in preparation for the future chapel. I still objected as I felt incapable of designing a stained-glass window. Matisse insisted, promising to help me. This went on for a year, but I knew that what Matisse had decided was almost accomplished already.'[9] It was then that the plan to build the Chapel of the Rosary in Vence began to take shape, and it was to develop gradually over the following few years.[10] Matisse's investigation into the architecture and decoration of religious buildings began in Vence, then continued in the Régina apartment to which he returned in 1949. His apartment soon turned into a vast studio, with his sketches and studies, many of them life-size, covering the walls.

The pain caused by his illness and the anxieties assailing him had an influence on the creation of the chapel. These warring elements – pain and anxiety on one hand, peace and serenity on the other – found a kind of resonance in the treatment of the wall tiles that Matisse designed for the chapel: 'The Saint-Dominique [*sic*] panel and the panel of the Virgin and Child are in a similar elevated style, their serenity has a meditative tranquillity

that is appropriate, whereas the panel depicting the Way of the Cross has quite a different spirit, it's very stormy.'[11]

Matisse was unable to attend the inauguration of the chapel in June 1951 because he was unwell. However, he wrote a letter to Monsignor Rémond, Bishop of Nice, expressing his feelings about his creation: 'This work took four years of intensive labour, to the exclusion of all else, and it is the culmination of my whole working life. In spite of its imperfections, I regard it as my masterpiece.'[12] Sister Jacques-Marie continued to be the link between Matisse and the chapel. She preserved all the papers relating to the early stages of the work, and until her death in 2005, she remained a living witness to the generous spirit in which the work had been undertaken.[13]

Time for the Chapel

In a message addressed to his birthplace, Le Cateau-Cambrésis, in 1952, composed after the town had honoured him by setting aside a room in the town hall for the display of his work, Matisse described the course his life and his work had taken. He revealed the determination with which he had found his feet as a painter, and the importance of Vence in his eventual self-discovery: 'The creation of the chapel in Vence eventually awakened me to my own nature.'[14]

The decorative scheme used in the chapel closely reflects the different stages of Matisse's work and his life as an artist. Henri Matisse was born in northern France in 1869, and spent his childhood in Bohain-en-Vermandois in Picardy. Both places left their mark on the artist; particularly influential were the traditional northern work ethic and the local manufacture of textiles of various designs. In 1891, after a period of illness and a long convalescence, Matisse gave up the legal studies that were intended to ensure him a position as a solicitor's clerk in Saint-Quentin, Picardy. The colours in a paintbox and some colour prints proffered for study during this time provided the young man with the key to a new destiny. After a few false starts, Matisse became a pupil of the painter Gustave Moreau, who had some inkling of the role his student was to play in the future of painting.[15] In 1895, in the company of fellow painter Emile Wéry, the young artist discovered Brittany. This first contact with the natural world and its light was the revelation that began a long relationship. At the age of 30, Matisse visited England on his honeymoon, and discovered there the work of J.M.W. Turner, whose intense handling of light particularly pleased him. Later, in Corsica, he was to experience for the first time the incandescence of the Mediterranean landscape. Henceforward, Matisse gave himself up to light. During the summer of 1904 he joined Signac, the master of Divisionism, in Saint-Tropez. The following summer he withdrew to Collioure with Derain. He adopted a new way of painting, using colour directly from the tube: 'Fauvism'. Another phase began in 1912. While in Morocco, Matisse discovered the brilliant colours and dappled shade of the streets of the kasbah. He was drawn to different cultures and their art, and surrounded himself with exotic objects and furniture, expanding his scope of graphic and pictorial representation.

Matisse's taste, acquired over a lifetime, manifested itself in the way in which he undertook and conducted the chapel project. In many ways, by concentrating all the stages of his career together, this enterprise repeated all

the phases the artist had been through in his lifetime. Each one, however, was here enriched by his recent ordeal of illness and pain; as he recovered from his operation he gained new creative power. 'I have been through a terrible time but now I am stronger than I was before.'[16] A period of vivid colour and light was the result of this renewed energy. First came an illustrated version of an anthology of the poetry of Ronsard, *Florilège des Amours de Ronsard*; Matisse produced the plates for this, creating a delicate balance between text and illustration as if the volume were a work of architecture.[17] This was also the period when the writer Louis Aragon met Matisse. He wanted to write a book about the Master: 'Monsieur, I considered writing a novel about you …'[18] The painter accepted the project as a testimony to his work; after all, the author had just finished writing a preface, *Matisse-en-France*, to his collection of drawings published as *Thèmes et Variations*.[19] The artist chose different subjects to draw – faces, languorous young women, still-lifes, and executed them first in charcoal, followed by repeated variations in pen and Indian ink. The dexterity of the line, the simplification of forms and the energy and emotion behind each stroke exemplify the modern spirit that was later to characterise the Chapel of the Rosary. In spite of his frail state of health, Matisse pressed on. Illustrating the *Poèmes* of Charles d'Orléans, he tried to envisage the truth of a face without resorting to any existing portrayal for inspiration.[20] Matisse was at this stage pondering the whole question of resemblance. He asked himself the same questions when it came to drawing the faces of St Dominic, the Virgin and Child and finally of Christ.

Matisse's move to Vence in 1943 saw the beginning of a series of paintings of interiors characterised by their intensity of colour and the originality of the drawing and composition. The space and brightness of his work conceal Matisse's anxieties at this time about his daughter and his wife Amélie, who had both been arrested for being members of the Resistance. On 23 July Matisse wrote to Charles Camoin: 'You probably know that poor Madame Matisse has been sent to prison for six months … I thought I had been through every kind of agony, physical and mental. But no, as it turns out! I had to go through this final hurdle. I dare not think about Marguerite, of whose fate nothing is known … To make my anxiety bearable over the past three months I have worked as much as I could.'[21] The paintings of this period have no clearly defined borders; thanks to the luminous quality of their colours they have the appearance of a kind of *trompe-l'oeil*. Matisse merges the confined spaces of the interior of the house with the limitless space outside, the open sky. He was to adopt a similar approach for the Chapel of the Rosary.

In 1946 a film made by François Campaux presented Matisse as *the* French painter, at the zenith of his career, the apogee of the mastery of his art and style. In 1947 the Musée National d'Art Moderne, recently founded in Paris, purchased some large works by Matisse for its collections.[22] He embraced novelty again in a commission for the publisher Tériade, a book entitled *Jazz*.[23] It was within the context of this general recognition of his work and its importance in the history of art that Matisse, with the greatest modesty, took on the chapel in Vence.

An Encounter with the World of Religion

While Monique Bourgeois had illuminated the painter's sickroom with her youthful enthusiasm, encouraging him to continue his work, as Sister Jacques-Marie she connected the artist with the world of religion, an experience that for him represented a deepening of feeling rather than a spiritual revolution. 'I did not need to be converted to design the chapel in Vence. My innermost feelings did not change, they remained what they had always been, the feelings I have before a face, a chair or a piece of fruit.'[24] Materialistic man has to confront the spirituality of the message to be delivered: the human soul moves towards the divine. 'I began with the profane and now, in the evening of my days, I am ending quite naturally with the divine.'[25] Matisse worked boldly, as he had always worked, but with humility and conviction. His approach was the fruit of observation and emotion. He lived his work, and followed his intuition and his emotion in a relaxed manner. The work sustained his body as it battled with illness, and his mind opened up to the project he was engaged in. The remission of his illness helped him find new meaning in freedom, in the importance of living in the moment, even in existence. 'During my career I've struggled … One day I found myself facing an outcome that I greatly desired. It was not I who discovered it, who worked out my state of mind; it seems to me that an idea, an ideal imposed itself upon me.'[26] The spirit of the chapel, oscillating between intuition and things strongly felt, was transformed into creative movement. The project was translated into the wish for its accomplishment. 'My only religion is the religion of love for the thing to be created, the love of creation and of genuine sincerity.'[27]

Matisse approached the phenomenon of religion through the idea of creation, as he was himself a creator. The steady rate of progress he imposed on himself during the production of his work, his sustained effort and diligent observation of nature all culminated in a state close to faith. '*Do I believe in God? Yes, when I'm working. When I am being submissive and modest I feel so strongly assisted by someone who helps me do things that are beyond me.*'[28] The enthusiasm with which he worked breathes a kind of mysticism into the work, part confidence and part exaltation. 'It requires a great love, capable of inspiring and sustaining this continuous striving for truth, this overall generosity and the profound analysis needed at the beginning of any work of art. But love is at the origin of all creation, isn't it?'[29] With these feelings and this glow of enthusiasm, Matisse sought the kind of representation that, thanks to its universal nature, would appeal spontaneously to the feelings of any spectator. In the chapel, Matisse took great pains to forge a direct link between expression and feeling. The liveliness of his gesture gave life and control to his drawing. The artist's forced encounter with the world of religion and its visual codes seemed in fact to suit him. He felt at ease because he was working with modes of reflection and of expression similar to the ones he was accustomed to. 'All art worthy of the name is religious. Any work created from lines and colours: if the work is not religious it does not exist.'[30] This spiritual dimension comforted the artist as the work progressed, in a way that his youthful experience in the closed world of academic art had not. 'When one left one's easel, one either had a feeling of happiness or of discontent, according to whether it had gone well

[following pages]

The interior of the chapel, showing the *Tree of Life* window and the ceramic panels depicting *St Dominic* and the *Virgin and Child*

The interior of the chapel seen from the congregation's entrance, with the *Way of the Cross* ceramic panel

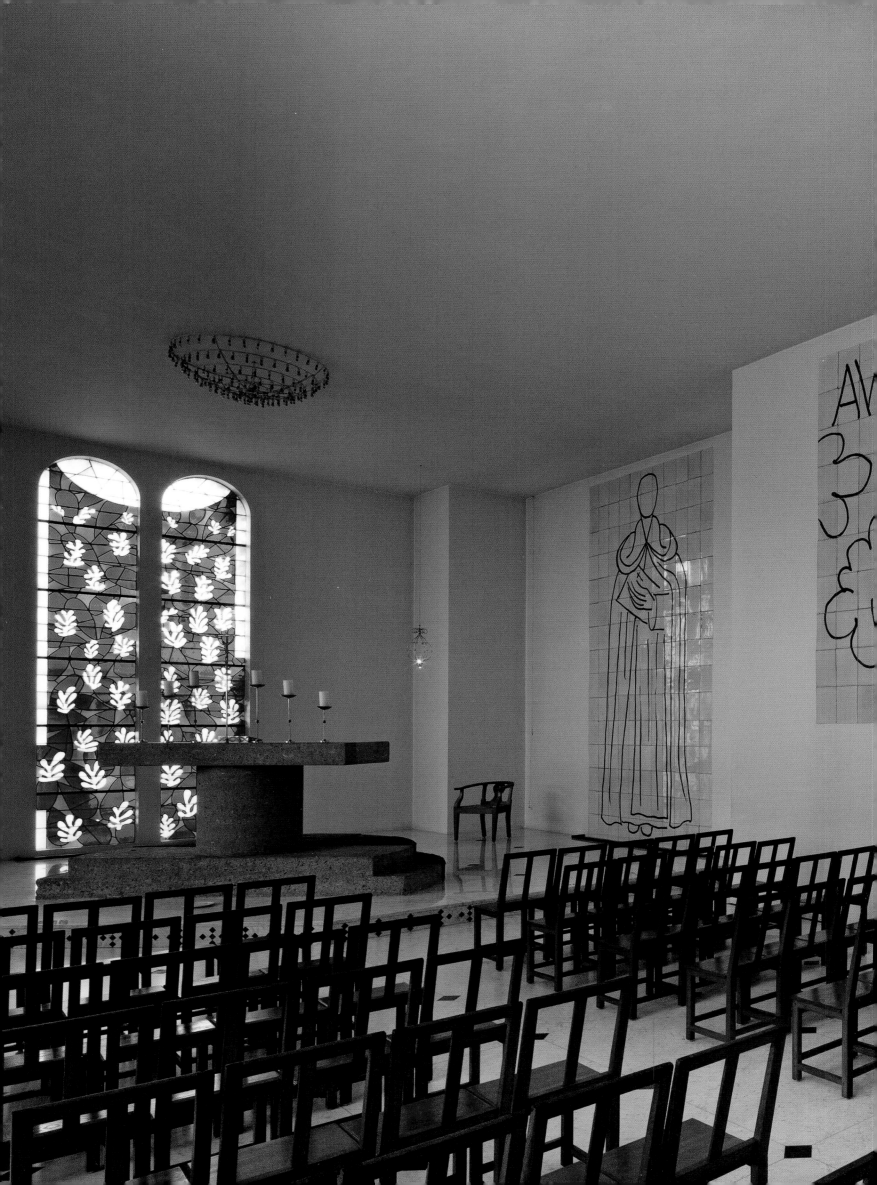

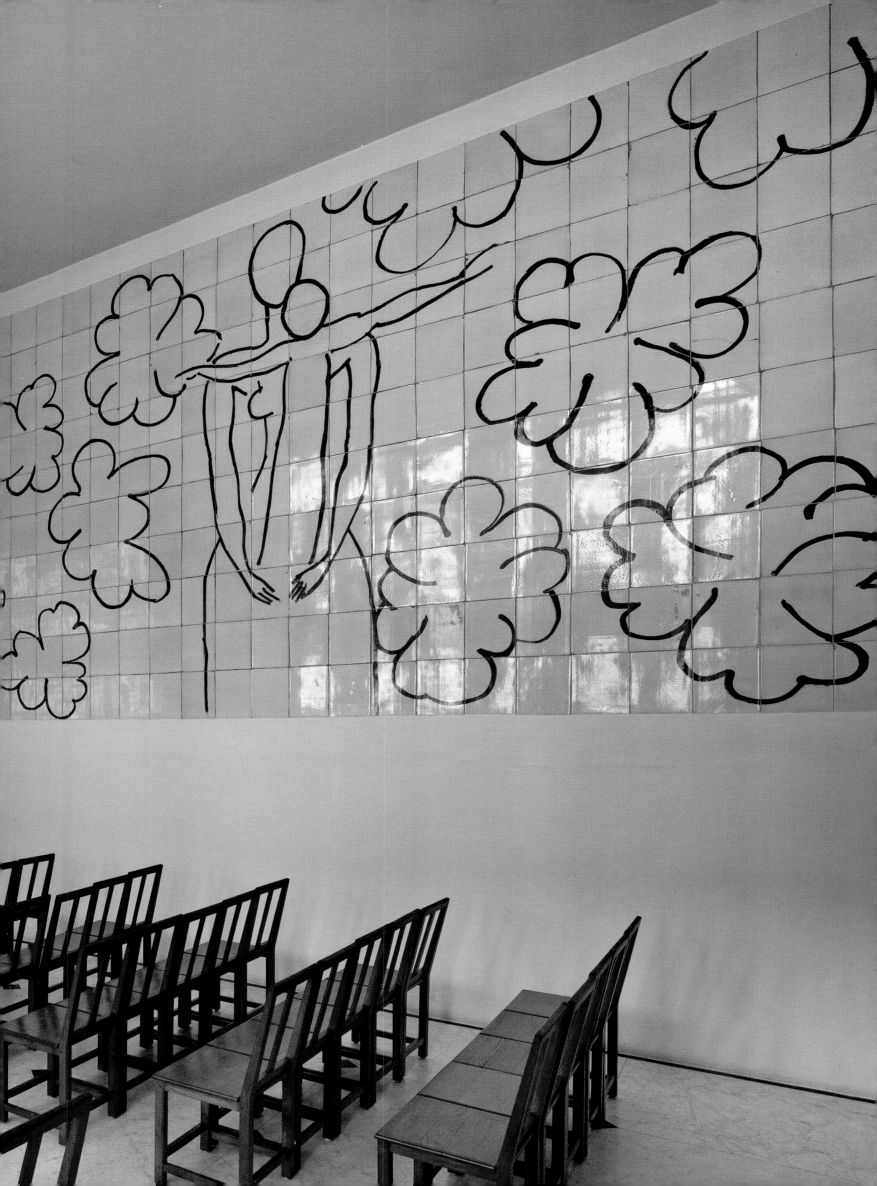

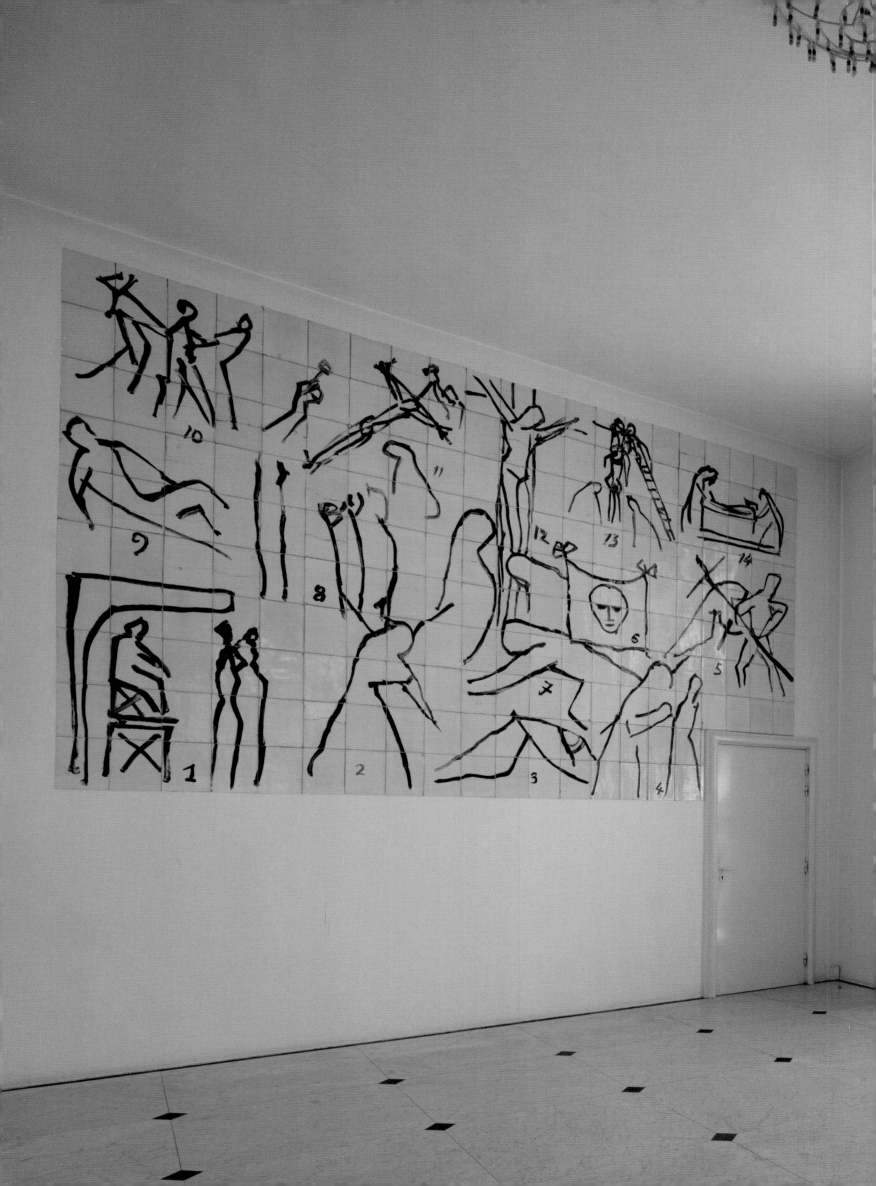

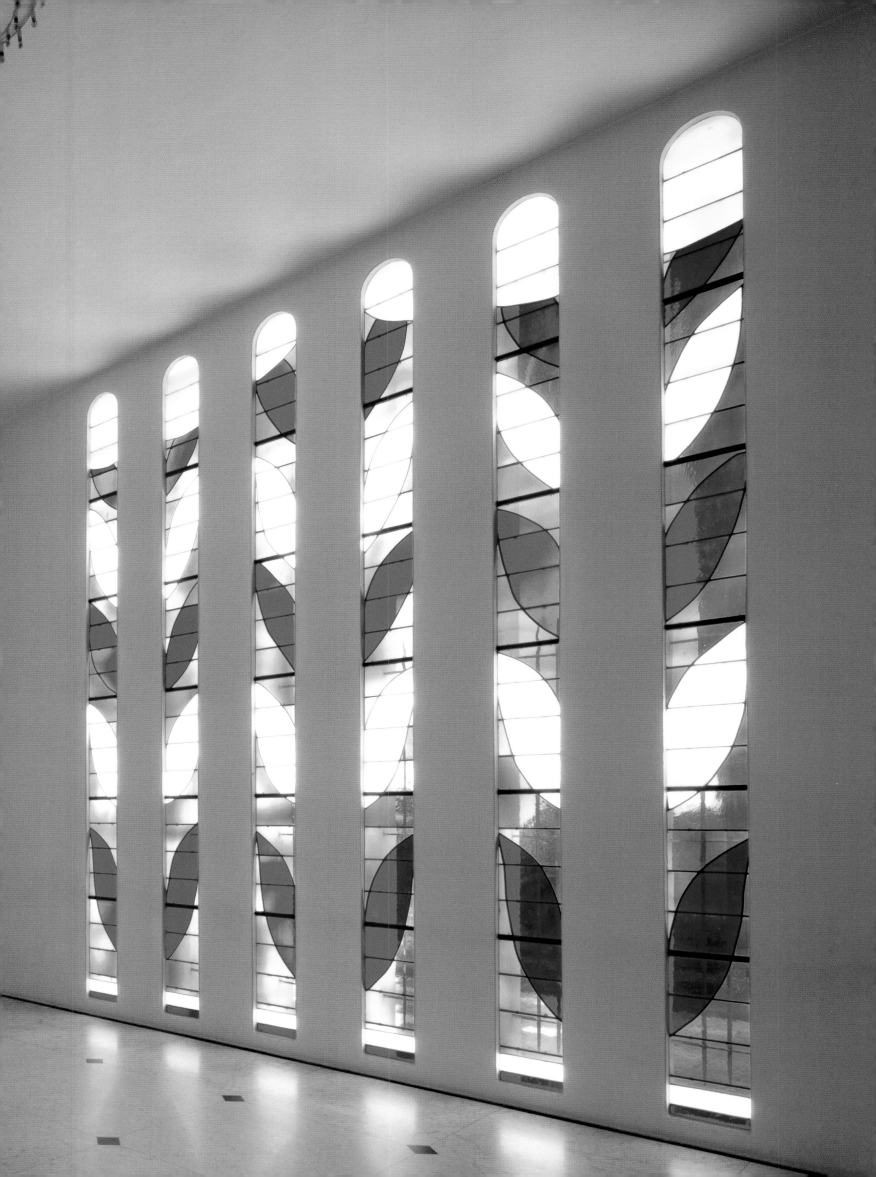

or badly. Meanwhile, all contact with the painting in hand was lost.'[31] At the end of his life, through the 'truth' of the chapel, Matisse was aiming to achieve a new paradigm.

'Active Contemplation': Towards the Creation of a Spiritual Space

For Matisse, the creation of the chapel assumed the nature of 'active contemplation'.[32] To start with, he carried out research into the different representations throughout the history of art of the subjects he was tackling: the Virgin and Child, St Dominic and the Way of the Cross. However, thanks to the very personal character Matisse gave to his versions of these subjects, he was able to penetrate beyond the visible world to a subjective dimension whose meaning can be perceived by all. In the simplicity of their design, the composition of the three tiled panels reflects a universe to which, as Matisse perceived it, 'the imagination itself gives depth and space'.[33] The attitude of the artist, and also that of the spectator, who in some way emulates the artist, is described by Matisse in his notes to the drawing *Tree* (1951). The artist writes to Rouveyre about the beauty and mystery of the trunk and the foliage of the tree that inspired the drawing: 'Nature accompanies me and inspires me. Contemplative action, active contemplation, how can I express it?'[34] To this is added the importance of empty space: 'I had already observed the way that in Oriental painting the composition of the space around the leaves was just as important as the drawing of the leaves themselves.'[35] In the Vence chapel, the luminous quality of the windows, with the colour they project onto the walls and floor of the chapel, magnifies the space by modifying and pushing back the visible boundaries of the architecture, giving it a spiritual dimension. This helps the visitor to arrive at a state of meditation and contemplation.

The Dominicans at the Time of Matisse

The creation of the Vence chapel occurred at a unique and significant moment in the history of the Dominicans in France. The Dominicans, also known as the Order of Preachers, have traditionally been privileged with great independence, and Dominican nuns belong to a separate religious body, under a superior who is under the direct authority of the Pope. In the name of freedom of thought, the French Revolution a century and a half before Matisse came to design the Vence chapel had completely unsettled the world of religion, thereby challenging the very identity of certain orders. Over the past few decades, however, the Dominicans had sought to restore the good name of their order and transform the manner in which their religious message was perceived. At the beginning of the nineteenth century, the preacher and activist Henri-Dominique Lacordaire gave new impetus to the Dominicans, establishing a return to strict observance of the rule, and putting much effort into the renovation of Dominican churches and chapels; these were to be places for meditation, and for preaching strong and structured religious opinions, intended to be shared and passed on. Architecture and decoration played a vital role. The Order viewed artists as possessing techniques that allow them to create work that intensifies faith in God more directly than words. Through its search for beauty, art matches the raising of the religious spirit. A work of art is able to deliver a religious message and

make even abstract concepts universally discernible. Within this context, the Dominicans began to call upon artists from a variety of cultures and styles, holding the view that it is not necessary to be a believer in order to create a religious work of art. Since 1920, the efforts of various Dominicans, including Canon Jean Devémy, have led to the creation or renovation of chapels such as Notre-Dame-de-Toute-Grâce, built for the patients in the sanatorium in Plateau d'Assy, in Haute-Savoie,[36] as well as the churches and chapels of Audincourt,[37] Ronchamp[38] and Les Bréseux.[39]

In 1937 the Dominican friar Father Marie-Alain Couturier began to devote himself to the revival of religious art. As the chief editor and guiding spirit of the journal L'Art Sacré, along with Father Régamey, he conducted an enquiry into the place of art in the Church as it related to the spiritual nature of artistic creation itself.[40] He thus opened up the world of religion to contemporary artists of varied beliefs and confessions. The wider cultural community began to take an interest, as evidenced by the exhibition at the Petit Palais in Paris, Vitraux et tapisseries (4–30 June 1939), in which 'religious work hung companionably alongside profane pieces signed by artists such as Braque, Picasso, Léger and Lurçat'.[41]

Georges Rouault was invited to design the stained-glass window for the Chapelle d'Assy, Fernand Léger the mosaic façade, and Pierre Bonnard the decoration of an altar. Germaine Richier created the crucifix on the high altar and Georges Braque was responsible for some of the decoration, as was Chagall. In 1948 Matisse was also approached. The painter, who had been working for the past year on the Chapel of the Rosary in Vence, borrowed the design of St Dominic from the Vence chapel and turned it into a painted bust that could be placed in a niche above a side altar. Like the drawing of St Dominic in the chapel in Vence, this was done with a brush. The black outline stands out against the yellow ceramic tiles. A vine bearing bunches of grapes follows the curve of the arcade.

During this period of artistic enthusiasm, the Chapel of the Rosary took on a very original character. In his studies and sketches, Matisse was taking into account the views of the Dominicans as well as liturgical tradition, but he wanted to delve deeper. By simplifying his style he managed to transcend material limitations and go beyond the visible. On the panel containing the Virgin and Child, the inscription 'Ave' may be read by the worshiper in silent prayer. The Dominican interpretation of the divine message finds its echo in Matisse's composition: the three letters forming the word 'Ave' correspond to 'Amor Verbum Eternitas' – 'Love, the Word, Eternity' – the main axes of Dominican preaching. Thanks to the spiritual message that art is able to communicate, the intangible aspects of divinity are able to make contact with mankind.

Matisse was aware of taking on a great responsibility when he agreed to design a building that connected man with the divine. He realised that his work should be in keeping with the long history of religious art and its masterpieces. This did not put him off at all. His response was to push back the boundaries of the traditional representation of religious subjects.

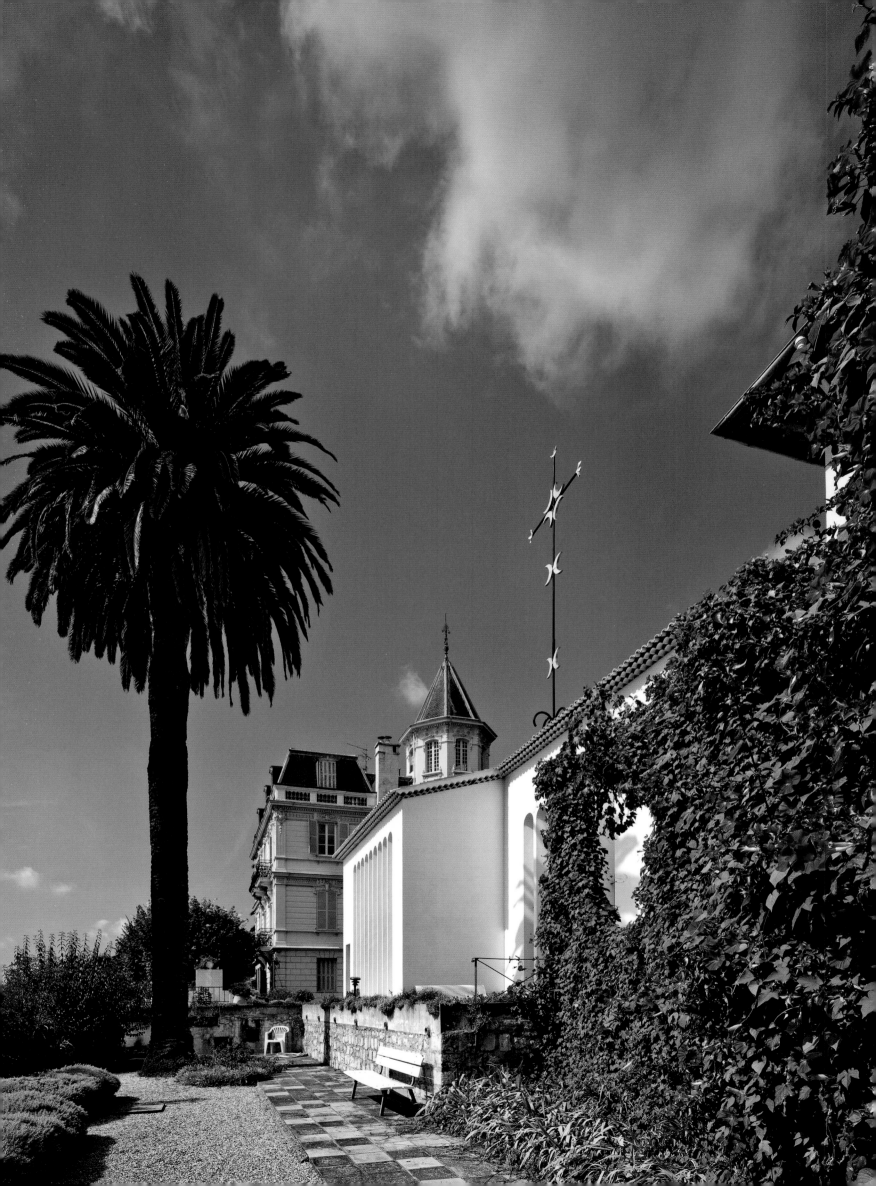

2

The Architecture and Decoration of the Chapel

*Within a very restricted space, as the width is only 5 metres, I wished
to establish (as I had previously established in paintings measuring
only 50 centimetres or a metre) a spiritual space, by which I mean
a space whose dimensions are not limited by the existence of the
objects represented.*[1]

M atisse's vision for the Chapel of the Rosary won recognition from the
outset. The artist believed that he had been 'chosen',[2] and each stage
of his work on the chapel was the outcome of the encounter between the
information he had gained from the Dominicans, his own iconographic
research and the pencil studies he worked on constantly. His experience as an
artist, his recent serious illness and his encounter with Sister Jacques-Marie
were also important elements in the creation of the chapel. In addition, for
the past few years Matisse had been creating very large pieces in which
decoration and architecture were combined, for example *La Danse*, created
for the Barnes Foundation in Merion, Philadelphia, in 1931.

Matisse's encounter in 1947 with the Dominican monk Brother Rayssiguier
was to play a very important part in the development of the chapel project.
The friar, a novice at the time, was spending a holiday with the Dominican
nuns of Passe-Brest in Saint-Paul-de-Vence. He had some architectural
experience and was currently architect to the Dominicans of the Province of
France, in Paris. He was interested in contemporary art and was eager to be
involved in the campaign, begun by Father Couturier, to revive religious art.
When he learned from Sister Jacques-Marie that Matisse lived in Vence, he
requested an introduction to the painter, and finally visited him at Villa Le
Rêve on 4 December 1947.[3] He had drawn up a plan for a chapel at an earlier
date and wished to show it to the artist, knowing about Matisse's interest in
the similar project for the Dominican sisters in Vence. A dialogue began
between the Dominican and the painter, and general agreement about the
main outlines of the project was reached: 'The young Dominican had taken
his inspiration for the design of the chapel from plans and photographs of
churches in German Switzerland which had appeared some months earlier in
L'Art Sacré, and had drawn a simple parallelepiped with a side aisle off the
choir to accommodate the nuns.'[4]

Their ideas, however, rapidly proved to be divergent. In April Matisse
decided that his decorative panels should be placed high up, and this ran
counter to Brother Rayssiguier's plan to establish equilibrium between the
windows and the mural compositions. He informed Matisse in May that the
windows would be installed at the same height as the mural panels. At their
next encounter, on 24 May, Matisse suggested increasing the importance
given to the windows. The painter's concept was so different from that of the
friar that Brother Rayssiguier decided to withdraw. He nevertheless worked on
a new plan and, with the agreement of Father Couturier, proposed the

[opposite]
The south side of the chapel,
the garden and the Foyer
Lacordaire

inclusion of Le Corbusier.[5] Matisse rejected both the plan and the proposal. In fact, he was not keen for an architect to be involved at all, but he agreed to the choice of Auguste Perret, who specialised in the use of concrete. Modifications were made to the existing plans, most importantly in raising the height of the ceiling, another idea opposed by Matisse. The painter requested that, if necessary, the architect Milon de Peillon, who worked in Nice and whom he knew, should be consulted. 'But there was little to be said, except that he had innocently but unwisely promised to build Matisse "a little gem"... However, he was to remain the professional, legal and official "umbrella" of the site in Vence.'[6] Matisse shared conversations and exchanged views on the subject of the windows with Father Couturier, and also with Paul Bony, a master glazier who had experience of working on projects with artists, including Rouault's windows for the Chapelle d'Assy. The correspondence reveals the part played by Matisse in the execution of the windows of the chapel in Vence.[7] After first worrying about where exactly they should be located in the building, Matisse taught himself about the techniques of making stained glass because he wanted the maximum amount of light to be admitted to the building. During the four years it took to build the chapel, discussions and modifications followed each other in quick succession. What was never in question, however, was that Matisse wished the chapel to be viewed in its entirety as a work of art, in the same way as a painting or a piece of sculpture might be viewed. He wanted to safeguard his own freedom of expression to the full, and to feel involved in all aspects of the project, studying the plan in great detail and establishing connections between the elements. The architecture and the positioning of the windows were second in importance to the light – this was, for Matisse, the chapel's most essential feature. Colour, graphic representations and furnishings formed the interior world of the chapel, which, through its windows, was to be half-open to the natural world and the landscape of Vence. Matisse invested a traditional building with a modern spirit that was to open the way to new forms of artistic expression, based on a radical simplification of graphic representation, and on the predominant position given to light and its relationship to colour. In this way the chapel has entered the canon of art history as a unique masterpiece.

Towards a New Space

A number of Matisse's earlier works contributed indirectly to the design of the chapel in Vence through the experience they afforded him. For example, Dr Barnes's commission for three decorative panels for his foundation in Philadelphia gave Matisse the chance to design work on a new scale, connected with architecture and space. Matisse was asked to create a decorative feature for three blind arcades above three high windows. Rather than planning a different subject for each of the three surfaces, he chose the overall theme of dance for the whole space – this was a subject he had already tackled in 1905–06 in the painting *The Joy of Life*,[8] and later in 1909–10 in a large painting, *La Danse*, designed for the monumental staircase of the Moscow residence of the Russian collector Sergei Shchukin.[9]

Twenty-six years later, Matisse adapted his earlier composition so that it could fit into the three high arcades of the Barnes Foundation. After completing a large number of preparatory studies, he achieved the effect he was looking for: the movement of the dancers alters the perception of the space and creates an illusion of continuity between the three arcades. The constraining effect of the pilasters thus disappears, so that they become an element in the overall scheme.[10] The contrasting colours and backlighting from the windows give scale and organisation to the whole scheme. 'My decoration connected together the different parts of the ceiling and the wall, making the whole space into a huge luminous ensemble. I compared it to the west door of a cathedral with its tympanum.'[11]

From the beginning, Matisse organised pictorial space in a novel manner that was to have a profound influence on twentieth-century art. In his Fauvist work in particular, the artist used chromatic effects with great originality, depicting the modelling of a face by juxtaposing bright colours, and differentiating the distances in a painting with certain hues, often complementary colours. His perception of space, and the relationship he forged with what he observed were also original and unexpected: 'My aim is to express my emotions. My state of mind is created by the objects around me, which react with me: from the distant horizon to myself, including myself. Very often I put myself into a painting and I am aware of what exists behind me. I also express space, and objects located in space as naturally as if there was just sea and sky in front of me, in other words, the simplest things in the world.'[12]

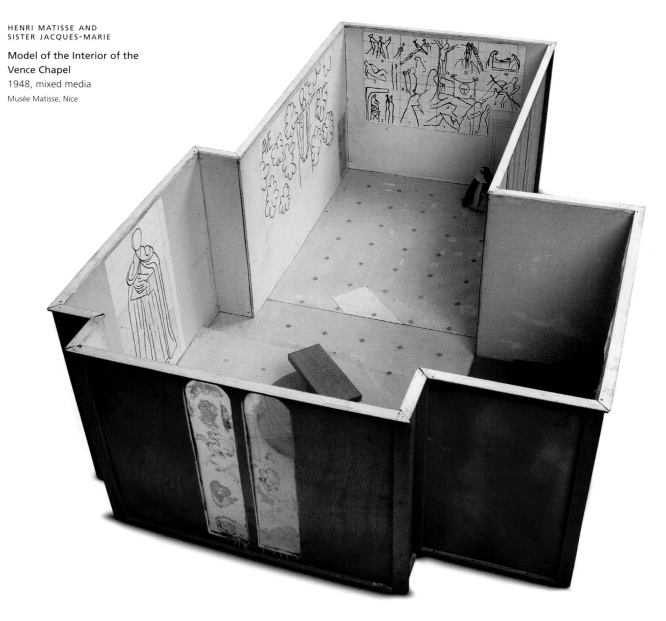

HENRI MATISSE AND
SISTER JACQUES-MARIE

**Model of the Interior of the
Vence Chapel**

1948, mixed media

Musée Matisse, Nice

The plan of the chapel

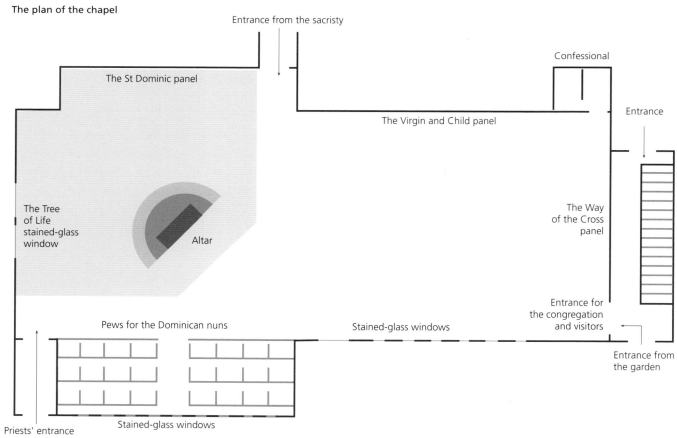

Entrance from the sacristy

Confessional

The St Dominic panel

The Virgin and Child panel

Entrance

The Tree
of Life
stained-glass
window

Altar

The Way
of the Cross
panel

Pews for the Dominican nuns

Stained-glass windows

Entrance for
the congregation
and visitors

Entrance from
the garden

Priests' entrance

Stained-glass windows

Matisse delighted in the merging of sky with sea, having experienced the effect while bathing in the Polynesian lagoons of Tahiti during a visit in 1930, and he continued to be inspired by this commingling in his later work. Also important in contributing to Matisse's design for the chapel was his transition, in the mid-1940s, from painting to monumental compositions cut out from paper painted with gouache; here the artist became totally immersed in new combinations of shapes and colours.

As the design of the chapel progressed, its interior became space as imagined and designed by Matisse. Around November 1948 the plan was settled. In 1949 Matisse left Vence and moved back to the Régina building in Nice, the dimensions of which corresponded to the dimensions of the chapel. He worked to scale, enjoying exceptional freedom of expression as he made modifications to his composition. The walls of his apartment became covered with his preliminary drawings, designs for the stained-glass windows cut out of gouache-painted paper, and models of the chapel made in collaboration with Sister Jacques-Marie; in this way he could clarify his ideas.[13] The simplicity of the plan and decoration helped to give life to his ideas. Brother Rayssiguier received Matisse's comments on the architectural suggestions made by Auguste Perret on 22 July 1948.[14] 'He repeated what he had said yesterday: what interests him is to insert space and light into an edifice which itself is of no particular interest.'[15]

The configuration of the completed chapel gives the impression of surprising size. A modest doorway, of no special distinction, gives access to an interior divided into three distinct areas by the way the space is arranged. On entering the chapel, a member of the congregation is in the area designated for him, from which he can see the rest of the building. The diagonal placement of the high altar, raised on two steps on a marble dais, places the priest opposite the nuns, who sit in a separate area, as well as the congregation. Behind the altar an open space allows the priest to move around during services. This careful organisation, taking into account the different functions of the nuns and the clergy, enhances the clarity of the chapel and encourages direct contact between the different groups. These limited sight lines, along with Matisse's minimalistic drawn lines, create a sensation of emptiness and infinity.

[following pages]
The south façade of the chapel, with views from the garden and architectural details of the façade

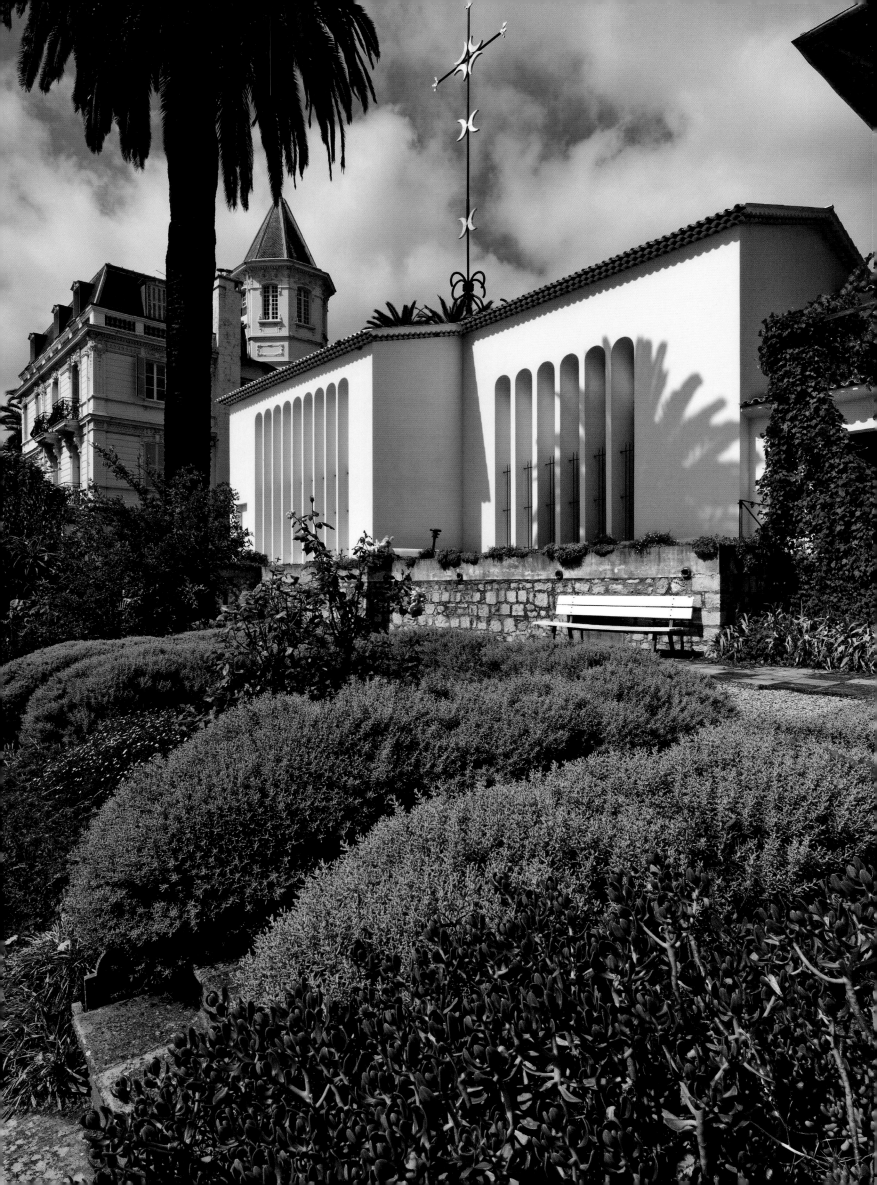

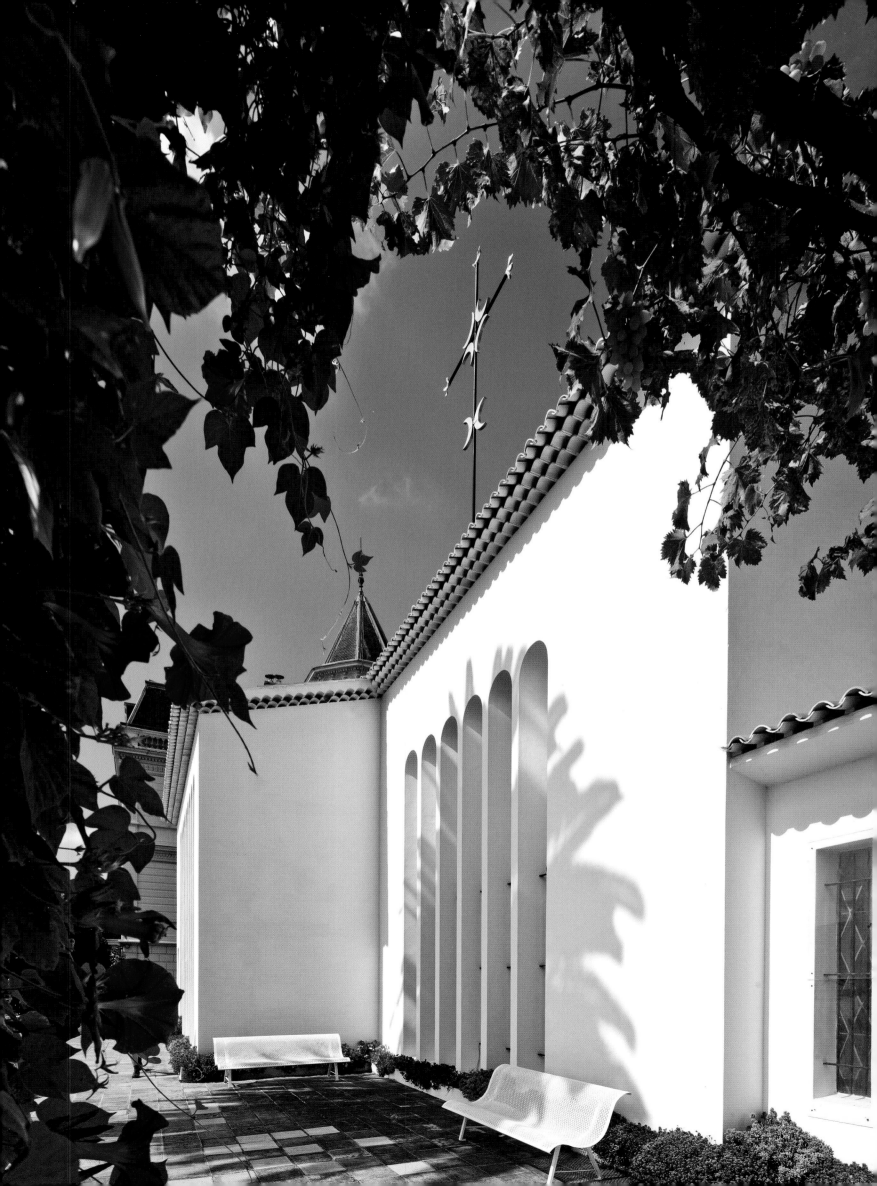

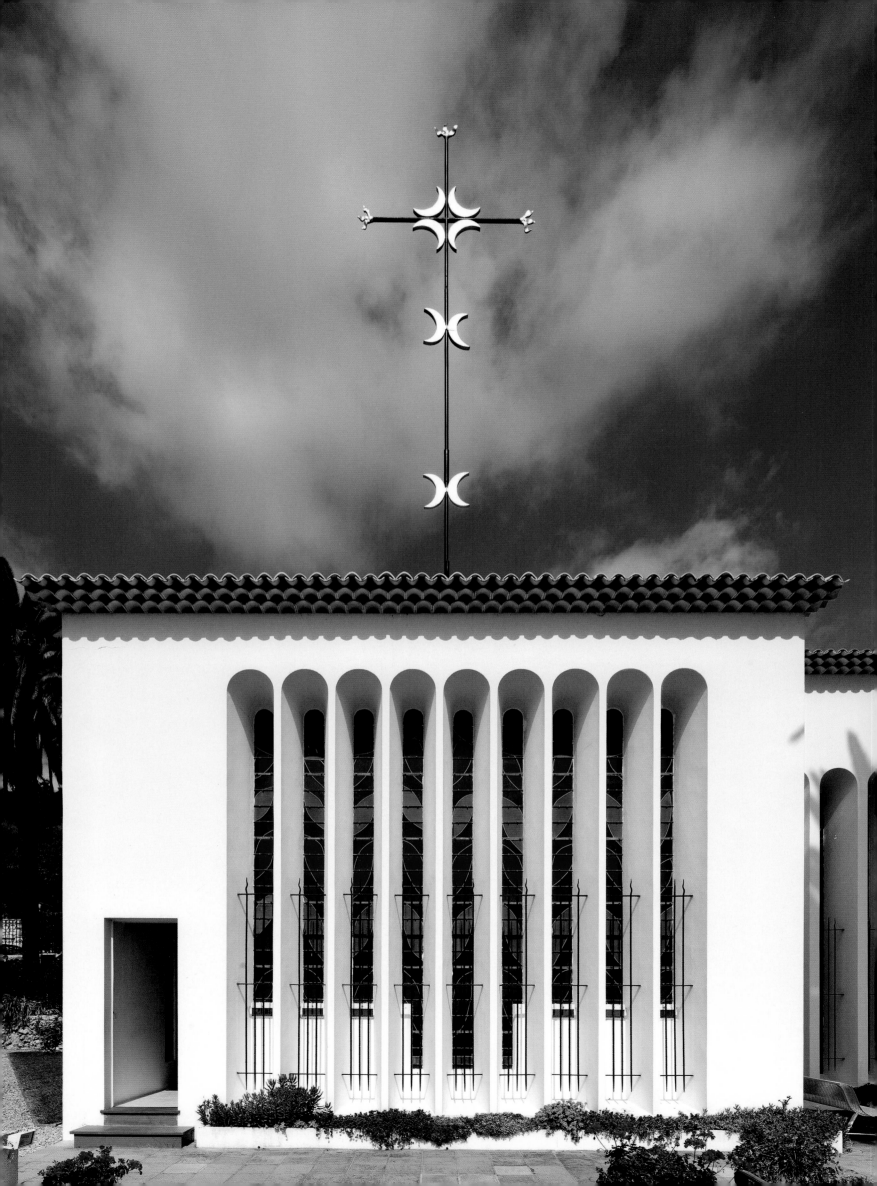

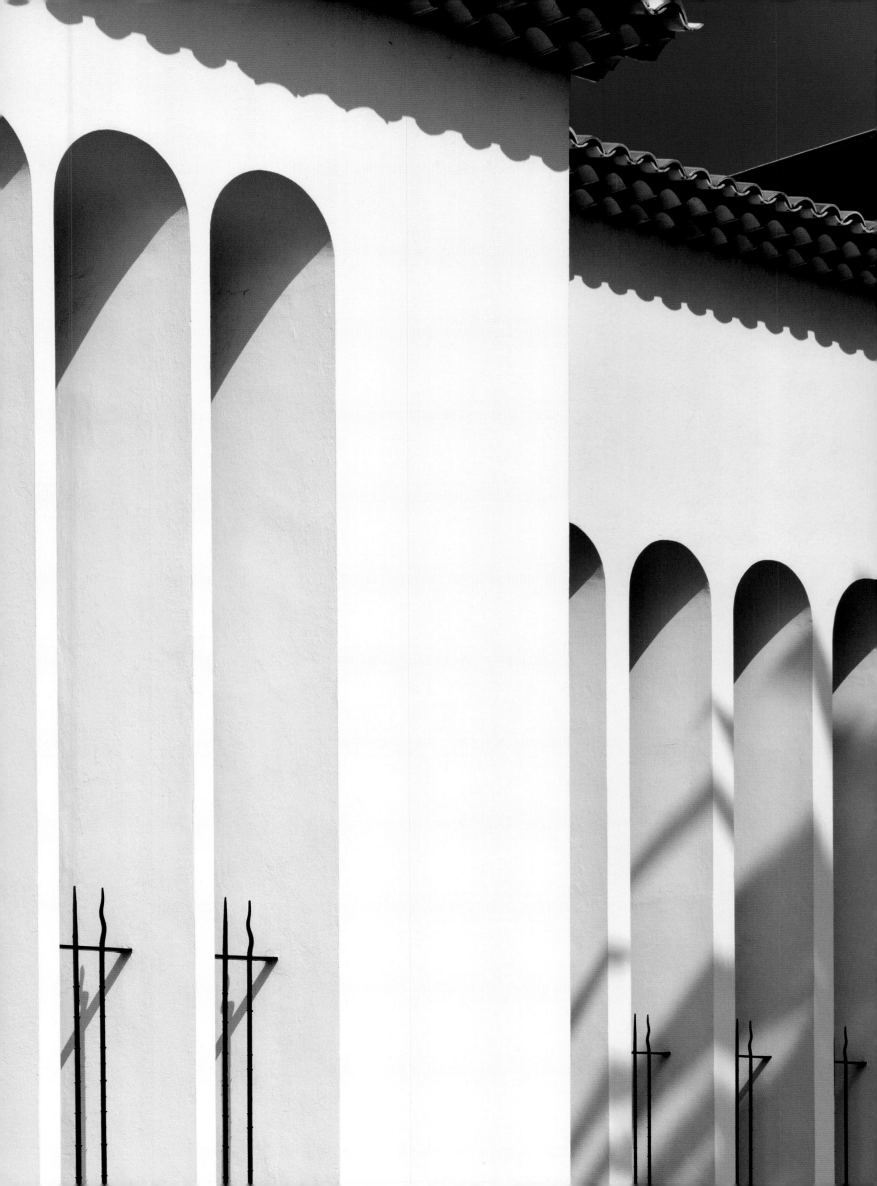

A Joyous Church

As Matisse himself noted, his work began as 'profane', and towards the end of his life became 'sacred'.[16]

Various writers had the opportunity to ask Matisse questions about the Vence chapel. In July 1948 Alfred H. Barr, one of the first people to write about Matisse's work, recorded comments from the artist that clearly demonstrate the pleasure Matisse felt when working on the chapel. Matisse told Barr that he felt deeply engaged in the project, and that it brought him a special feeling of satisfaction; he was to repeat this sentiment several times. He always talked of the chapel with enthusiasm. When the press began publishing information about the project, for example in *The New York Times Magazine*, Matisse declared that this unprecedented new departure, after 60 years as an artist, was not an act of repentance. He said to Barr: 'in my own way, I have always sung glory to God and all His works. I have not changed. This will give me an opportunity to apply everything I have learned throughout my life.'[17]

The completed work retains the appearance of a sketch, and this gives it an open character. It is not closed in on itself in a dogmatic fashion. It continues to live today in the same spirit of continuous development that Matisse intended – suffused by its own dynamic character and the joy of the process of artistic creation, in spite of conventions and constraints.

[opposite and following pages]
The congregation's entrance, with views through the chapel to the *Tree of Life* window

A church full of gaiety – a space that makes people feel happy ...
The forms will be of pure colour, very bright. No figures, only the
outline of forms. Imagine the sun streaming through the window –
it will cast coloured reflections on the floor and the white walls.[18]

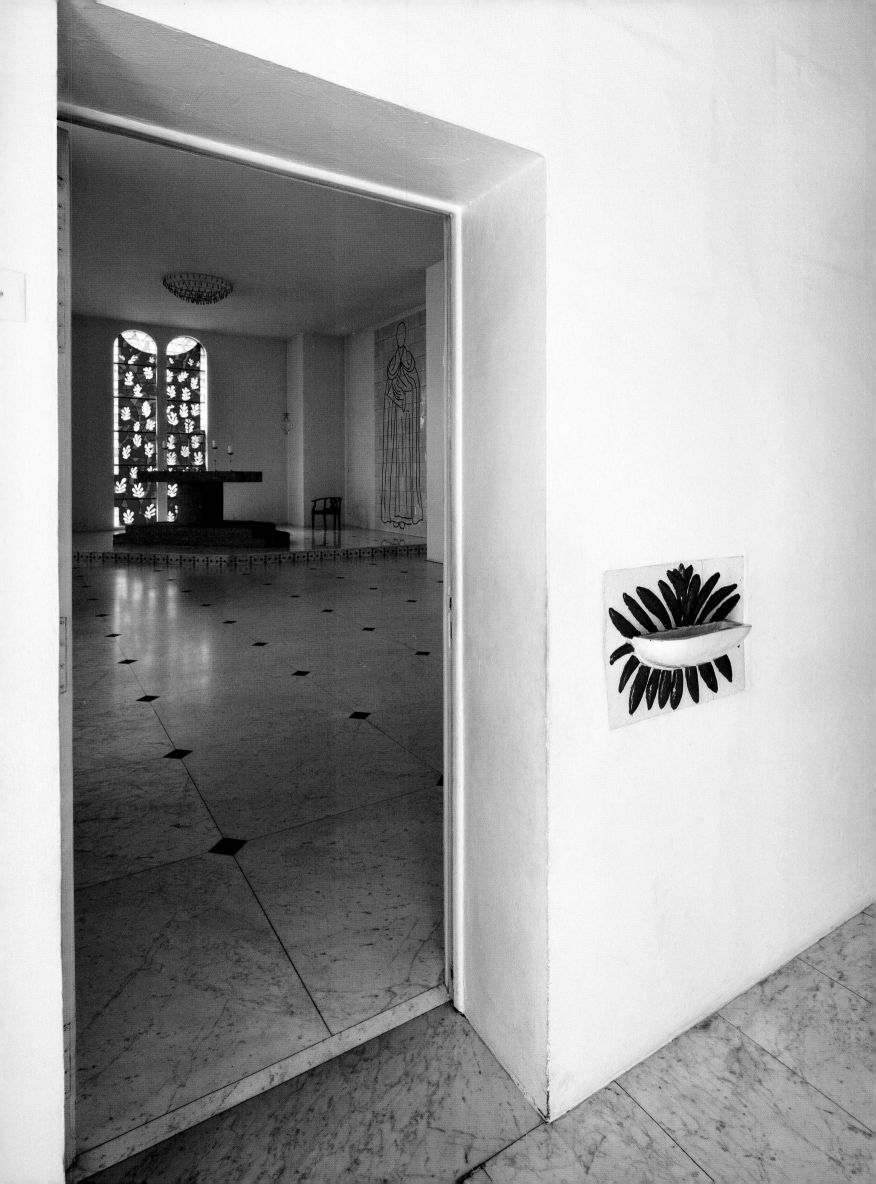

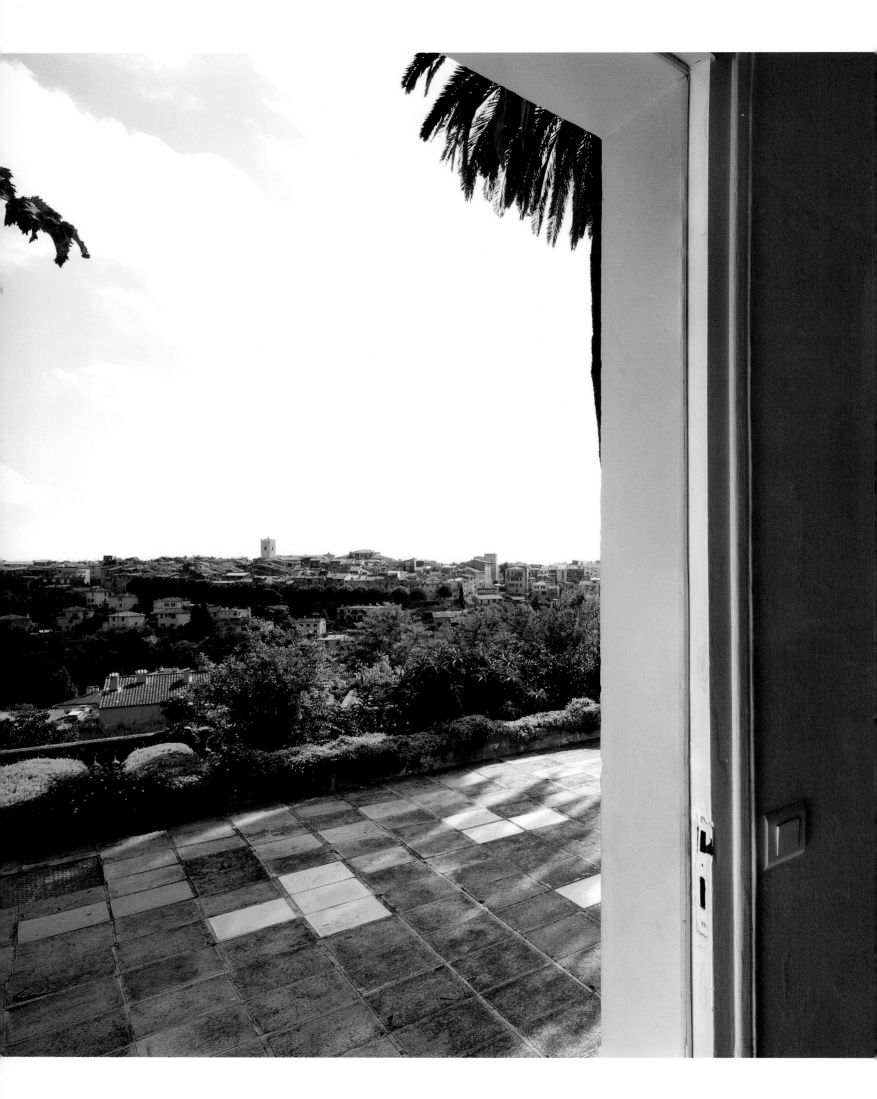

48

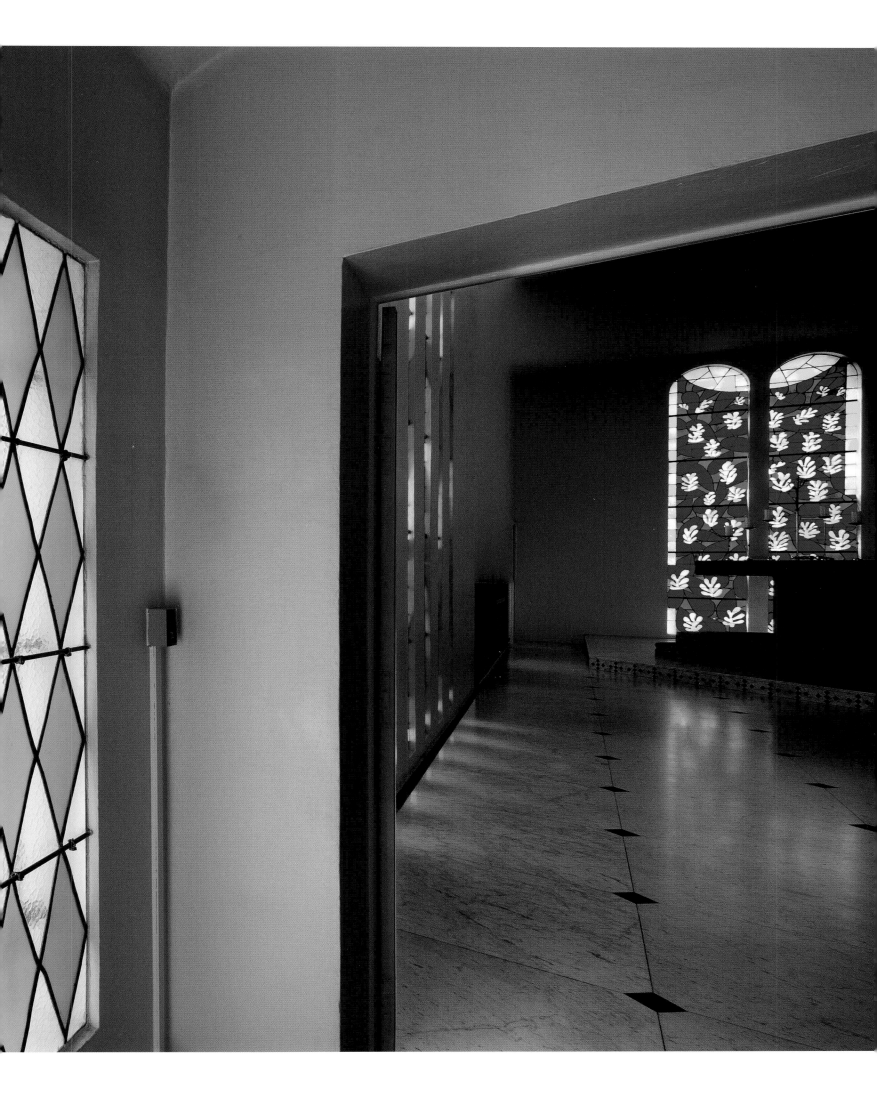

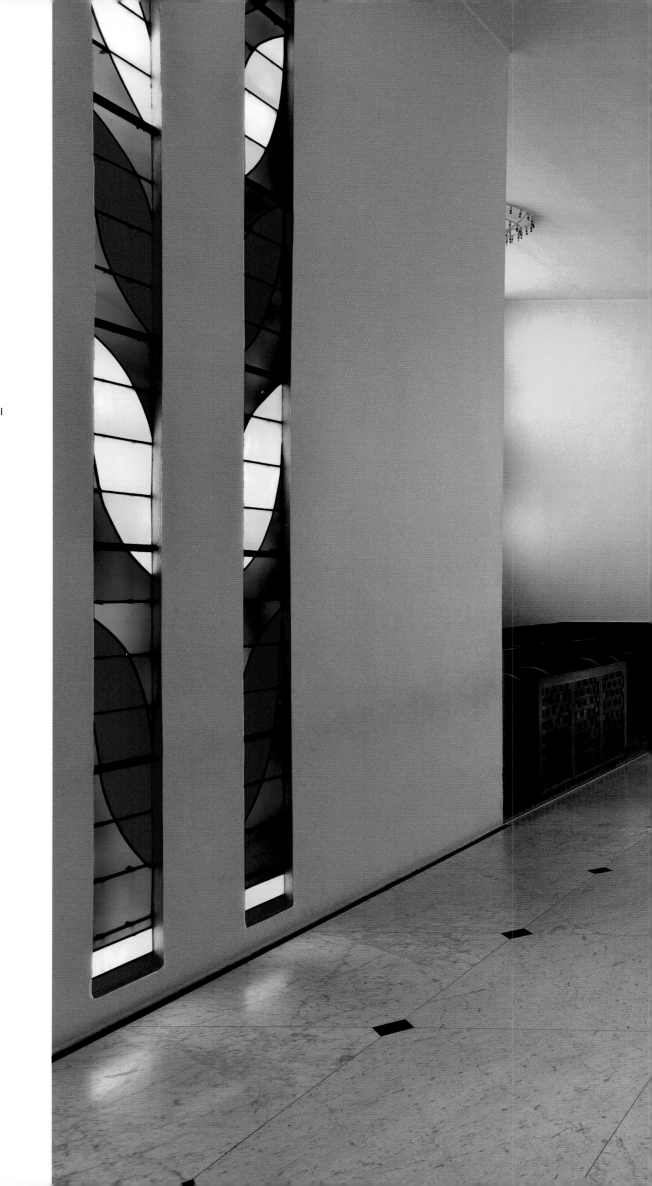

[this page and following pages]
The interior of the chapel

50

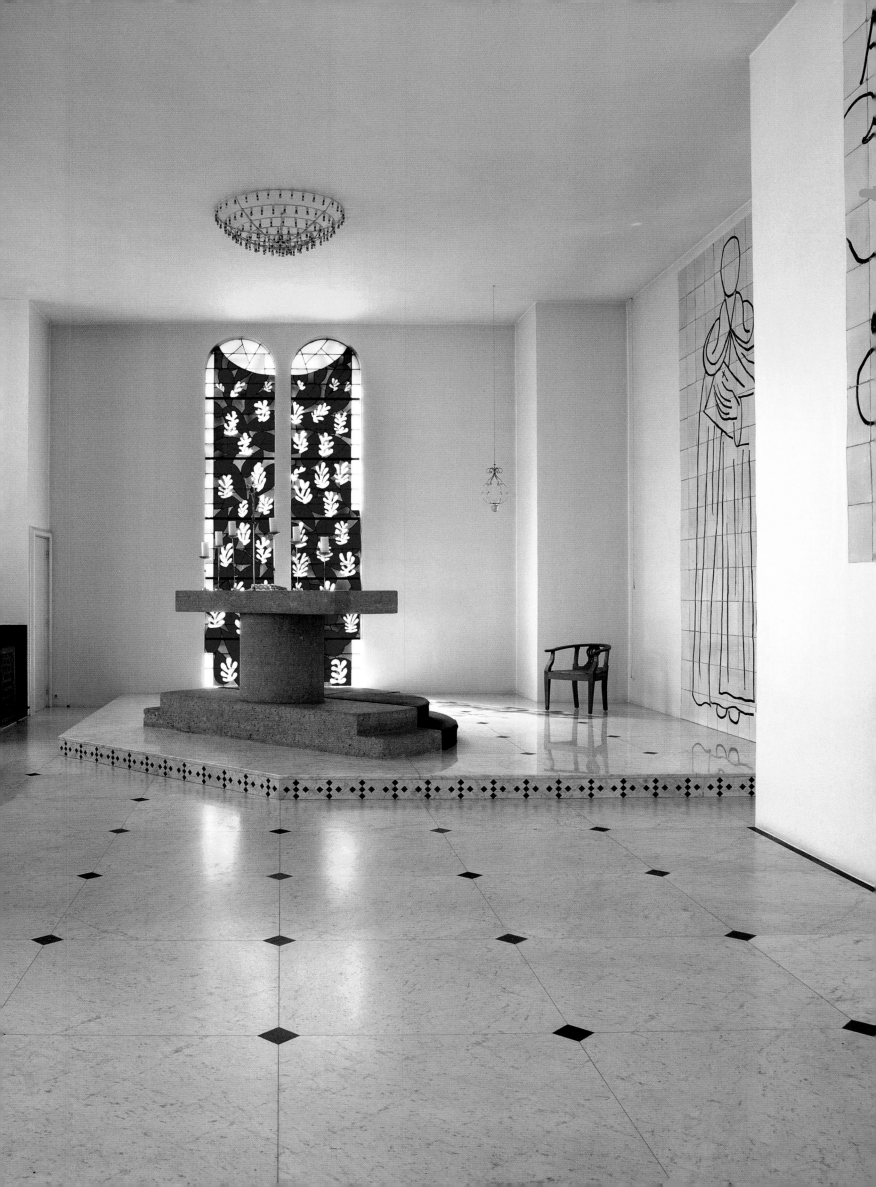

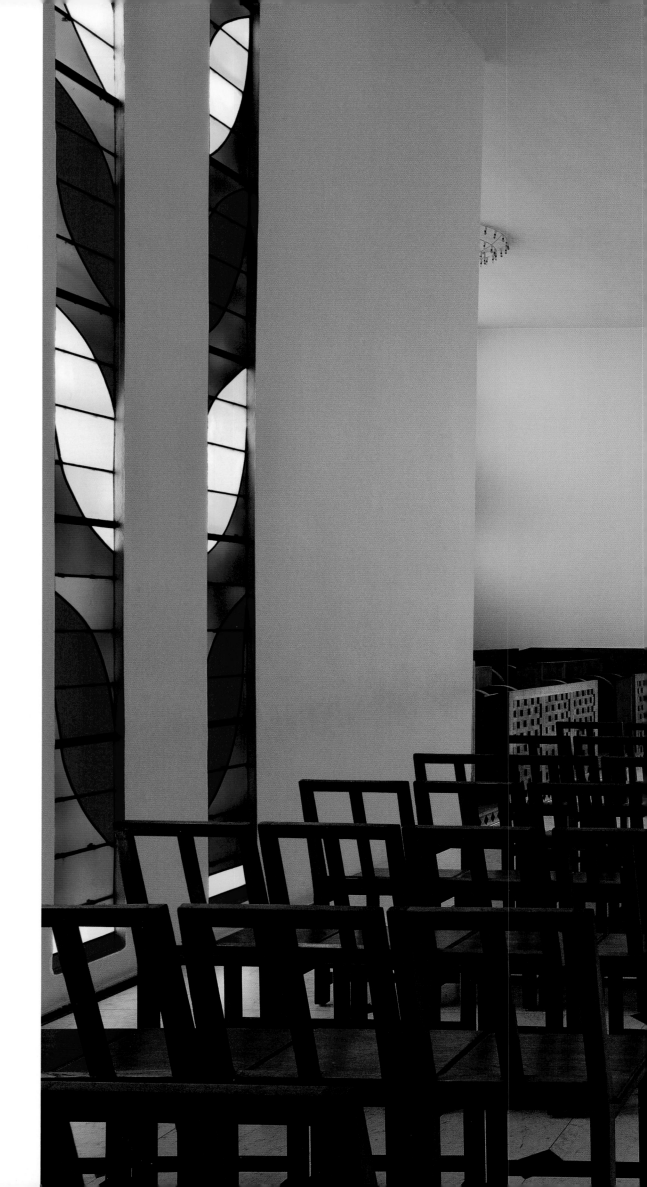

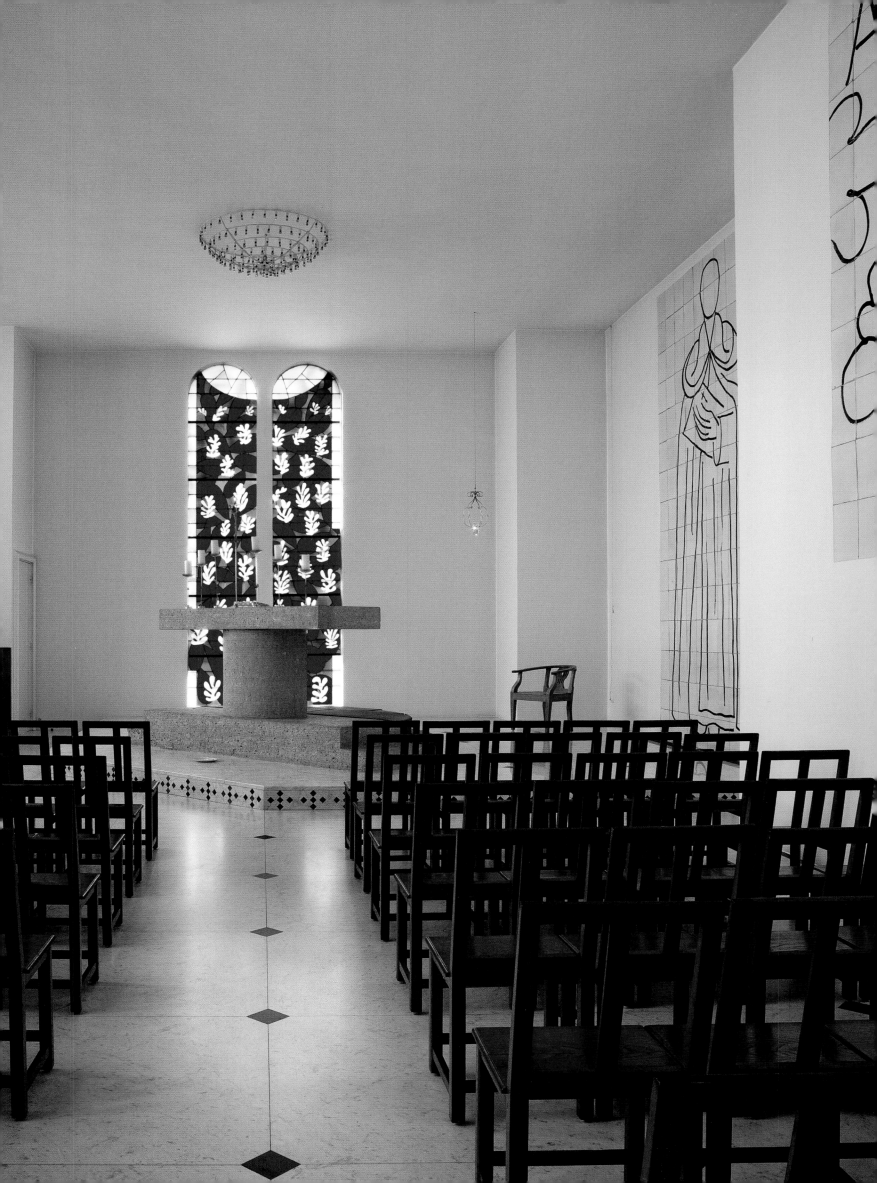

The Confessional

For Dominicans, the first step towards their vocation is an encounter with the self in the presence of God. Confession plays a very important role in the relationship between the individual and God. In the Chapel of the Rosary the confessional, in which the sacrament of repentance takes place, is connected with the symbolism of light through its design, layout and access.

In earlier Christian buildings the confessional was a small structure located, like the baptistery, outside the church. In the Vence chapel, however, the confessional occupies a different position, being accessed from the area reserved for the congregation, and positioned at the corner of the panels showing the *Virgin and Child* and the *Way of the Cross*. It is thus placed between representations of the hope engendered by birth, and the drama of the human condition, symbolising the hope of resurrection as invested in the act of confession.

The door to the confessional retains the texture of the wood from which it is made. It is painted white, and is constructed from eight cut-out panels. Each panel is different, and the sources of inspiration are varied. Among the objects and furnishings in his possession, Matisse owned palm-fibre fabrics with geometric patterns from the Congo and latticework balconies from North Africa, which he had used as backgrounds to his 'odalisques' of the 1920s. The door to the confessional was inspired by these fabrics and hangings.

The small, white-walled room of the confessional is lit by a plain glass window. Here the believer enters into a dialogue with himself; he is not isolated in darkness, rather he is in a light-filled space. At certain times of day the confessional takes on a curious colour, a mauve hue created by the daylight playing on the white walls, in contrast to the brightly coloured environment created by the stained-glass windows in the nave. The influence of Matisse's visit to Morocco in 1912 can be seen here. He had been overwhelmed by the quality of the sunlight in the kasbah in Tangier. The whiteness and sun-lit warmth of the walls contrasting with the chill of the shadows, and the colours of the doors and clothing created juxtaposing sensory and visual perceptions that helped give the artist's rendering of space an unexpected depth and vision; this can be seen in paintings such as *Zorah on the Terrace* (1912), in which the subject seems to float in an aerial universe, open and light-filled.[19]

The impression of airiness provoked by the glancing light on the walls of the confessional extends paradoxically to the representation of the Crucifixion, drawn on a ceramic tile above the grille of the confessional. As on the panels in the chapel, Matisse used a paintbrush and black enamel paint. The outline stands out against the white glaze. A wave shape formed of two lines modifies the stark impact of the crucified body. Depicted in a pose like a dancer, torso and arms forming a circle, Christ looks as if he is being borne upwards by a heavenly wind; his weightless ascent mirroring the lightness of the absolved soul.

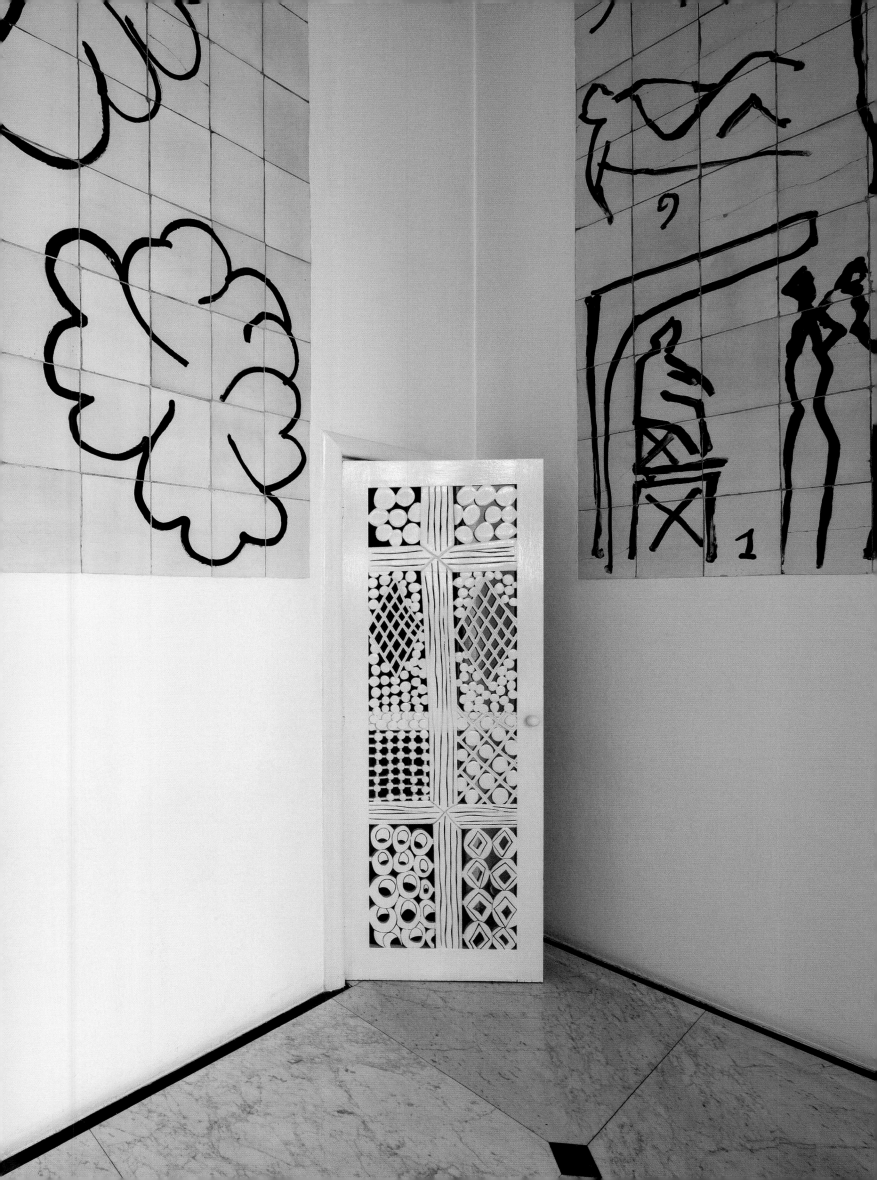

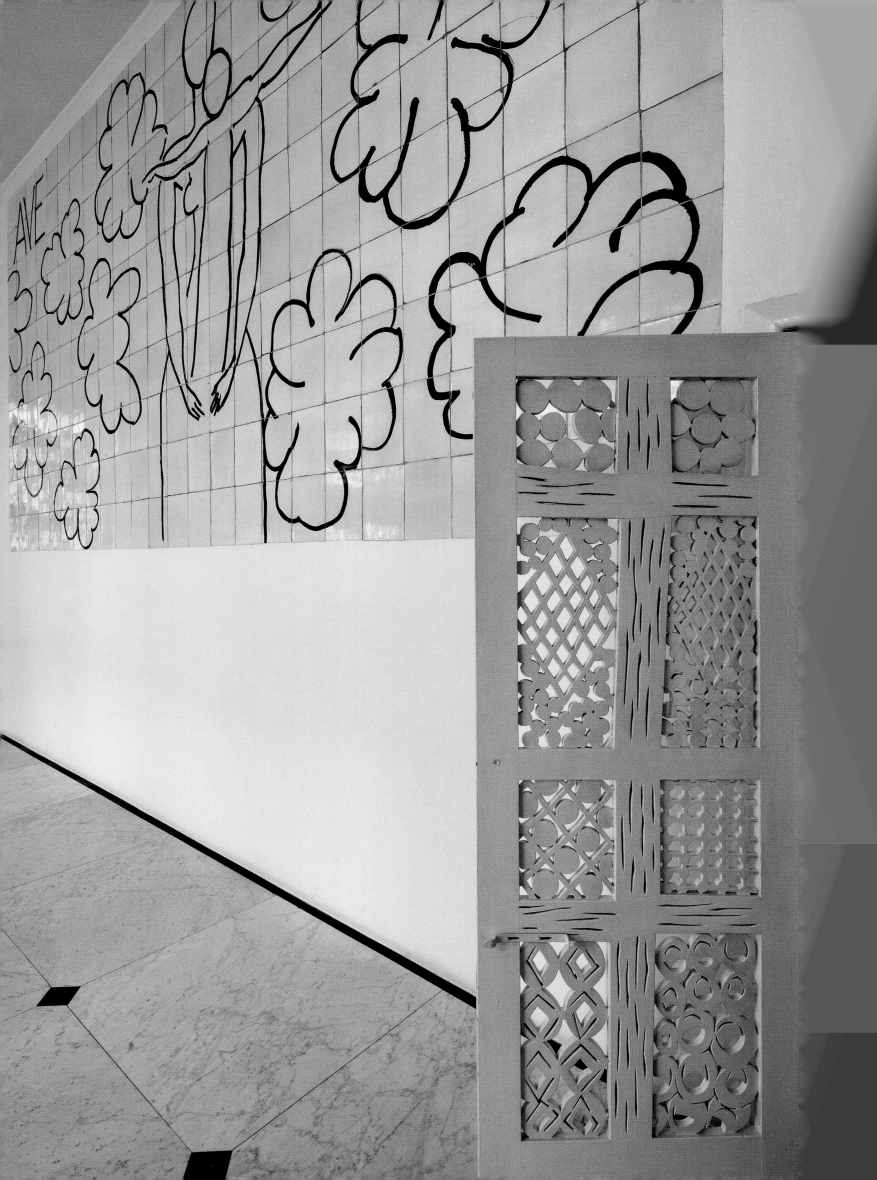

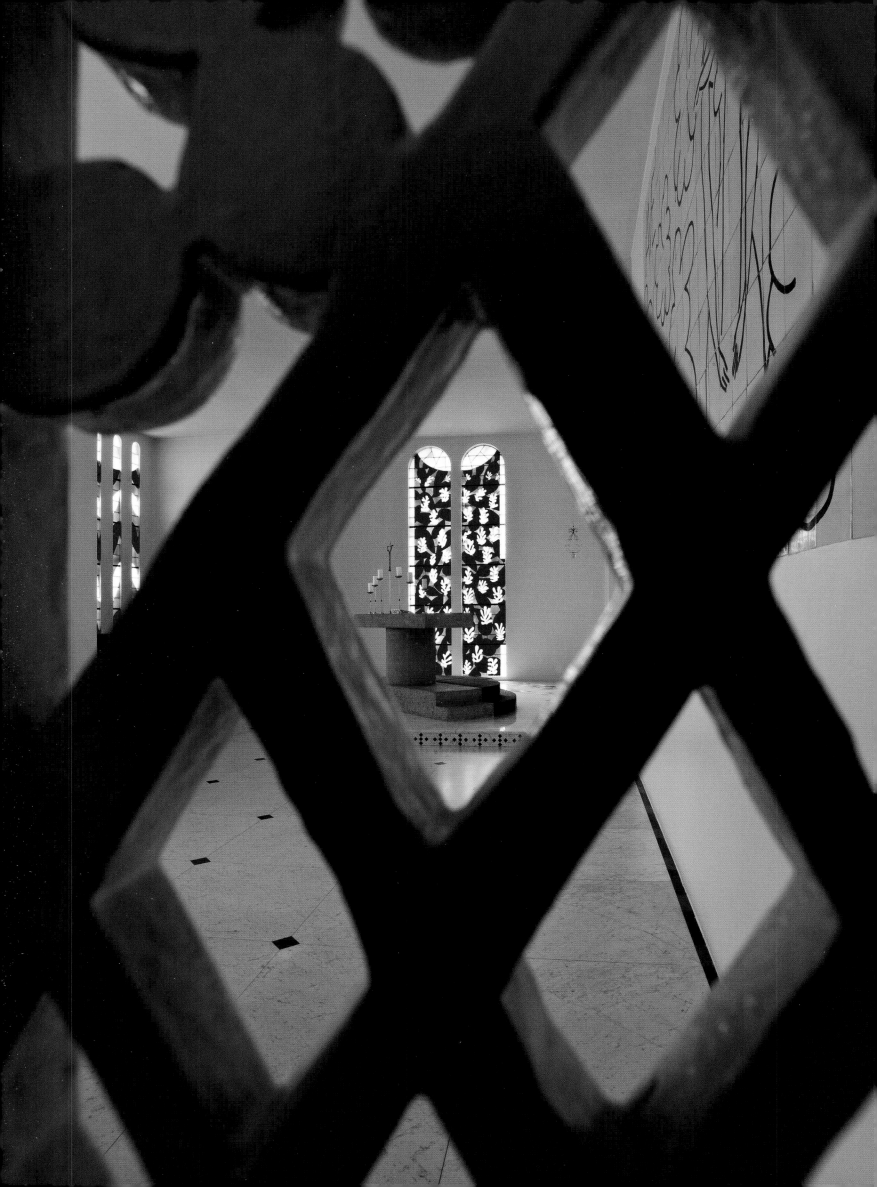

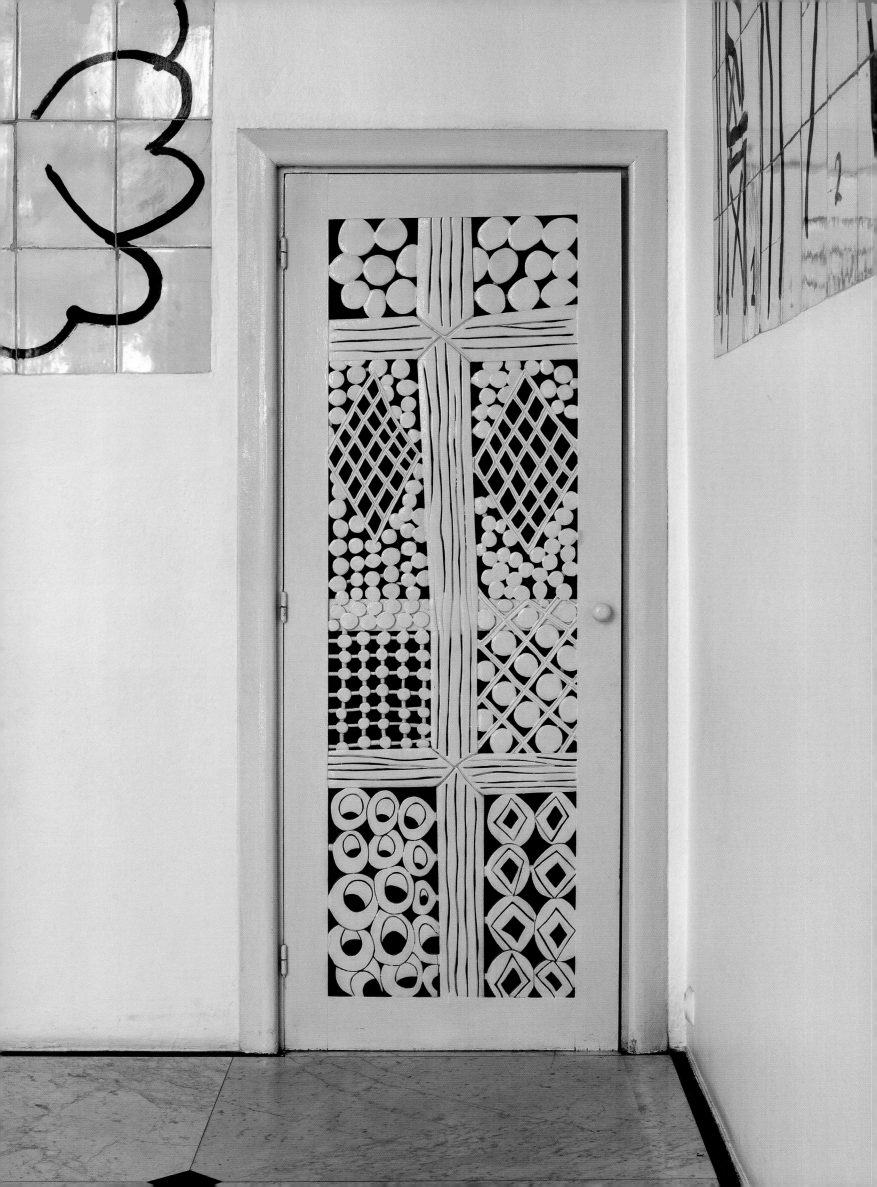

The interior of the confessional
and details of the grille with
the *Crucifixion* ceramic panel

[following pages]
Details of the door to the
confessional

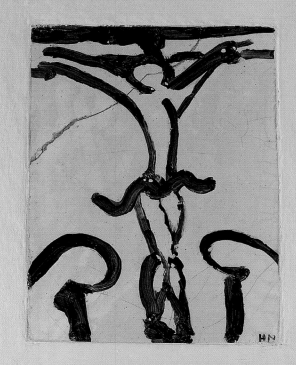

The Ceramic Panels

These ceramic panels are composed of large white glazed tiles bearing black line drawings; the drawings cover them completely yet leave them looking very bright. The result is a composition in black and white, the white predominating, solid enough to create a balance with the opposite wall, which consists of stained-glass windows.[20]

Matisse encountered a host of difficulties during the execution of the drawings on the tiles for the ceramic panels, and made numerous attempts at it. He wanted the tiles to be rectangular rather than square. In 1949 the tile project was put in the hands of Entreprise Ramier in Vallauris, near Cannes. Matisse, who had already worked on ceramic decoration with the ceramicist André Metthey during his Fauvist period, carried out some experiments on plates, but the results were not conclusive. In addition to the problem of firing the tiles and the need for a white glazed background, it was also imperative that the black lines of the drawings should move seamlessly from one tile to the next. 'We first decided to paint black drawings onto biscuit, covered on the decorated side with a layer of powdered tin oxide, but this layer absorbed the black faster than you could draw a line on it and the execution was very difficult. What is more, the fragility of the tiles prepared in this way made transporting them very complicated. It was therefore … decided … that the white would be fired before the decoration. This guaranteed the execution of the drawings. They could be done as on a plate.'[21] Firing was complicated. Most of the tiles cracked, as Sister Jacques-Marie noted on 19 August 1949: 'the tiles did not survive the new firing very well. Most of them broke. Fifty out of two hundred remain, badly glazed.'[22] The problem of the tiles was not solved until a few months later, in November.

In the final panels, the drawn line stands out against the white of the tiles laid side-by-side, and continuity is maintained. The single black lines were the outcome of long hours of practice, accompanied by much thought and effort, and are characteristic of Matisse's work. On 30 October 1941 Matisse wrote the following words to André Rouveyre: 'My inspiration for drawing is nearing its end and I am returning to painting.'[23] Six months later, on 3 April 1942, he wrote to his son Paul: 'For the past year I have been working with great effort at drawing. I say *effort* but it is not correct, what happened was a *flowering* after 50 years of effort. I did the same things with painting.'[24] At this point Matisse had just produced the series of charcoal and pen drawings that would be gathered together in the book *Thèmes et Variations*, published in 1943. The anthology presented one of the fundamental principles of Matisse's graphic art. He would start with the representation of a subject, for example a face or an object. In order to understand and grasp the forms, he would multiply the lines, later erasing the ones he did not want to keep. A kind of grey shading would be created from which the final drawing would emerge. In June 1942 the artist explained to his son how essential he felt it was to immerse himself in his subject, in painting as much as in drawing: '… to do in painting what I have done in drawing … to enter in to painting without

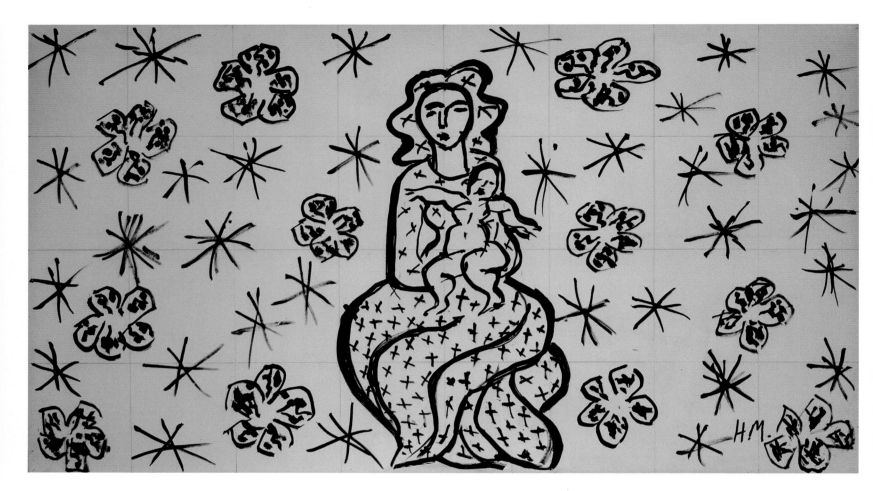

**Virgin and Child on a
Starry Background**
Study for the Vence chapel, 1949
Pen and Indian ink on paper
Musée Matisse, Nice

Study for the 'Virgin and Child'
The Vence chapel, 1949
Charcoal on paper
Musée Matisse, Nice

H matisse 49

inhibition as in the dahlias… '[25] Matisse was to use the same method for the three panels in the chapel: *St Dominic*, the *Virgin and Child* and the *Way of the Cross*. In each representation, the drawing is tailored to the specific nature of the subject: the softness and imposing height of St Dominic, the allegory at the heart of the representation of the Virgin and Child, the rhythmic sequence of the Stations of the Cross. The artist based his representations on information supplied by the Dominican Brothers, on academic and classical references, and on his own personal interpretation of the subjects.

As in his *Thèmes et Variations* images, Matisse achieved the vibrant rhythm of the drawing by means of repeated pencil lines. His perfect familiarity with the subject, in which he had immersed himself completely, set him free and allowed him to trace each line exactly as he wanted, in direct response to his emotion. The culmination of his experience and the mastery it brought him is the mystery of an independent, living line. 'What matters most to me? To work on my model until I have absorbed it sufficiently to be able to improvise, to let my hand run freely and yet manage to respect the dignity and sacred character of all living things.'[26]

The opportunity constantly to modify each line, or to erase it, means that when the time comes the line ceases to shift – it has become the appropriate representation of a particular moment. This gives Matisse's drawings a very special quality, which has left its mark on twentieth-century graphic art. Since the early nineteenth century, drawing has ceased to be regarded as simply a preparatory technique for painting. 'To give life to a line, to give *existence* to a form, is not something garnered from conventional academies, it is acquired out of doors, in nature, by the close observation of the things around us.'[27] With the creation of the chapel in Vence, Matisse gave life to drawing. In a manner that was precise yet free, he made drawings on the panels of rectangular tiles, using them as if they formed a flat, uniform canvas. The panels were laid on the ground and he painted directly onto them with a brush. He modulated his line to ensure its intensity, using the softness of the brush, like a calligrapher. The drawings thus became a kind of handwriting, integrated into the space of the chapel and interacting with the graphic compositions and the luminous colours of the stained-glass windows.

The Virgin and Child

Members of the congregation who enter by the door designated for their use find, on the right-hand wall, the panel of white tiles representing the *Virgin and Child*. With her featureless face and hands apart, the Virgin attunes her gesture to that of her son, who stands on her lap with his arms outstretched in the shape of a cross.

As with the other panels, the drawing is executed in black enamel paint with a brush. The pearly, luminous white of the background is respected. Matisse drew directly onto the tiles, as he would have done if he had been drawing on paper: 'As soon as my hesitant line has modelled the light on my

white page, without diminishing its affecting whiteness, I can add no more, nor take anything away.'[28]

This representation of the Virgin and Child embraces the Christian world in all its diversity, from the *Theotokos* to simple symbolic representations of maternity. Matisse followed a number of routes towards his final interpretation. In 1947 he had the opportunity to draw a young woman nursing her child, but did not use this study for the chapel; he did, however, use it to illustrate 'Tableau de sainteté', a poem by Charles Cros.[29] At some stages of his studies for the *Virgin and Child* Matisse gave the Virgin a maternal character, showing her holding a plump baby. In the final drawing he retains the frontal view of the Virgin, recalling the pose of a Byzantine *Maestà*. He preferred his own interpretation, however, in the representation and in the symbolism he wished to give the image; his comments as reported by Brother Rayssiguier bear witness to this: 'He sketched the outline of a new Virgin; "I've drawn the heads close together as in certain Russian icons", "It was too inhuman", "There needs to be more love".'[30] Matisse concentrated on depicting a mother whose destiny is dominated by the sacrificial offering of her own son. The Virgin's gesture of offering is symbolised by simple lines representing the fingers of her hands, which are not joined, whether to support the child or to restrain him. Matisse emphasises this destiny by inscribing, at the top left of the panel, the words spoken at the Annunciation by the Archangel Gabriel, 'Ave', as well as the Virgin's words of acceptance: 'fiat voluntas tua'.[31]

Matisse often represented his female models face-on in his paintings and drawings, thereby creating a direct relationship with the spectator; this pose also characterises the icon, in which the intersection of the gaze between the image and the spectator evokes the relationship between man and God. Another feature found regularly in Matisse's work is the deliberate inclusion or omission of facial features. Throughout his career, Matisse developed a particular idea of the portrait, juxtaposing the identity of the face and the spirituality of the life it represented. He sought a new form of artistic expression, one that attempted to delve beyond iconographic reality by guiding the spectators' gaze: 'We have to show them an image which leaves memories, perhaps involving them a bit more deeply … But we don't need that kind of art any longer, it's out of date.'[32] Thus the paintings *Woman in a Blue Gandoura* (1951),[33] *Katia in a Yellow Dress* (1951),[34] and *Woman with Pearls* (1942)[35] dispense with any representation of facial features. The face gains the intensity of the void. Matisse's aim was always to render the expressive intensity of the face rather than to make it resemble the sitter. He was able to suggest the sitter's gaze through a black oblong shape. The absence of the features traditionally used to identify a face catches the spectator's attention, engaging him outside his normal frame of reference.

The motifs surrounding the Virgin also have an aerial quality. She is no longer surrounded by the lilies that appear in the earlier studies; the forms are unidentifiable, but look like plant forms or clouds. The representation of the

The interior of the chapel with the *Virgin and Child* ceramic panel

Child is remarkable for the intuitive sensitivity it shows on the artist's part: 'Yesterday it was my lot to age the infant Jesus – I made a small boy out of a baby – I abandoned tradition.'[36] With his arms outstretched in the form of a cross, Jesus evokes his future crucifixion. The gesture could also be interpreted as a gesture of welcome or protection. Depicted at the height of the Virgin's shoulders, he could also be linked to the medieval subject of the Virgin with the mantle. A single line links the body of Jesus with the body of the Virgin, to symbolise their common destiny.

On the west façade of the chapel, above the *Tree of Life* window, there is another representation of the Virgin and Child. This is composed within the circle of an oculus, the lines overlapping, with the form of the Virgin seeming to envelop the Child, if only because of the shape of her encircling arms. Finally, on the tabernacle on the altar, engraved on copper, Matisse gives us another of his representations of the Virgin and Child, this time with St Dominic.

As with all his work, the artist adapted each project in the chapel to the place where it was to be located – the lintel of a door, the high altar, a mural panel. This allowed him to explore to the full the various emotions and connotations that a single subject can encompass. So, for example, above the visitors' entrance, the exact inclination of the heads of the mother and her son express maternal affection in a single line. The Virgin is present in various parts of the chapel, always appearing to wear a particular expression; Matisse created variations on the theme around her symbolic significance. The Dominicans regard the Virgin as the symbol of the purpose of human life, uniting birth and resurrection. These variations, like the final design, were also for Matisse 'like a prayer that gets better and better with repetition – I have never been able to do things that I did not feel strongly within myself'.[37] When he talked about the flowers surrounding the Virgin, Matisse added: 'I've had these flowers inside me for years, I'd seen them in the flowerbed in Vence.'[38]

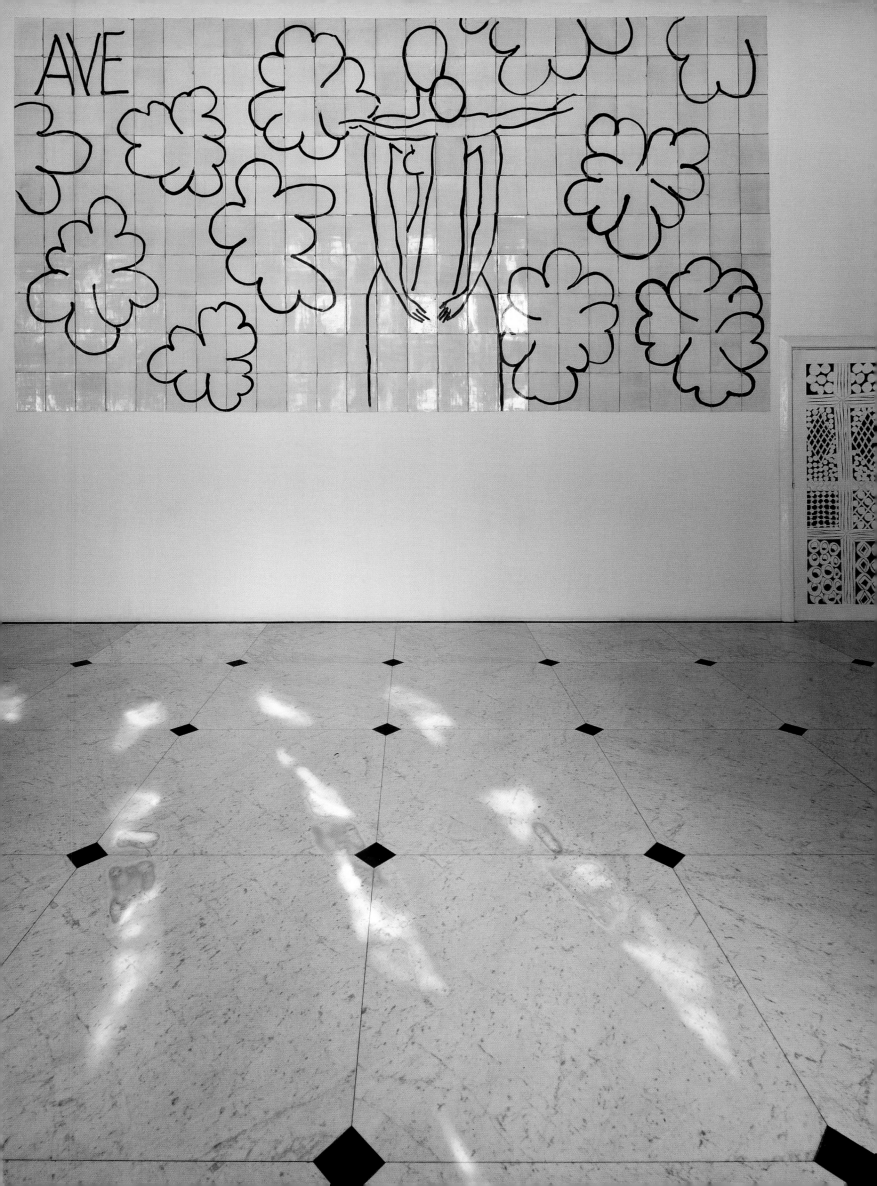

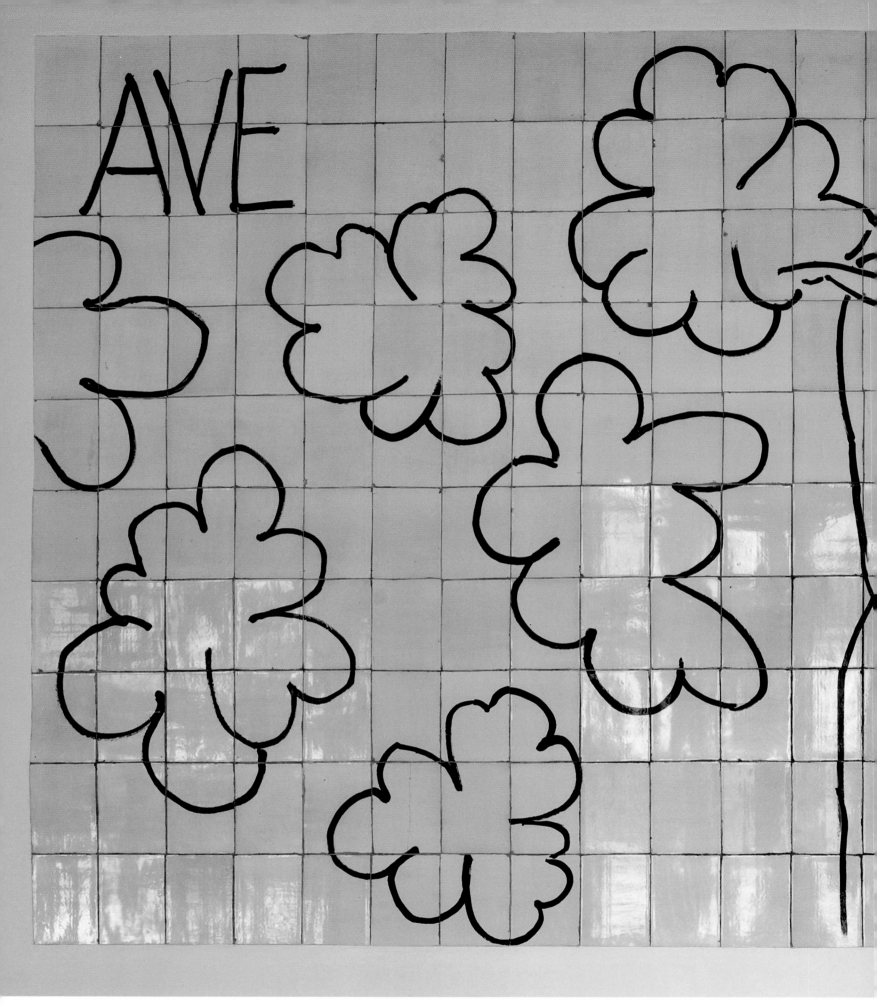

The *Virgin and Child* ceramic panel

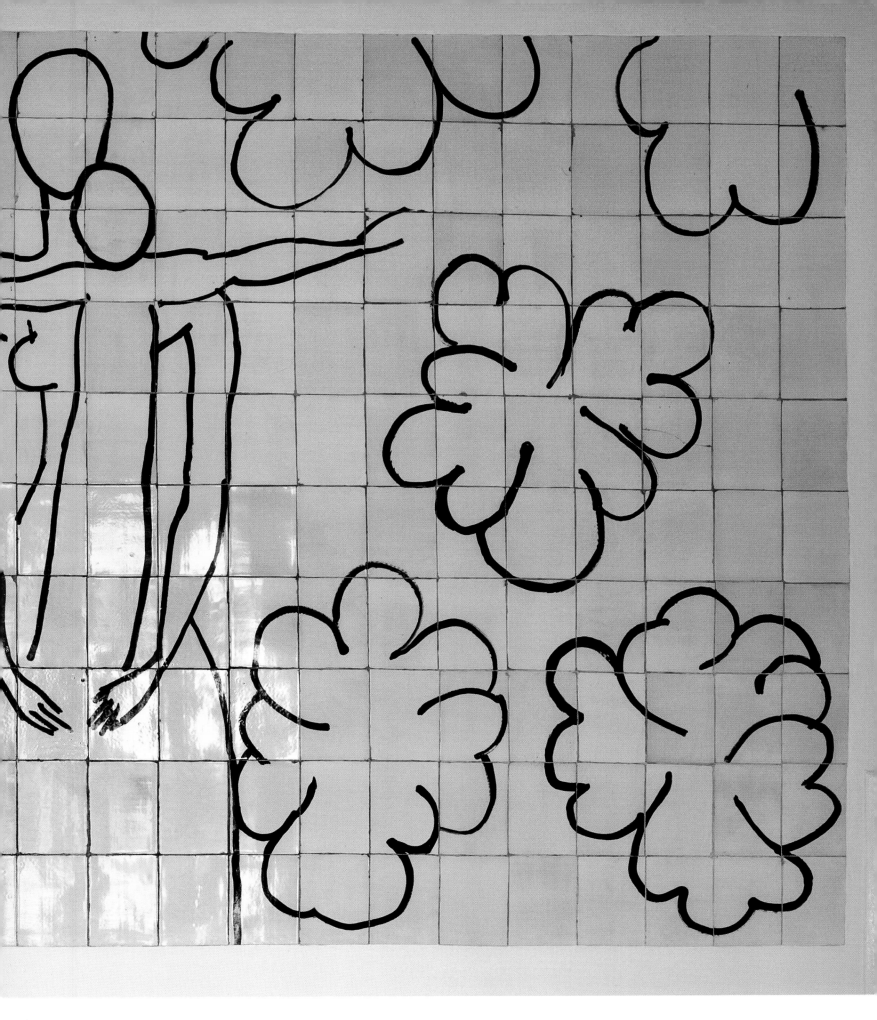

[following pages]

The exterior of the chapel, showing the entrance for the congregation and visitors with the ceramic panel depicting *St Dominic and the Virgin and Child*

The *Virgin and Child* circular ceramic panel on the northwest façade of the chapel

St Dominic

A single mark is sufficient to suggest a face, there is no need to give people eyes or a mouth … you must leave the field clear for the spectator's imagination.[39]

Inside the chapel, Matisse chose to place the drawing of St Dominic de Guzmán, founder of the Dominican Order, on the wall to the right of the *Tree of Life* window; he inhabits the liturgical space dedicated to the celebration of Mass, behind the high altar and opposite the pews reserved for the Dominican nuns. Matisse represented the saint in his cloak holding the Gospels – the basis of meditation and preaching – in his right hand. Traditional Dominican vestments consist of a white tunic with a leather belt and a black sleeveless scapular with a hood, both worn on the shoulder and covering the upper body and arms to the elbows. The outfit is surmounted by a cowl. Outside the monastery the friar wears a black cloak with a hood, and from the fifteenth century onwards Dominicans have worn a rosary of five decades around the waist. Matisse created his version of the saint from the cloak, the hood, the scapular and the Gospels, in addition to the face, although, as with the Virgin, this is bereft of features. He first took as his model Father Couturier, who was a man of impressive size, but as he worked on his preliminary studies he modified the scale and proportions. He became thoroughly familiar with the costume and its components, and also investigated ways of capturing the saint's spiritual message. He decided to increase the size of the only visible hand, the hand holding the sacred text. He made innumerable studies for this 'mystic hand',[40] from works such as Grünewald's *Isenheim Altarpiece*, or from representations of Christ Pantocrator.[41] Gradually, the earlier, more mannered style was replaced by a formal simplicity. The single hand holding the Gospel impresses the spectator by its disproportionate size and the way it seems to spring unexpectedly out of the cloak.

Matisse breaks with the tradition of identifying St Dominic by the attribute of the Marian lily. Each element of his work acquires its own identity, underscored by the rigorous simplicity of the artist's line. The Gospels are identified by the presence of a simple cross on a surface bounded by three straight sides. In the final representation of the saint, the artist increases the lines of the garment, making the figure more imposing. He emphasises the sinuous curve of the hood to match the neck and face of the saint, taking advantage of the unusual aesthetic of the garment. The physical presence of the saint and his place in the world are expressed by the absence of a halo. The overall effect is of a saint living permanently among his brothers and sisters, facing his fellow Christians.

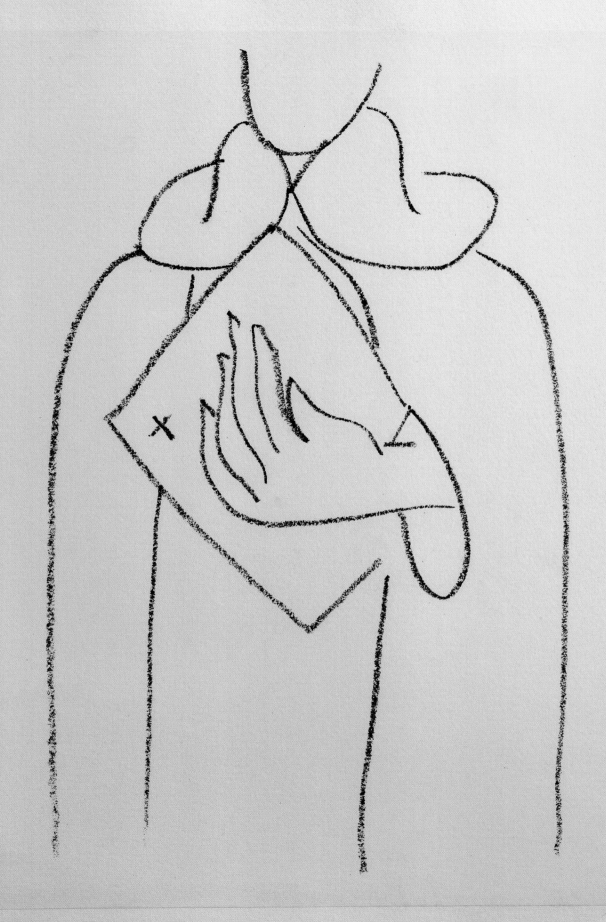

Essai

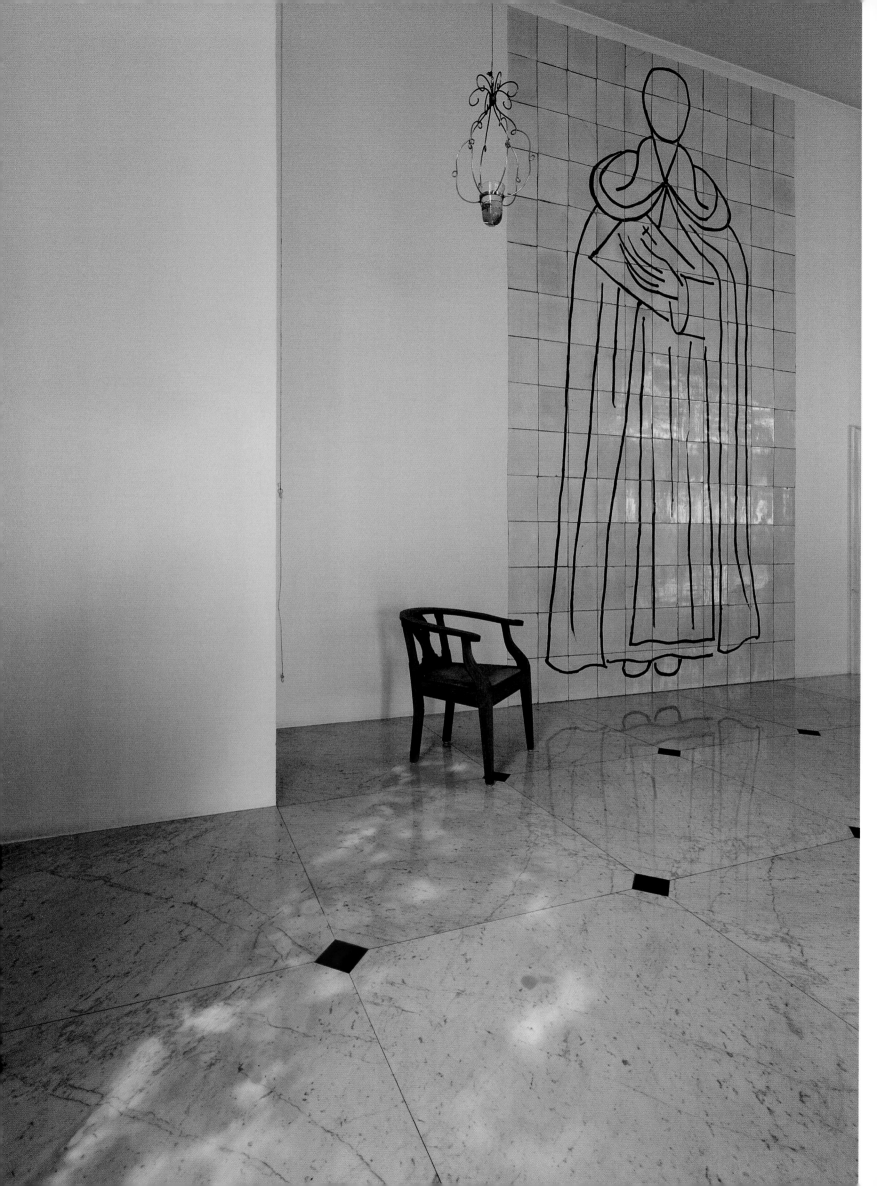

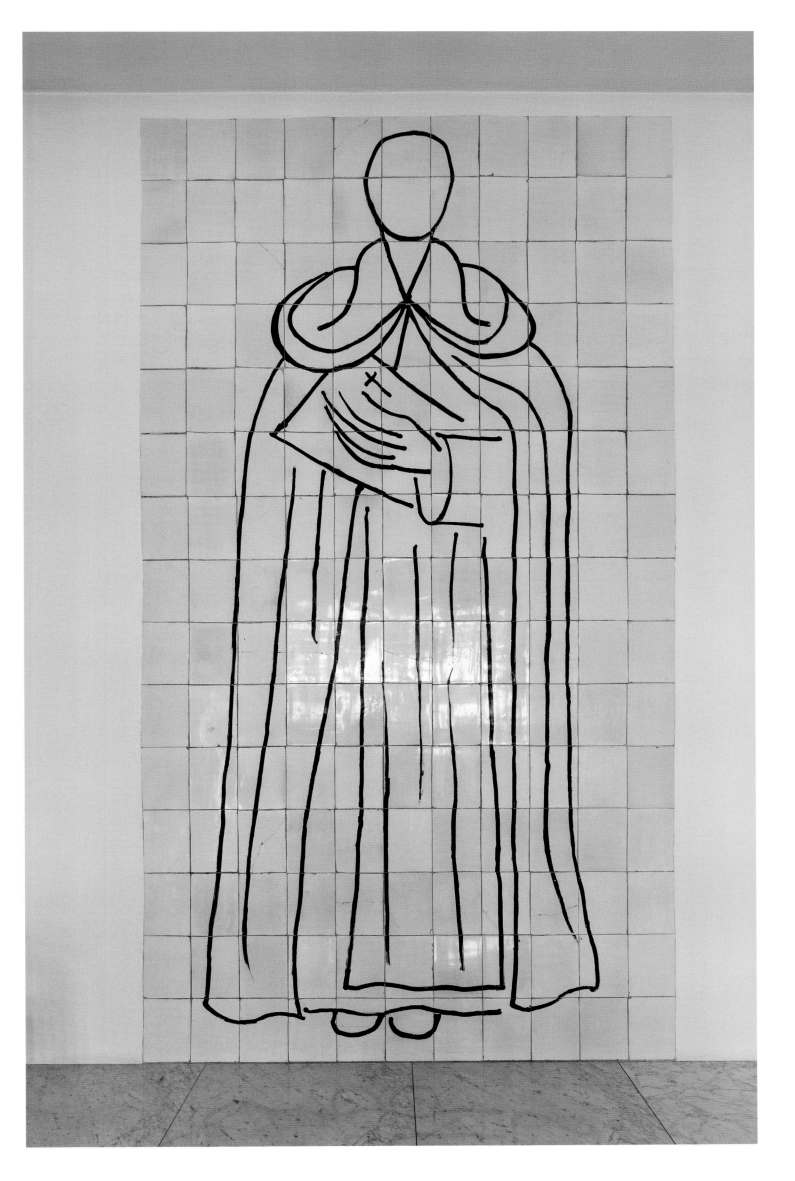

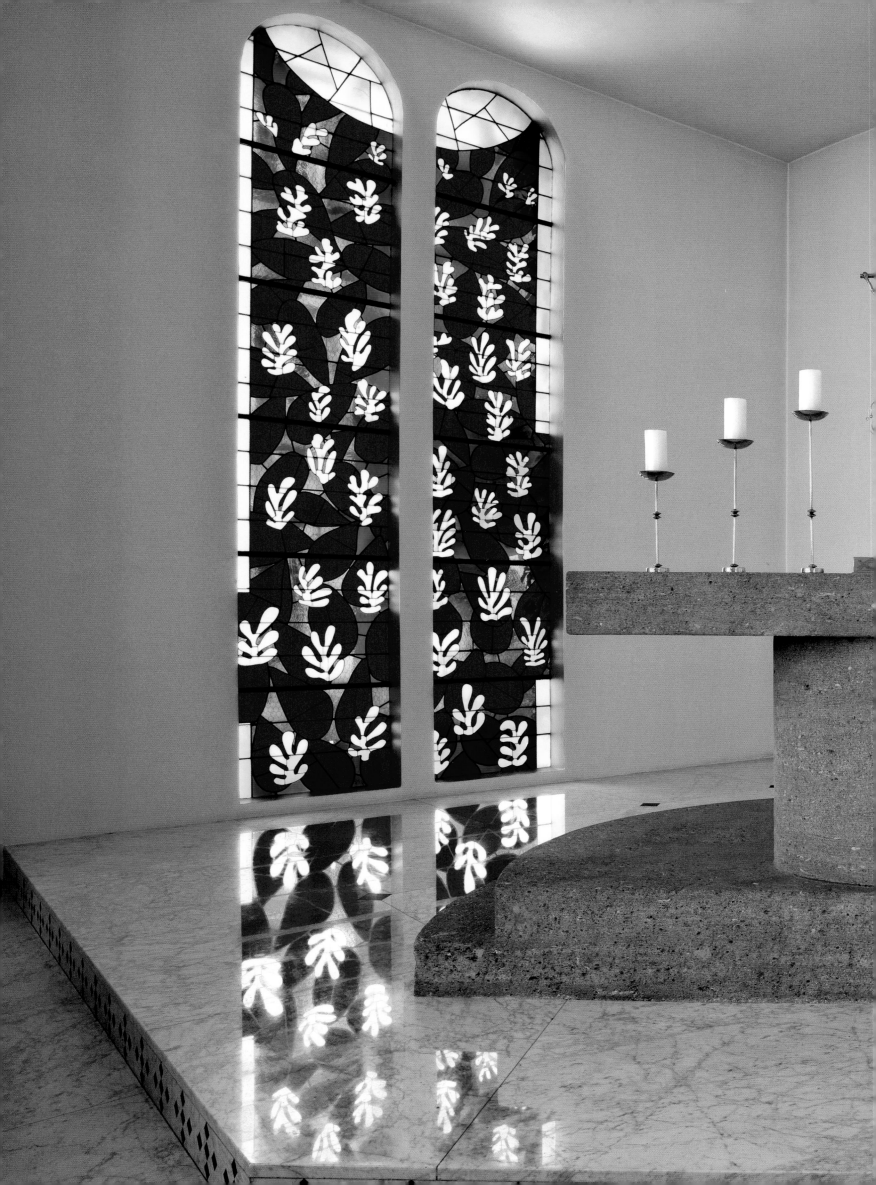

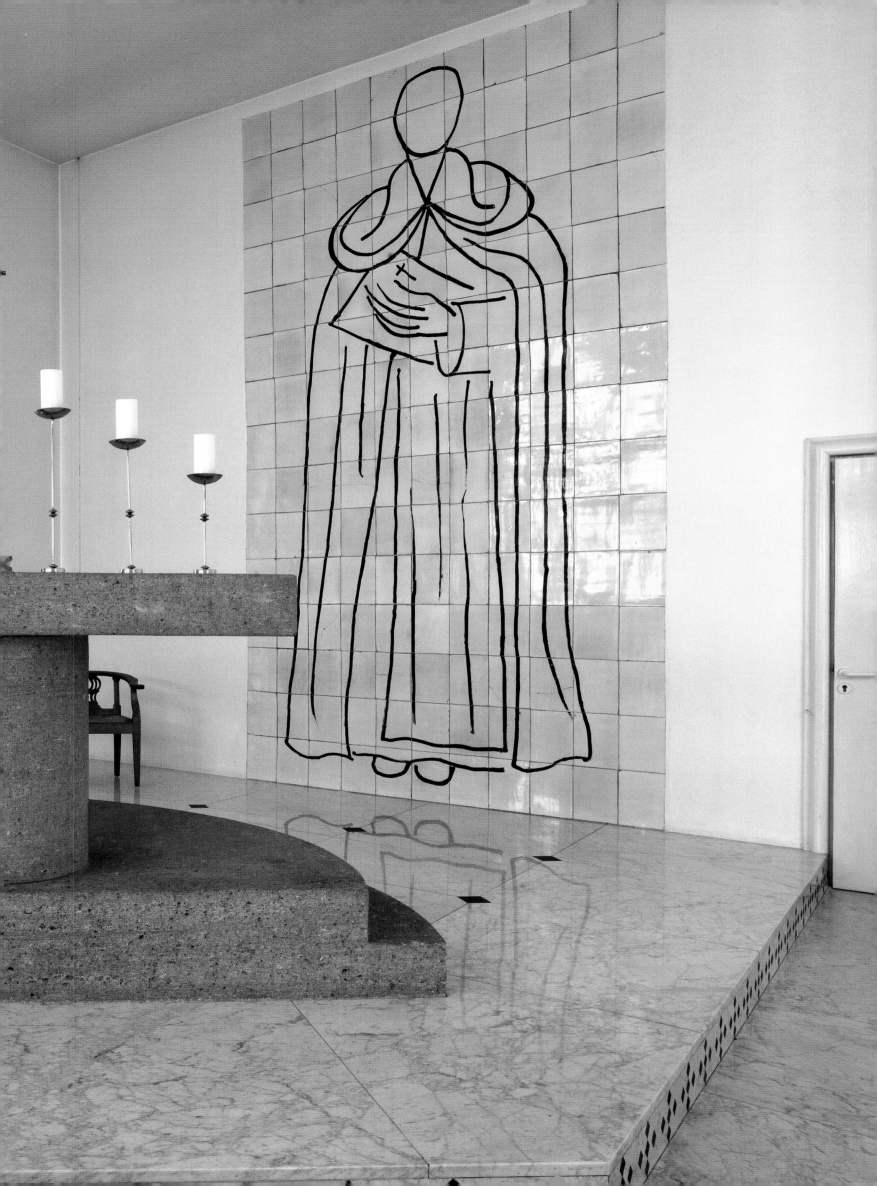

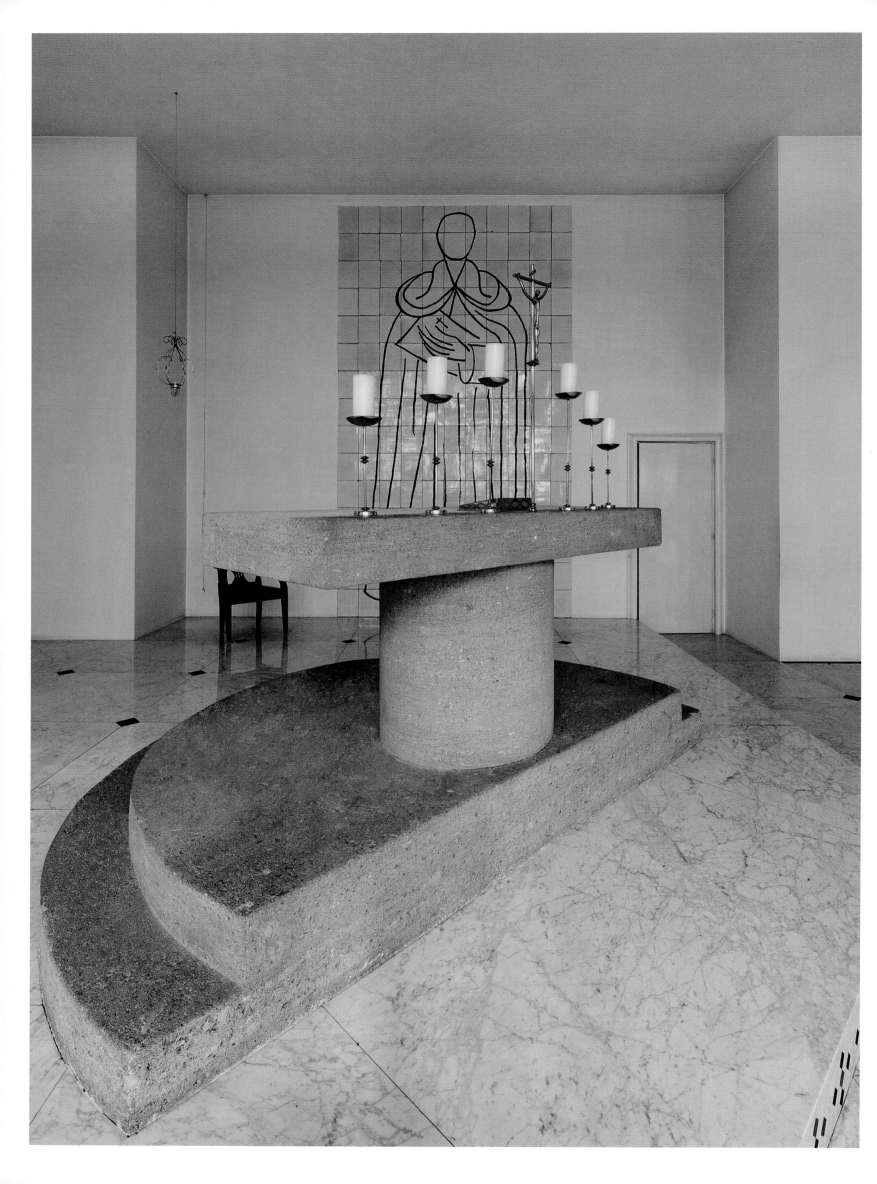

The Way of the Cross: The Silent Tragedy

I have to be so deeply penetrated, so impregnated by my subject that I would be able to draw it with my eyes shut ... It emerges naturally from me, and the sign is itself therefore ennobled.[42]

When Matisse executed the *Way of the Cross* he felt intensely involved in 'the pathos of this profound drama'.[43] His representation of the events of the Passion of Christ demonstrates his view of the relationship between the stations of the cross and the light of redemption. The 14 stations along the Way of the Cross, here grouped together on a single panel, symbolise the road to Calvary. In the Chapel of the Rosary they are presented as a single event, and in this they differ from those usually found in churches, in which each is presented singly.

The visitor entering the chapel does not see the *Way of the Cross* until he or she turns round. Only then does the ceramic panel near the confessional come into view.[44] The drawing style differs from that of the other compositions. It is a visual narrative whose rhythm and accentuated lines match what Matisse terms 'a drama ... which causes the artist's impassioned spirit to overflow into the chapel'.[45]

Within the simple white space of the chapel, enlivened by the colours of the stained-glass windows, the *Way of the Cross* has a particularly emotional impact. The stations are arranged on a panel measuring 4 metres in length by 2 metres in height. As noted, the work is different from traditional portrayals of the stations of the cross, which were first installed in churches in the twelfth century. They are usually arranged at intervals around the nave or the aisles, and are designed as processional stopping-places which, by requiring the worshipper or spectator to move physically from one to the next, symbolise the stages of Christ's suffering. In Matisse's version, however, the eye can absorb all the events at once, gathered as they are on a single surface, and this encourages concentration and contemplation: 'The ceramic panels provide the spiritual impact and explain the significance of the monument. So, in spite of their apparent modesty, they become the focal point that triggers the state of contemplation that we are bound to experience.'[46] This journey, represented in a unity of place and time, focuses interest on the drama of the Crucifixion, described by Matisse as the greatest of human dramas. In addition to gathering the scenes together on a single panel, through the use of incisive, rhythmic lines Matisse overlaps the stations to form a unified narrative. This interdependence concentrates the spectator's interest on the attitude of Jesus and the unfolding of the events, rather than on the absence of certain scenes. None of the imaginative or technical constraints that might have weighed on an artist accustomed to the

conventions and canons of religious practice affected Matisse. He was certainly fully aware of the religious context in which he was working, but the project did not involve any alteration to his beliefs. He viewed himself as an agent responsible for revealing emotions and feelings, seeking to share and provoke a spiritual emotion that would be accessible to believers and non-believers alike. The vector he chose for this was the drawn line and its modulation, adapted to the different stages of the road to Calvary.

The first station, showing Christ before Pilate, introduces a rhythm at once. In the preliminary studies, Jesus is of small stature, crushed by the monumental size of Pontius Pilate's throne. The final version presents a bold depiction of Jesus, his head at the same height as Pilate's head. After this, the stations follow one another in a sequence of lines and shapes. The cross Jesus bears in the second station follows the curve of his back, conveying a combination of suffering and effort.[47] In the third station, when Jesus falls to the ground for the first time, face down, the broken line accentuates the image of his fall. In the preliminary studies, the emotional intensity of the encounter between Mary and her son in the fourth station can be read in their gaze, but this has disappeared from the final version.[48] Jesus stands erect opposite his mother, who is leaning backwards as if to allow her son to pass; his acceptance of his destiny is total. In the fifth station, the lines depicting the cross appear in the foreground, across the silhouette of Jesus, who is fainting, and Simon, who is coming to his assistance.[49] For the sixth station, Matisse represents the Veil of St Veronica as a square suspended in space, with bows at the top corners; the decorative aspect of the cloth contrasts starkly with the sorrowful features of Christ's face, the only face in the chapel. In his representation of Jesus's second fall, Matisse accentuates the scale and the rhythm of the line.[50] In this scene the body of Jesus dominates, to the point of overlapping with the scene of the Crucifixion. The eighth station presents the three holy women in a minimalist fashion; they are represented simply by three vertical lines. Following this, in his third collapse, Jesus is depicted with his face turned upwards.[51] Composed entirely of curved lines, his fallen figure leads the eye towards the upper part of the composition, the apex, and the location of the torture that will end with Jesus's death. In the next station Jesus is stripped of his garments: Matisse represents this scene with firmly drawn lines, like scarifications, to express the violence of the event.[52] The moment when Jesus is nailed to the cross lends symmetry to the

whole composition.[53] The cross of the Crucifixion, the *axis mundi* that joins earth to heaven, is fixed at the base to the seventh station.[54] The figures of Mary and St John at the foot of the cross add weight to the scene, increasing its tragic impact. The central axis of the Crucifixion rises up into the architecture of the chapel and is placed opposite the stained-glass window representing the *Tree of Life*. Following the Crucifixion, the tangled lines of Jesus's descent from the cross restore movement to the composition.[55] By contrast, the entombment of Jesus, the final scene of the drama of the Passion, is constructed from lines that have been stilled; this is the transitional moment that precedes and anticipates the Resurrection.[56]

In spite of the unusual way in which Matisse deals with this subject, the *Way of the Cross* belongs at the heart of the manner in which the artist approached the Vence chapel. The panel gives the space a work in which simplification of the outline joins experiments with the 'sign' in the creation of a graphic language that is capable of being understood and experienced by all.[57] In its own particular manner, the *Way of the Cross* fits into Matisse's overall vision of of a chapel that both lightens the spirit and heightens emotions.

On this panel, according to a rhythm imposed by the ceramic tiles, the work is constructed like a piece of choreography or a musical score. The stations are not all represented to the same scale – as in a musical composition, the drawing emphasises particular elements of the drama. This was a method frequently employed by Matisse, who would enlarge certain features of the face or body; in the portrait *Woman on a Red Chair* (1936), for example, the hands are very large and lead the spectator's eye towards the young woman's face; this is composed of simple brush strokes and the eyes are represented as almond-shaped and black.[58]

Matisse's interpretation of the *Way of the Cross* goes beyond a straightforward chronological and narrative account of the Passion of Christ, becoming at once a representation of a tragedy whose power invites meditation, and a guide, leading the spectator from station to station. Each is clearly identifiable and numbered along a course that moves from bottom to top – from earth to heaven, on three levels. The journey progresses first from left to right and then right to left; these inverted movements mark the major stages of the Passion, as noted in the Christmas issue of *France Illustration* in 1951 in a description of the manner in which Matisse planned his work:

'At first, having designed it in the same spirit as the previous panels, he created a procession of scenes that followed one another. But then, struck to the heart by the poignancy of the drama, he turned the sequence of his composition upside down.'[59]

The decision to invert the composition was the culmination of many experiments. Matisse stepped up the number of studies he made in charcoal, pencil and ink, working as usual in a state of total immersion in the subject, using a variety of formats and exploring a mixture of sources and shades of meaning. Comparison of these studies with the final version drawn on the ceramic tiles shows the extent to which Matisse gradually reduced the elements included in the scenes. Numerous photographs taken at the Régina trace the different stages of the composition. Matisse juxtaposed his drawings, finally overlapping them to create a large scene with a unique narrative – a monumental page, produced with unwavering energy. Some of the lines clash with lines belonging to other stations, and sometimes they merge. For example, in the drawing of Christ carrying the cross, the lines of the cross merge with the lines of Christ's back.

The production of the *Way of the Cross* involved intense effort for Matisse. The overall composition underwent various transformations as the artist became more and more immersed in his subject. 'The artist has quite naturally become the main actor; instead of reflecting the drama, he has lived through it and expressed it in this way. He is fully aware of the mental impulse that allows the spectator to progress from serenity to high drama.'[60] '*The Way of the Cross is finished*. … It is no longer the procession of the cartoon, but a sort of grand drama in which the scenes, although always accompanied by a number, intermingle, starting from the figure of Christ on the Cross which has taken on a dream-like quality – like the rest of the panel … . It savours of drama. It's a Calvary composed in the fashion of a Breton Calvary. This is a great result for me. The execution is rough, very rough in fact, it will reduce most who see it to desperation. God held my hand. What could I do? Bow down before him – but other people know nothing of all that.'[61]

The brushwork is imbued with Matisse's particular sensitivity to the subject he is dealing with. To achieve this level of sensitivity and immersion, the artist employed his usual method: to start with, he studied all the most important interpretations of the Way of the Cross by the Old Masters, taking inspiration

from them. Among others, he echoes Mantegna's *The Judgement of St James* to illustrate the first station, *Jesus Before Pontius Pilate*; in Mantegna's *Calvary* on the San Zeno altarpiece (1456–59), he studies the doleful expression of the Virgin Mary, supported by the Holy Women, a moment that will be conveyed on the eighth station simply by three brush strokes. *The Descent from the Cross* is inspired by a painting of the same scene by Rubens, copied in oils by Matisse during his youth.[62] Similarly, Philippe de Champaigne's *Dead Christ* (c. 1654) can be compared with the studies for the fourteenth station, *The Entombment*. In spite of all his research, Matisse remained very unsure about the reception his work would receive: 'I'm afraid this panel will be difficult to accept as it does not correspond very closely to the notions of the faithful of Vence.'[63] The way the artist dealt with the subject, using his own form of graphic expression, is very personal. The result undeniably provokes feelings of pain and tragedy, yet it may seem difficult to read and there remain questions to be answered about its interpretation.

The *Way of the Cross* panel is installed facing the priest as he turns towards the altar. This arrangement makes it invisible to the congregation at prayer. Its presence thus provides a continuous invitation to turn towards the spiritual light, symbolised by the glow from the *Tree of Life* window, designed by Matisse to represent the way to heaven.

[following pages]

The view from the celebrant's position: the crucifix on the altar forms an axis with the crucifix on the *Way of the Cross*

The interior of the chapel as seen from the altar, showing the *Way of the Cross* on the far wall

The *Way of the Cross*, ceramic panel

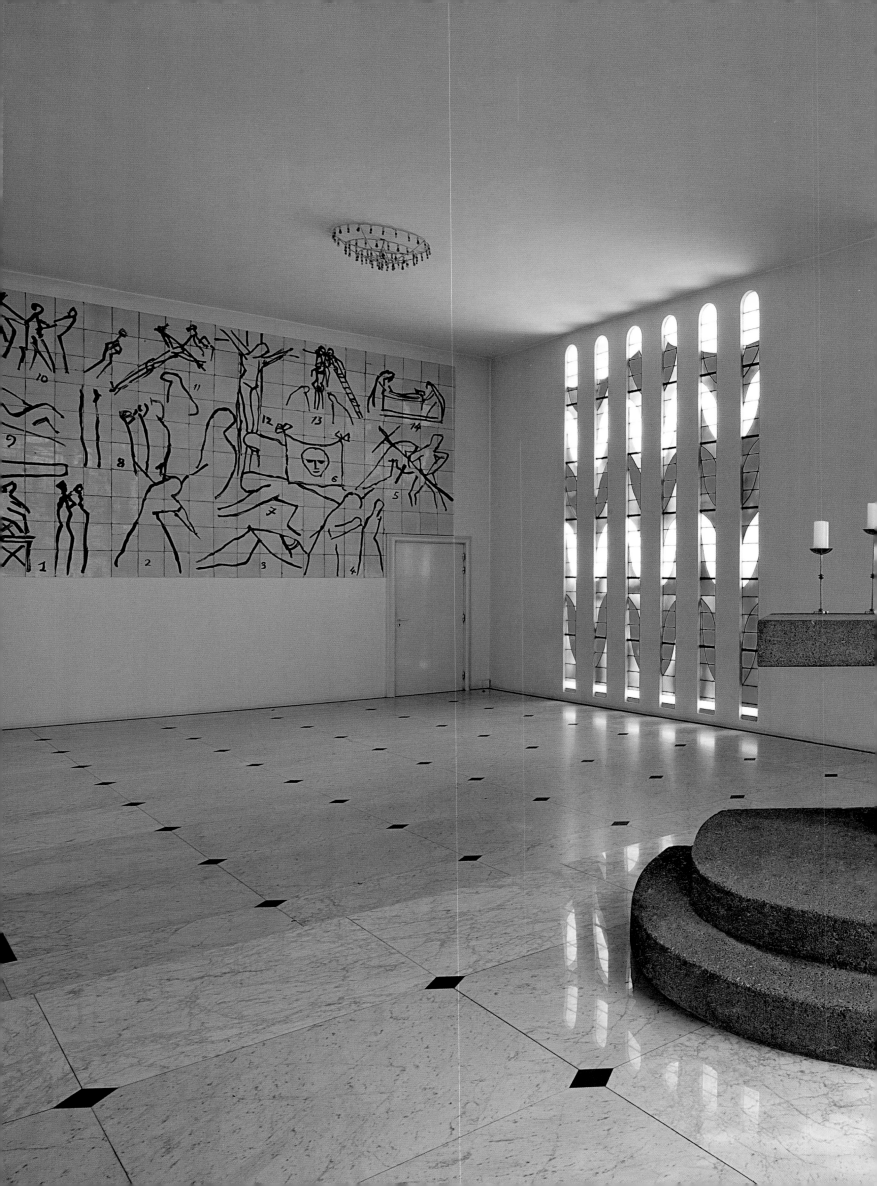

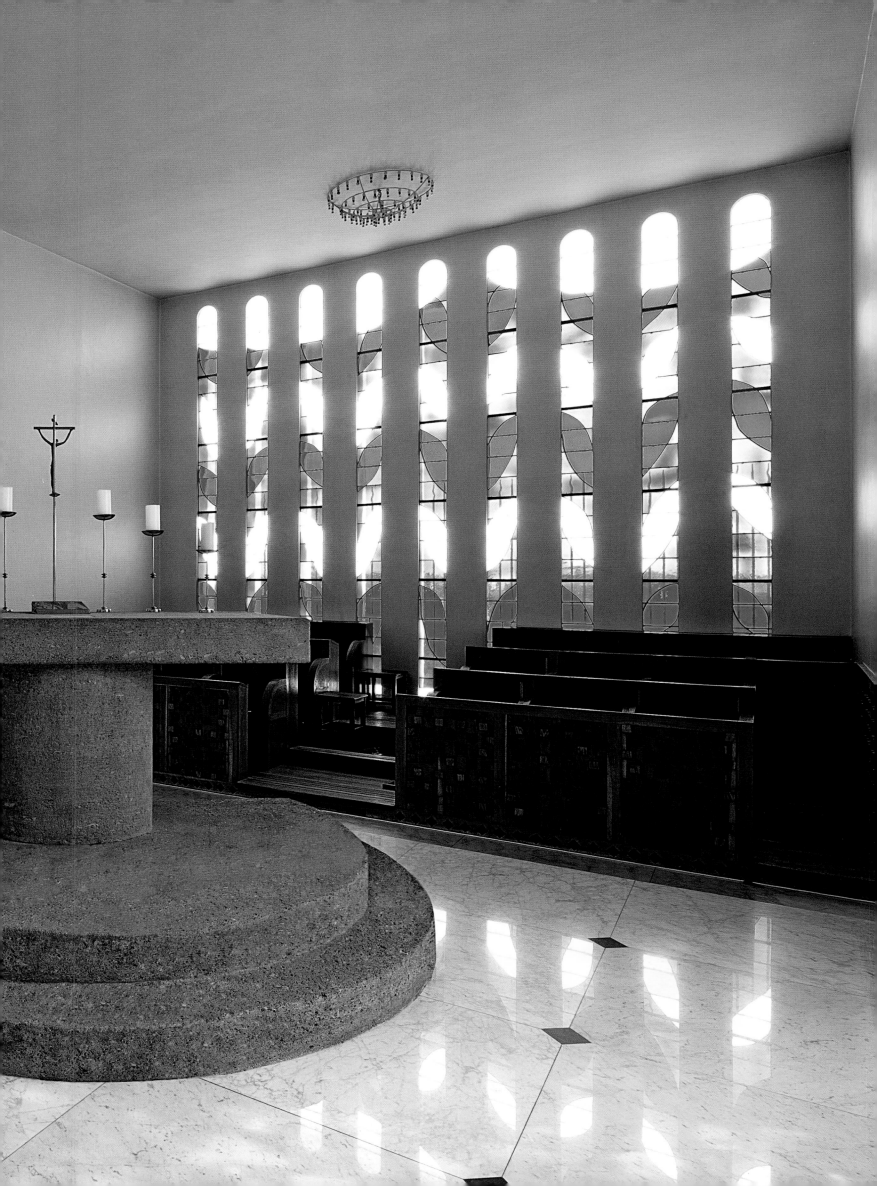

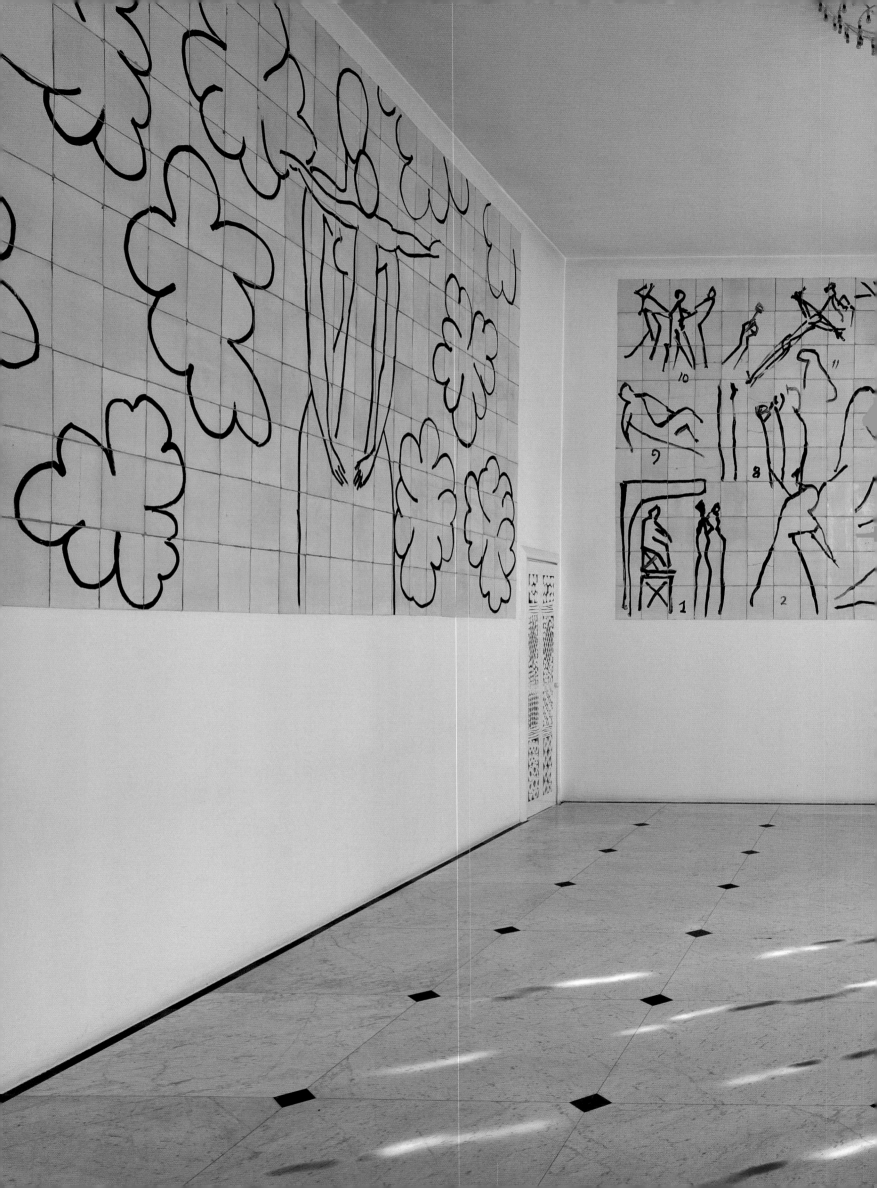

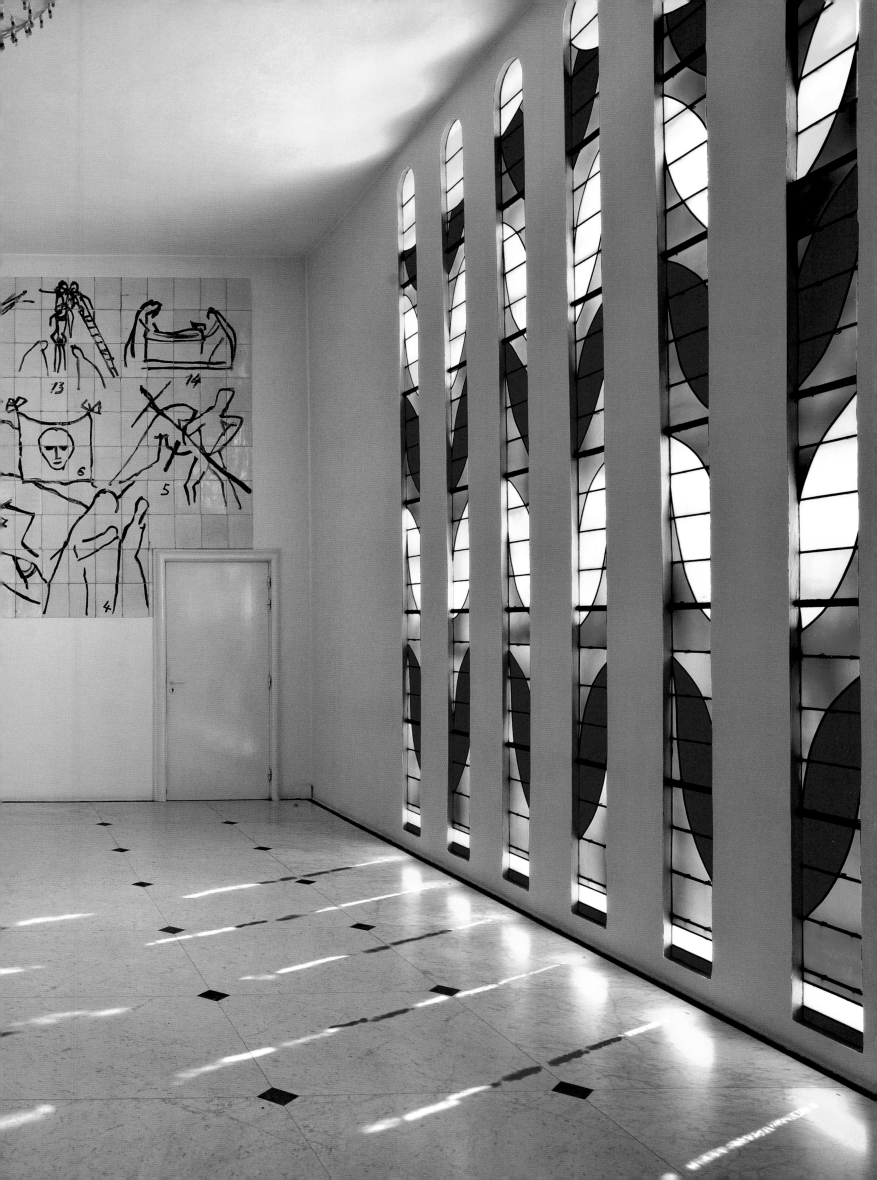

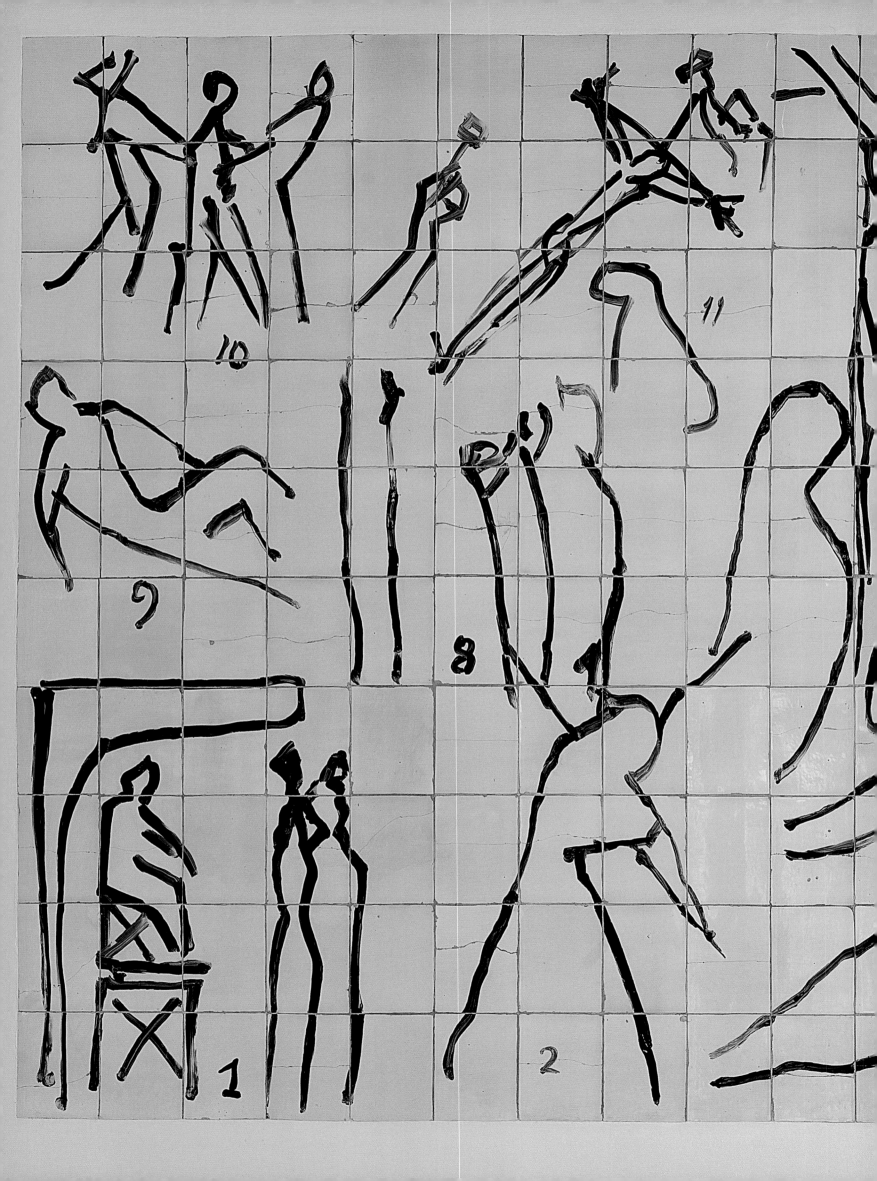

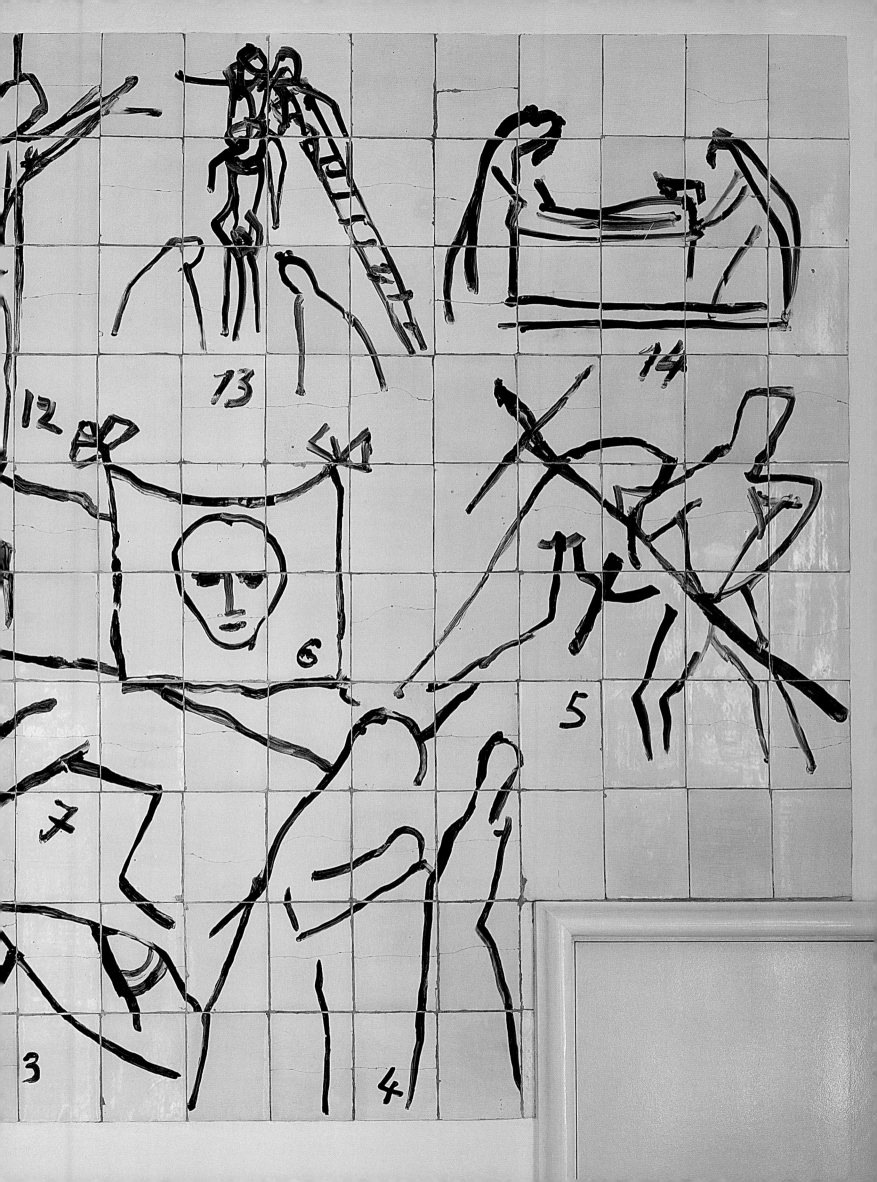

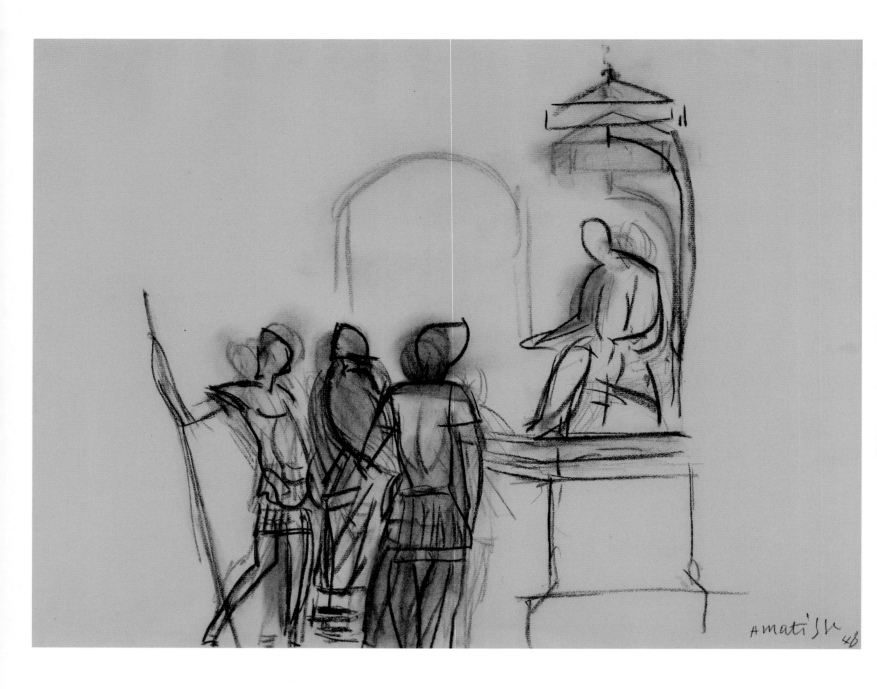

Jesus Before Pontius Pilate
Study for the *Way of the Cross*,
the Vence chapel, 1949
Charcoal on paper
Congregation of the Dominican nuns of the
Rosary, Vence

[opposite]
**The Way of the Cross: Jesus
Before Pontius Pilate** (detail)
Ceramic panel

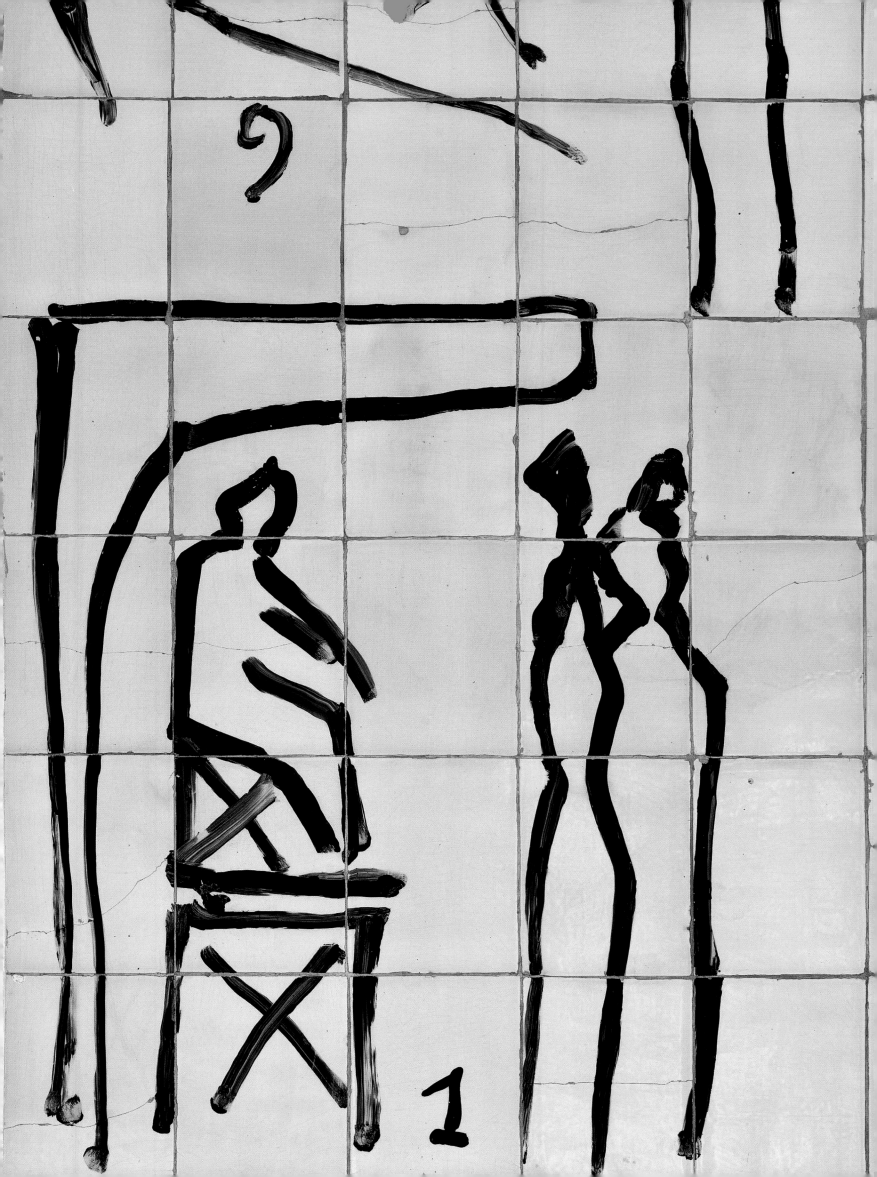

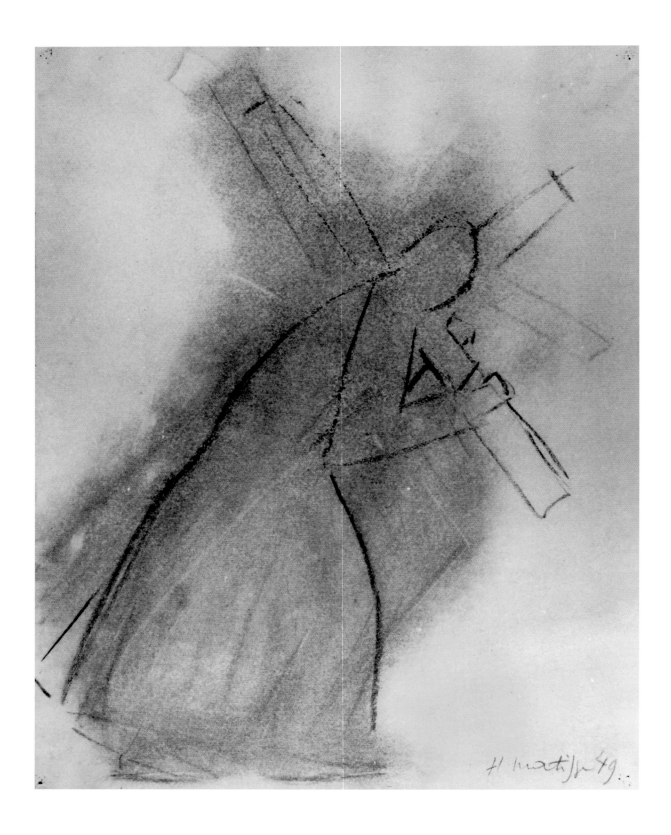

Christ Carrying the Cross
Study for the *Way of the Cross*,
the Vence chapel, 1949
Charcoal on paper
Musée Matisse, Nice

[opposite]
**The Way of the Cross: Christ
Carries His Cross** (detail)
Ceramic panel

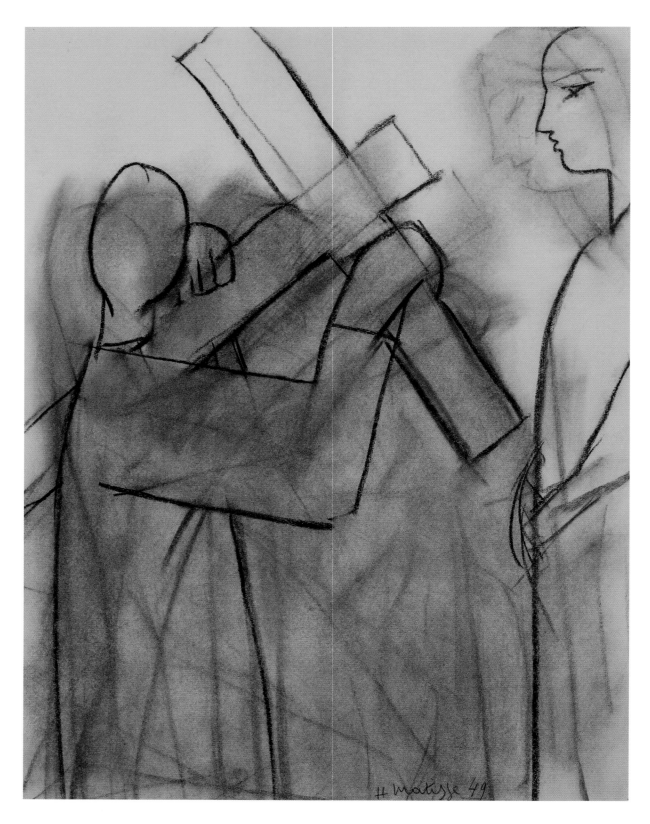

Jesus Christ Meets His Mother
Study for the *Way of the Cross*,
the Vence chapel, 1949
Charcoal on paper
Congregation of the Dominican nuns of the
Rosary, Vence

[opposite]
**The Way of the Cross: Jesus
Chris Meets His Mother** (detail)
Ceramic panel

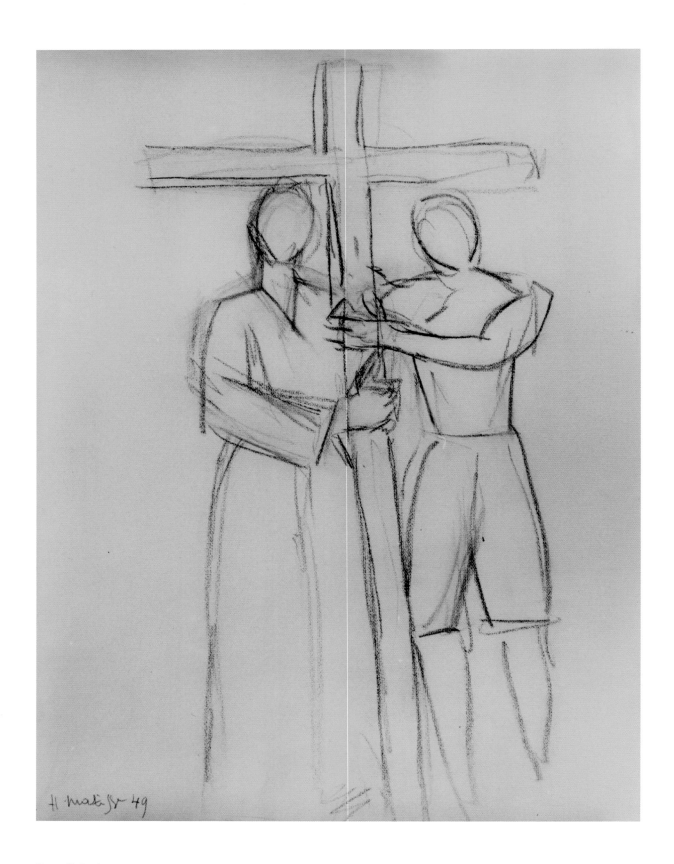

Simon Helps Jesus
Study for the *Way of the Cross*,
the Vence chapel, 1949
Charcoal on paper
Musée Matisse, Nice

[opposite]
**The Way of the Cross: Simon
Helps Jesus** (detail)
Ceramic panel

100

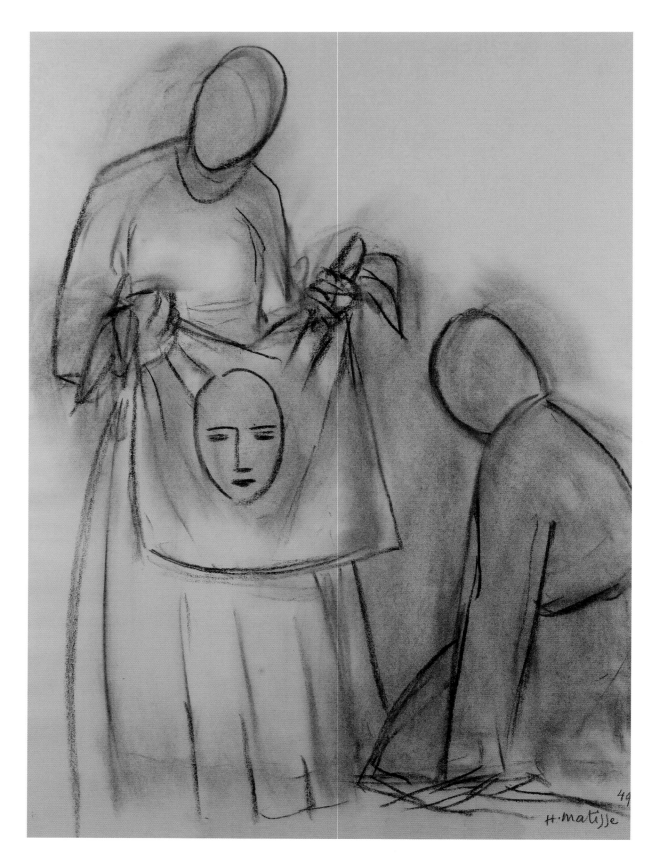

St Veronica's Veil
Study for the *Way of the Cross,*
the Vence chapel, 1949
Charcoal on paper
Congregation of the Dominican nuns
of the Rosary, Vence

[opposite]
The Way of the Cross:
St Veronica's Veil (detail)
Ceramic panel

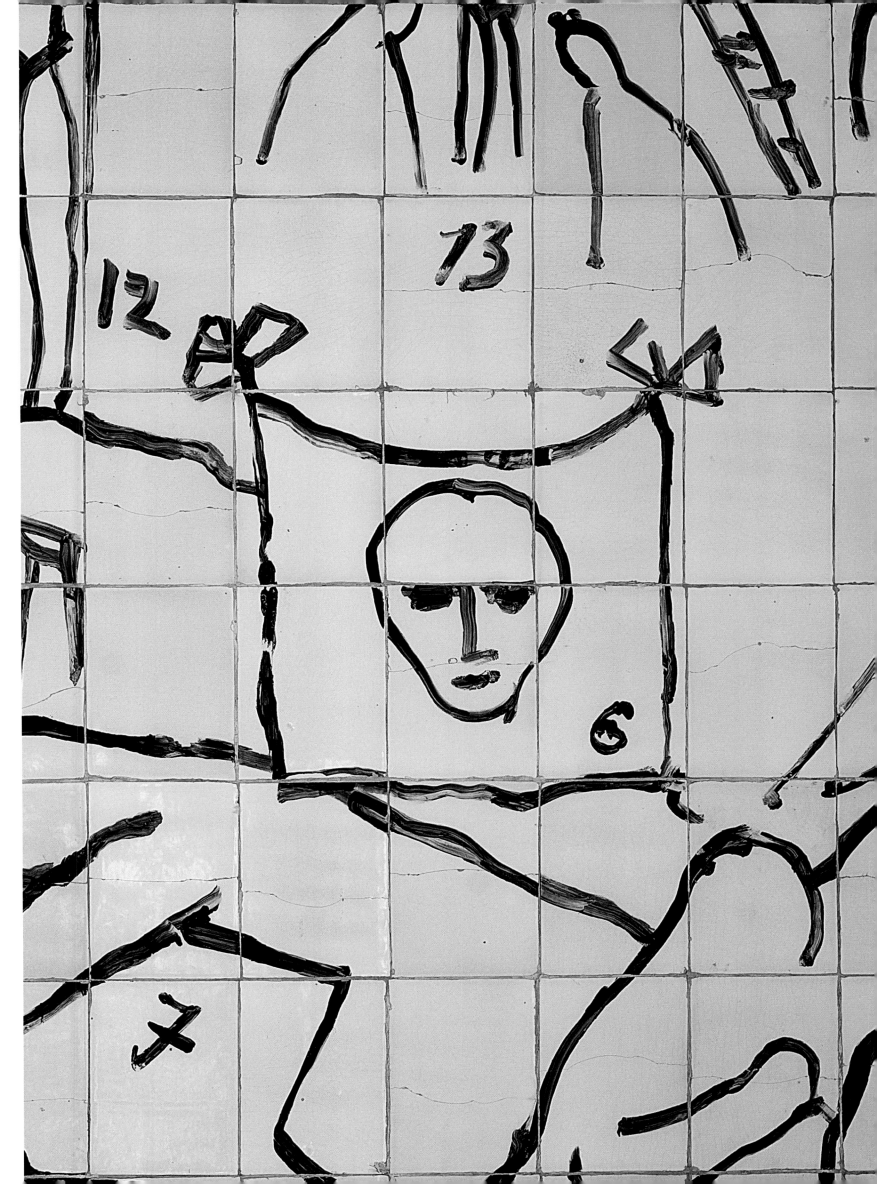

The Holy Women
Study for the *Way of the Cross*,
the Vence chapel, 1949
Charcoal and blending stick
on paper
Musée Matisse, Nice

[opposite]
**The Way of the Cross: The Holy
Women** (detail)
Ceramic panel

Recumbent Figure
Study for the *Way of the Cross*,
the Vence chapel, 1949
Charcoal on paper
Musée Matisse, Nice

[opposite]
**The Way of the Cross: Christ
Falls for the Third Time** (detail)
Ceramic panel

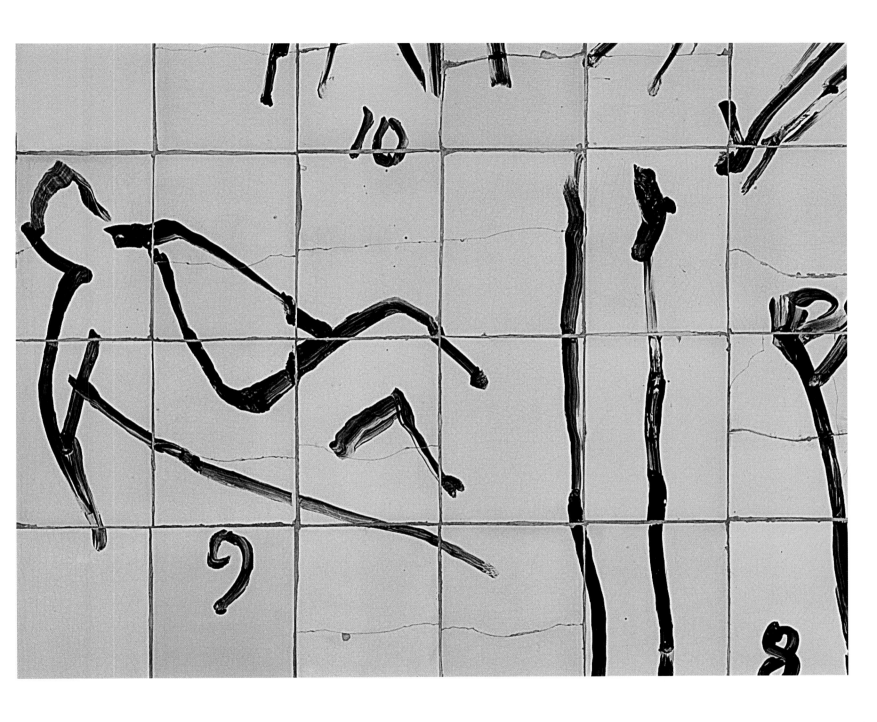

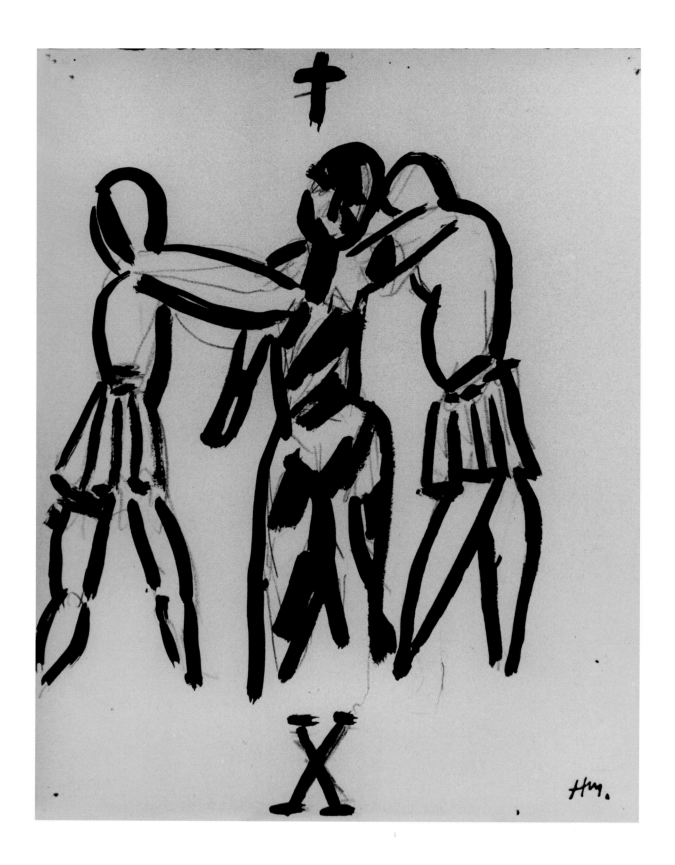

Christ Is Stripped of His Garments
Study for the *Way of the Cross*,
the Vence chapel, 1949
Pen, Indian ink and pencil
on paper
Musée Matisse, Nice

[opposite]
The Way of the Cross: Christ Is Stripped of His Garments (detail)
Ceramic panel

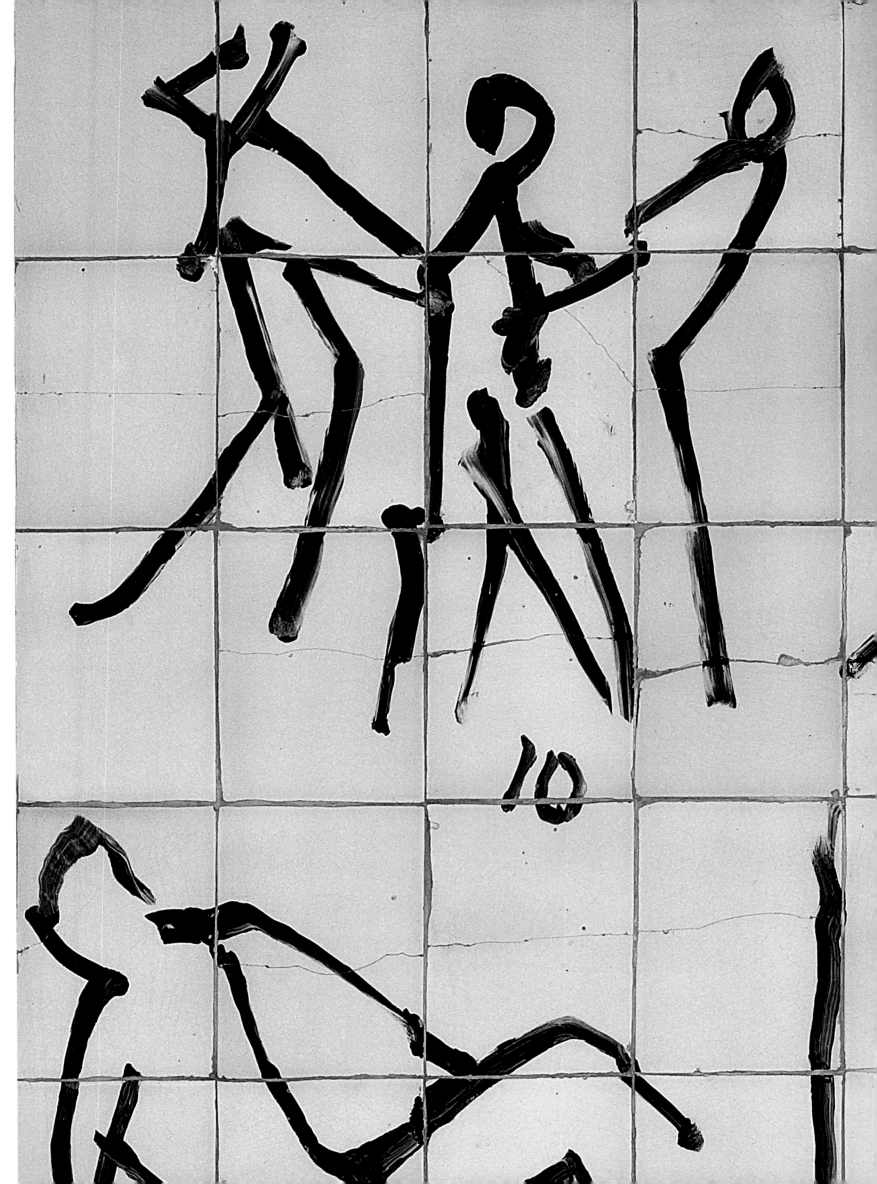

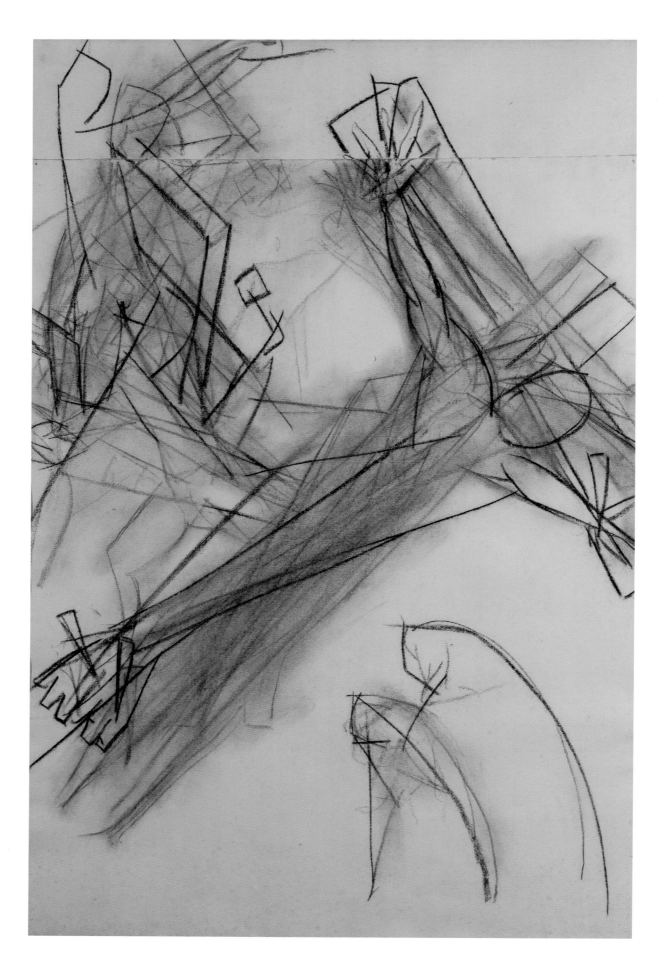

Jesus Is Nailed to the Cross
Study for the *Way of the Cross*,
the Vence chapel, 1949
Charcoal on paper
Private collection

[opposite]
**The Way of the Cross: Jesus Is
Nailed to the Cross** (detail)
Ceramic panel

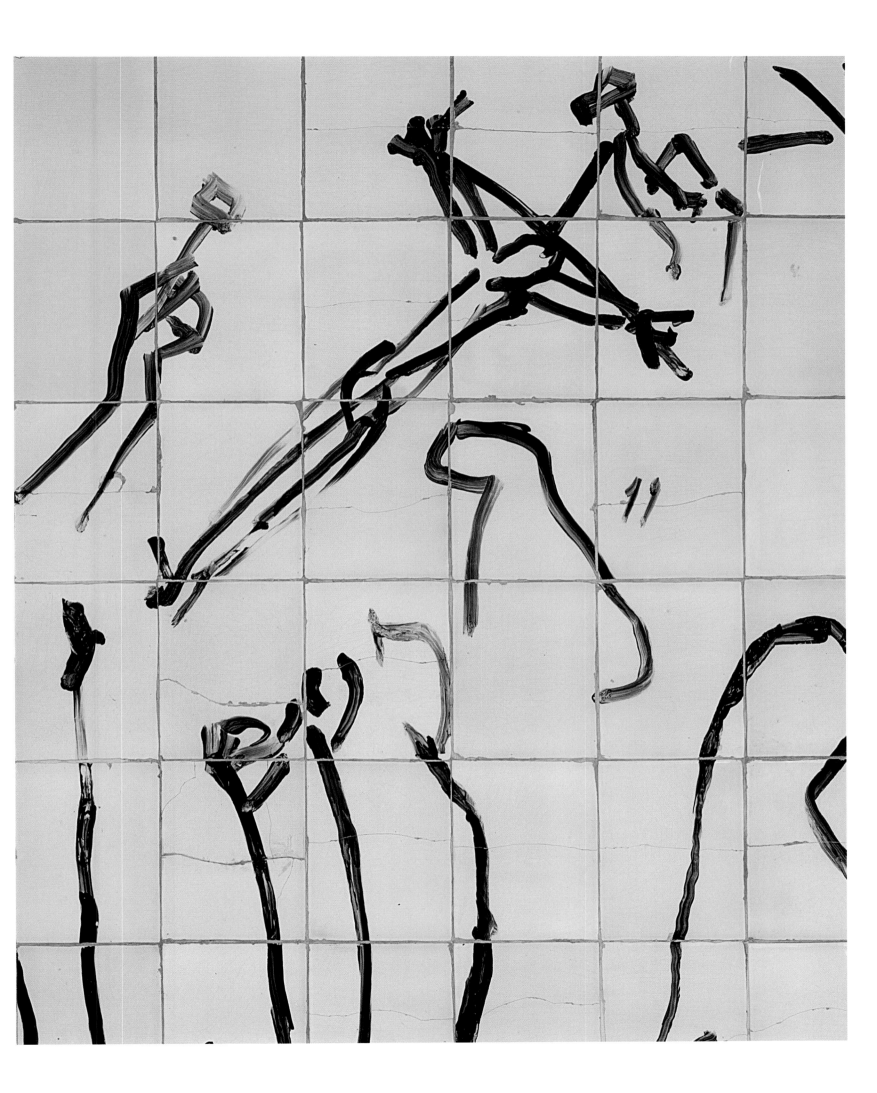

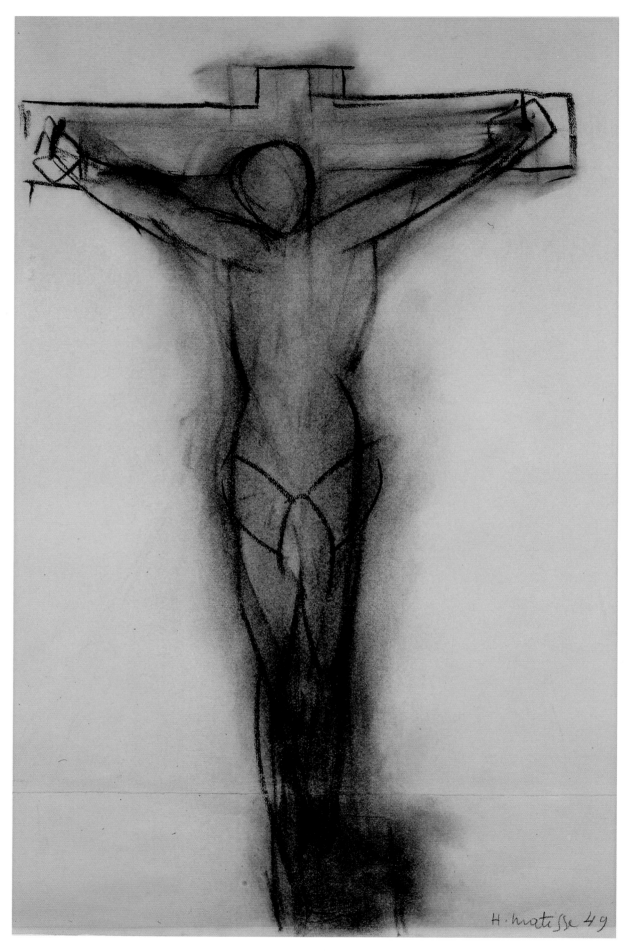

H. matisse 49

Christ on the Cross
Study for the *Way of the Cross*,
the Vence chapel, 1949
Charcoal on paper
Musée Matisse, Nice

[opposite]
The Way of the Cross:
Christ on the Cross
(detail)
Ceramic panel

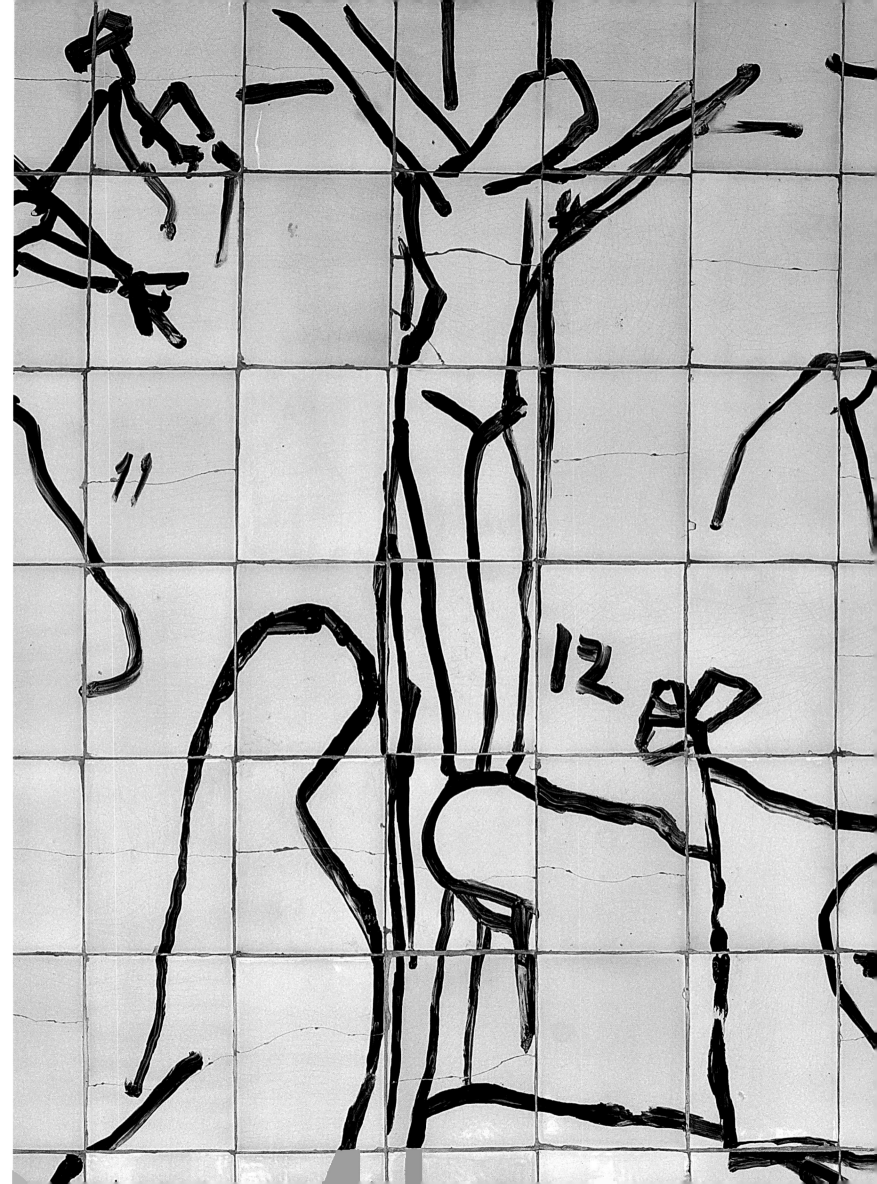

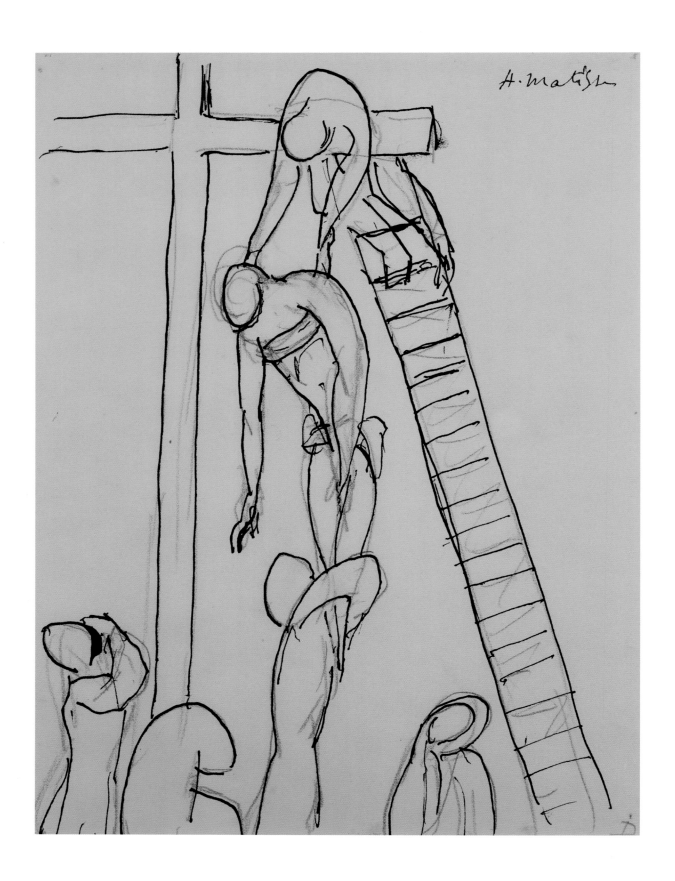

The Descent from the Cross,
after Rubens
Study for the *Way of the Cross,*
the Vence chapel, 1949
Pencil and pen on paper
Private collection

[opposite]
The Way of the Cross: The
Descent from the Cross (detail)
Ceramic panel

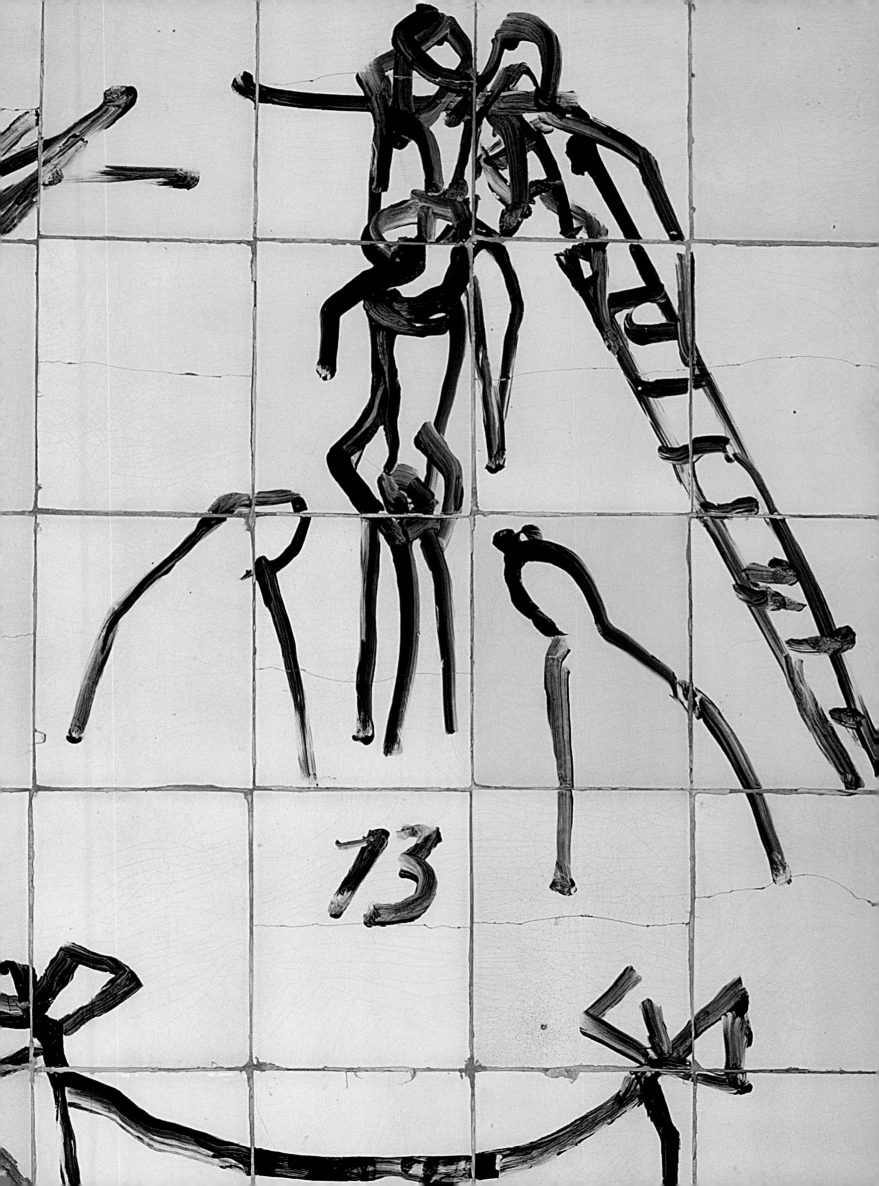

Recumbent Figure
Study for the *Way of the Cross,*
the Vence chapel, 1949
Charcoal on paper
Musée Matisse, Nice

[opposite]
**The Way of the Cross: The
Entombment** (detail)
Ceramic panel

116

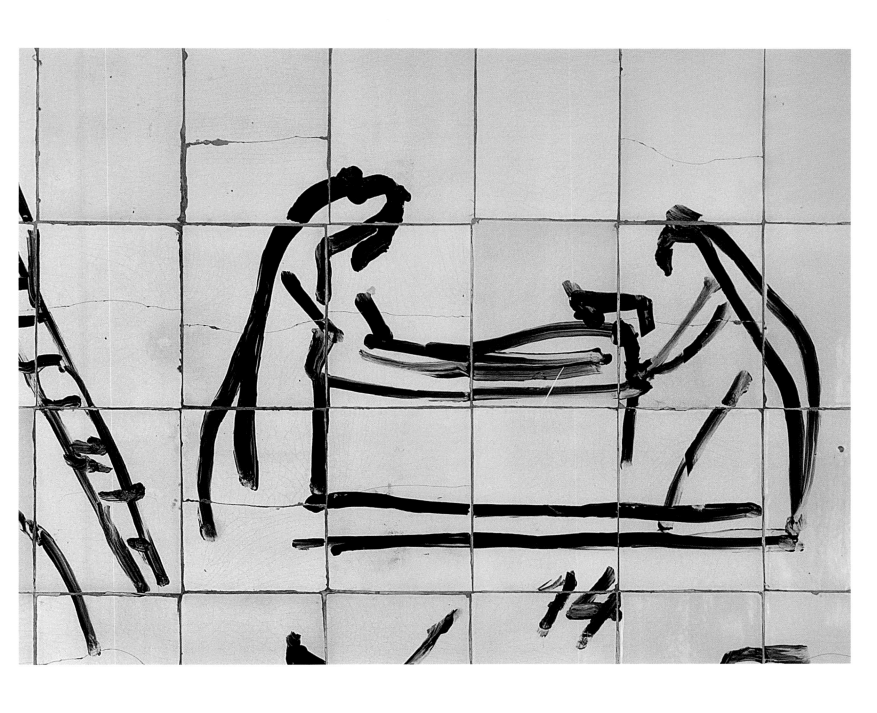

The High Altar

The altar in the Chapel of the Rosary is designed to face the Dominican nuns and the congregation in a novel manner. After the Council of Trent (1545–62), the high altar in churches was traditionally made part of the reredos that decorated the far end of the choir. The officiating priest stood symbolically facing God, only turning round to face the congregation at appropriate moments. In the liturgical tradition after the Second Vatican Council (1962–65), the priest has stood facing the congregation. The altar in the Vence chapel is placed diagonally across the nave, facing both the nuns, whose pews are installed to one side, as well as the congregation.

The Crucifix

The crucifix on the altar table bears another version of Christ on the cross, represented by Matisse several times in the chapel. As the central subject of the *Way of the Cross*, the figure of Christ dominates proceedings, but he can also be found in the confessional, in the sacristy and on the lintel of one entrance to the chapel. Matisse brings different nuances to the three representations of the Crucifixion. As in other preparatory studies made for the chapel, Matisse dug deep into art history. He studied the altarpiece by Matthias Grünewald on the high altar in Isenheim showing Christ with doleful face and twisted hands, but finally opted for another approach. Matisse's version of Christ's body is elongated and smooth, like the body on an early Christian crucifix. The body of Christ and the top bar of the cross to which his hands are nailed have the same texture. Matisse gives the arms a curve, like a gesture of prayer or of universal welcome, a calyx shape that is unlike more traditional representations.

For the altar: an officiating priest stands before the public.
The altar had to be decorated with a light touch, so that the priest
could see the congregation and the congregation could see the priest.
The decorative elements respond to this requirement. The lightness
gives a feeling of release, of freedom; to the extent that my chapel
does not say: Brothers, you must die. It says the reverse:
Brothers, you must live.[64]

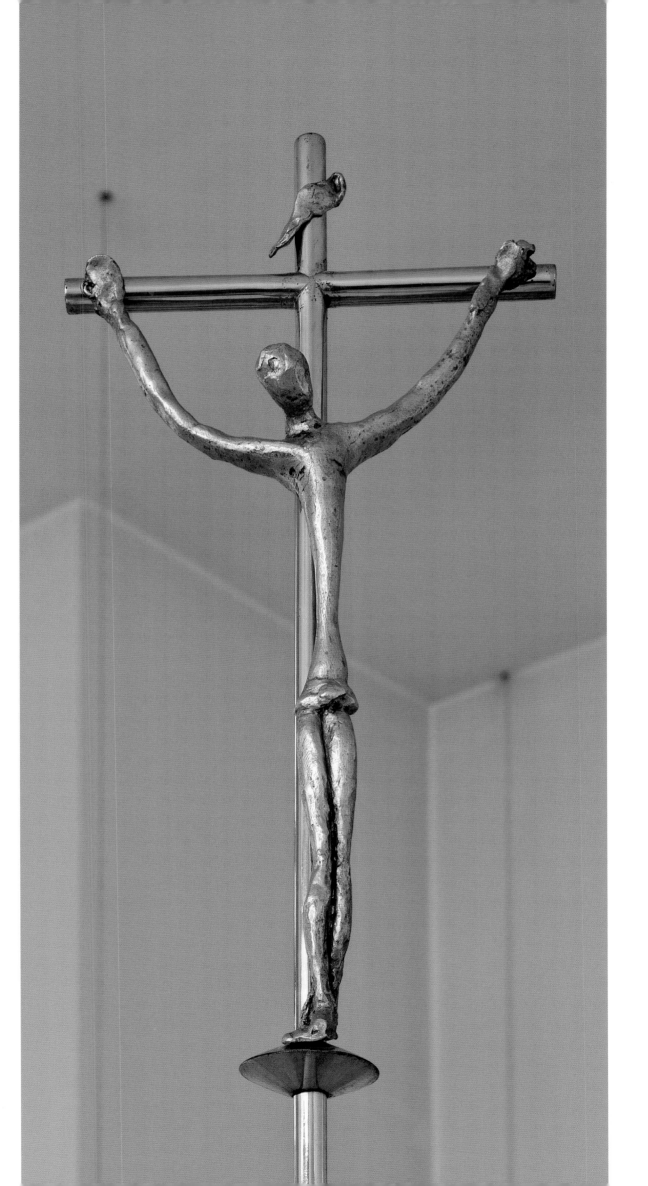

The Crucifix on the high altar
Gilded bronze

[following pages]
The high altar, a complete view
and details with the tabernacle

119

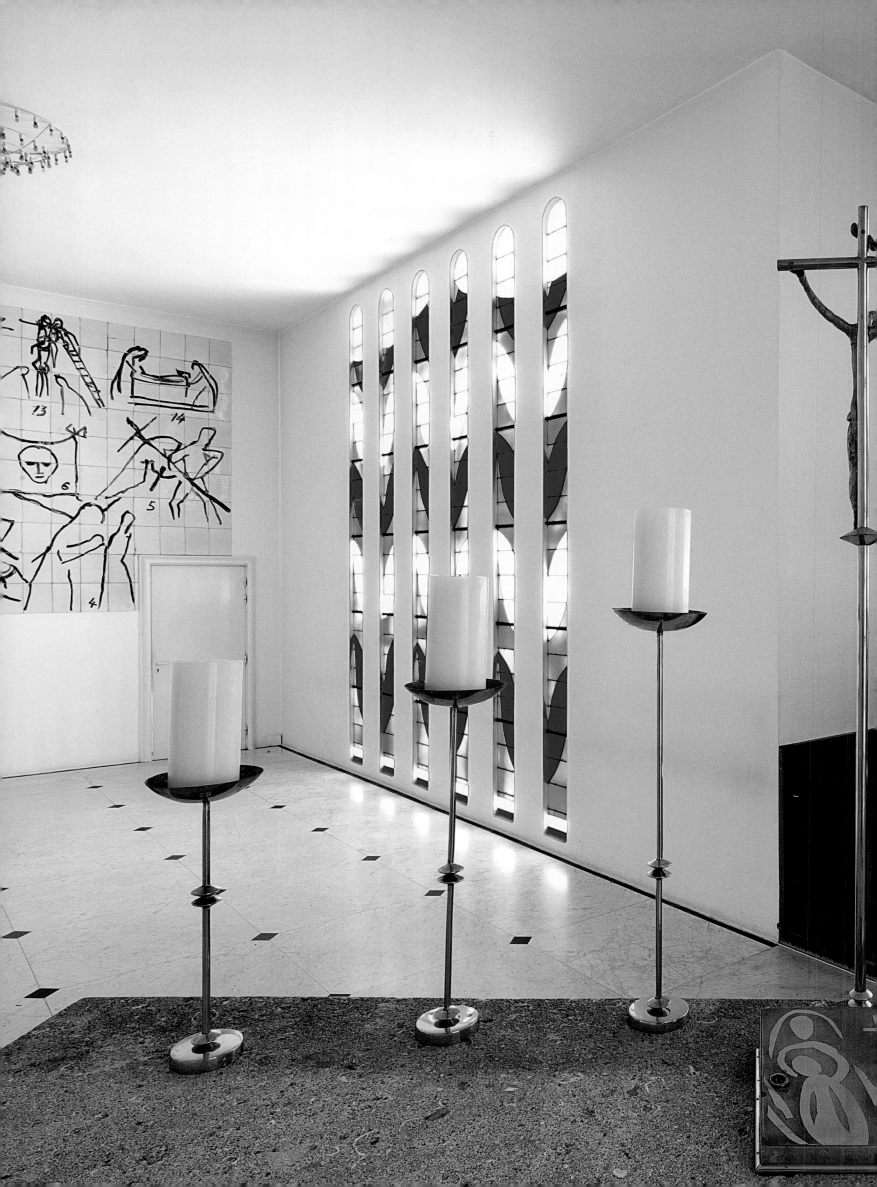

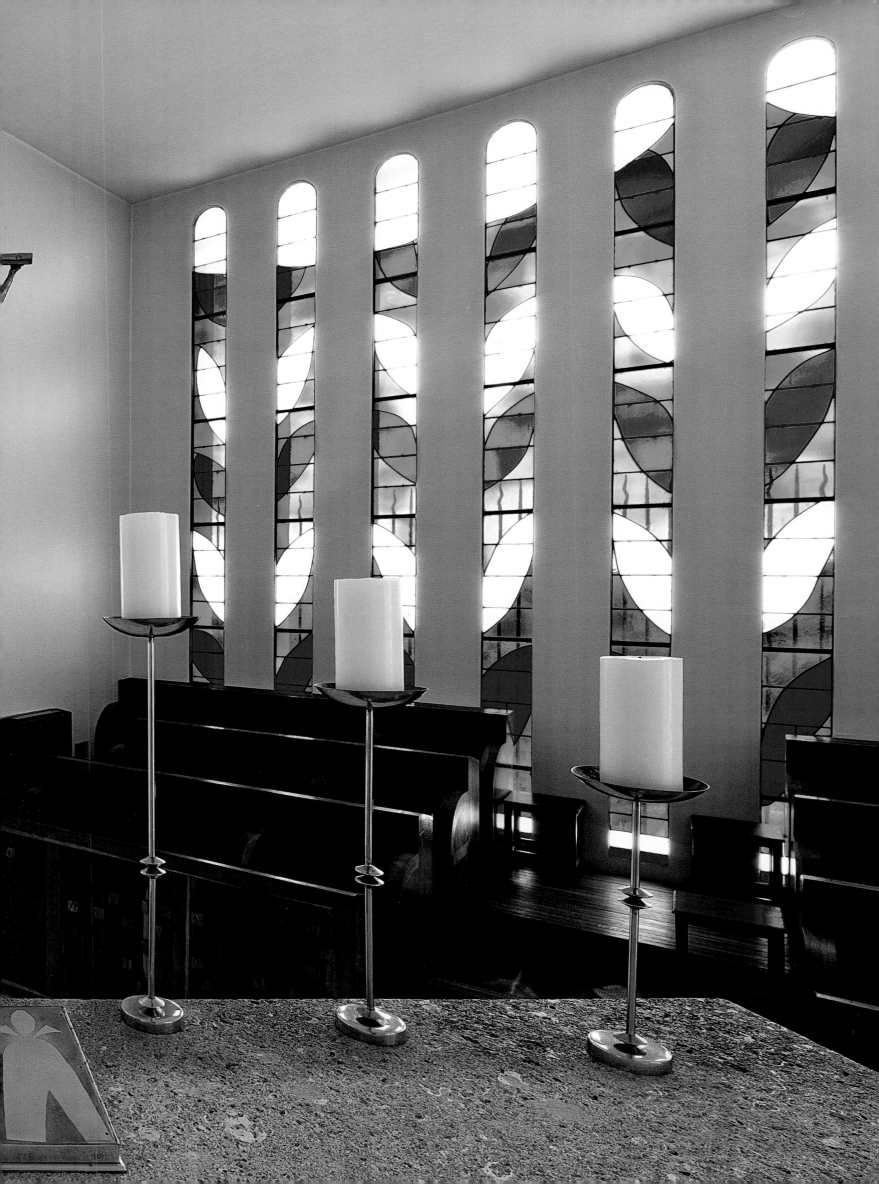

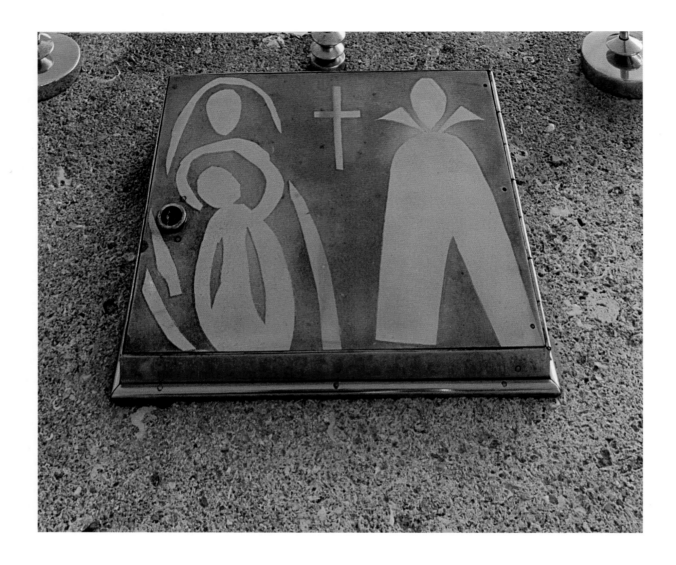

The tabernacle on the
high altar

[opposite]
**The altar with the crucifix,
tabernacle and candlesticks**

122

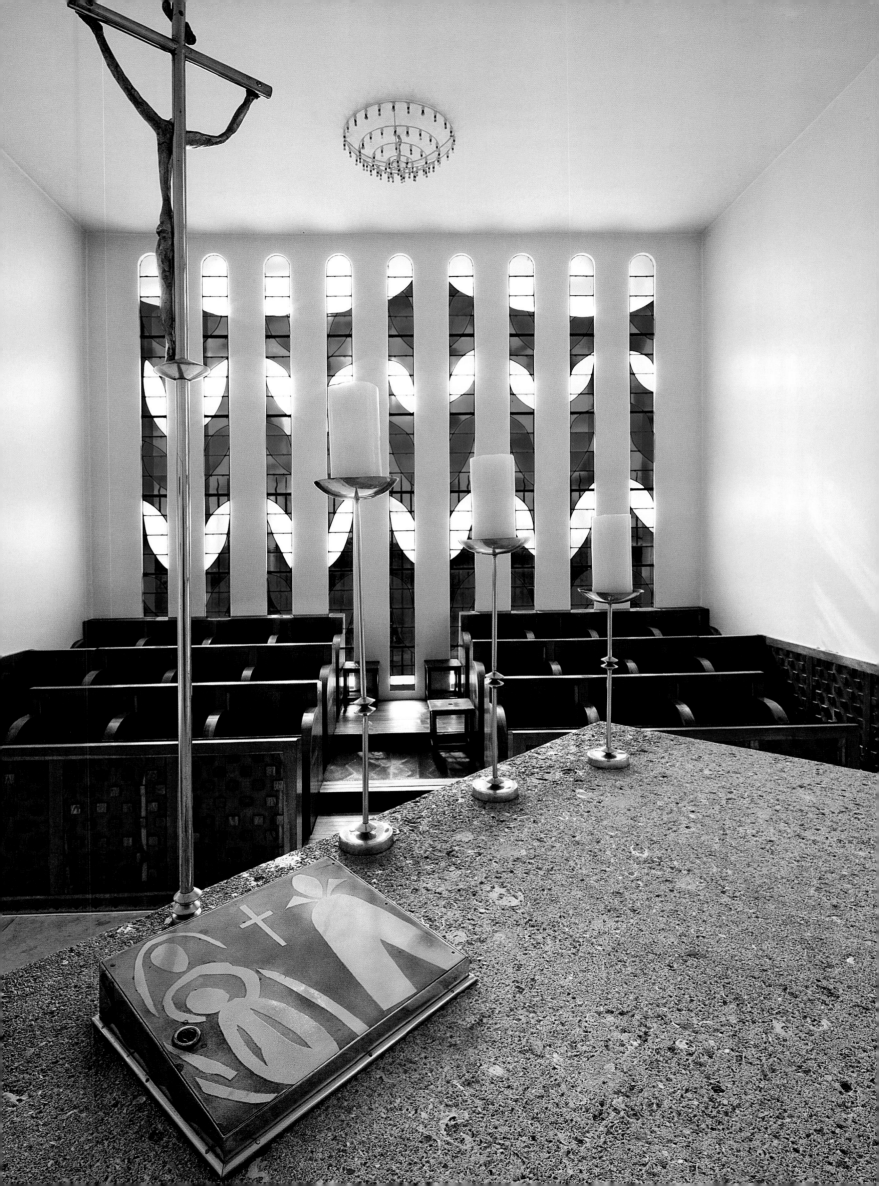

The oil lamp over the altar

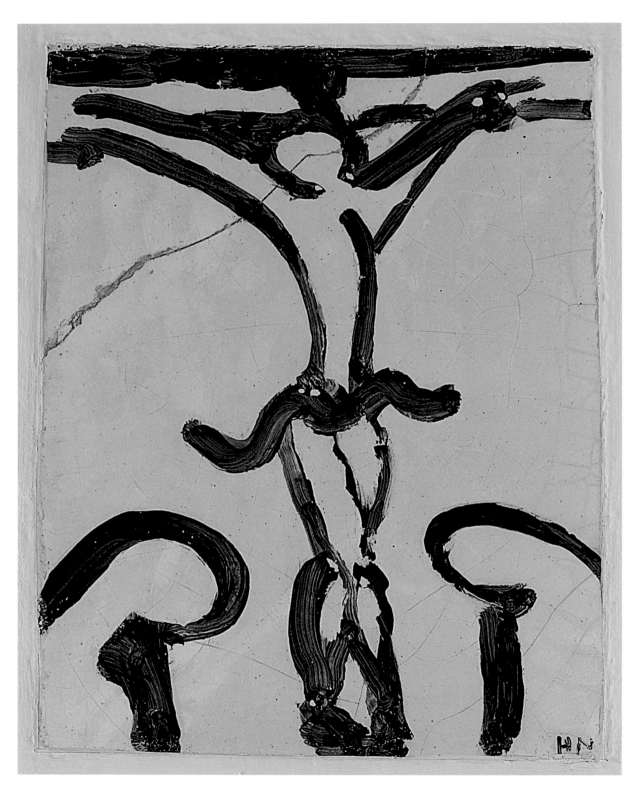

The ceramic tile depicting the
Crucifixion in the confessional

[opposite]

The ceramic tile depicting the
Crucifixion from the entrance
to the sacristy

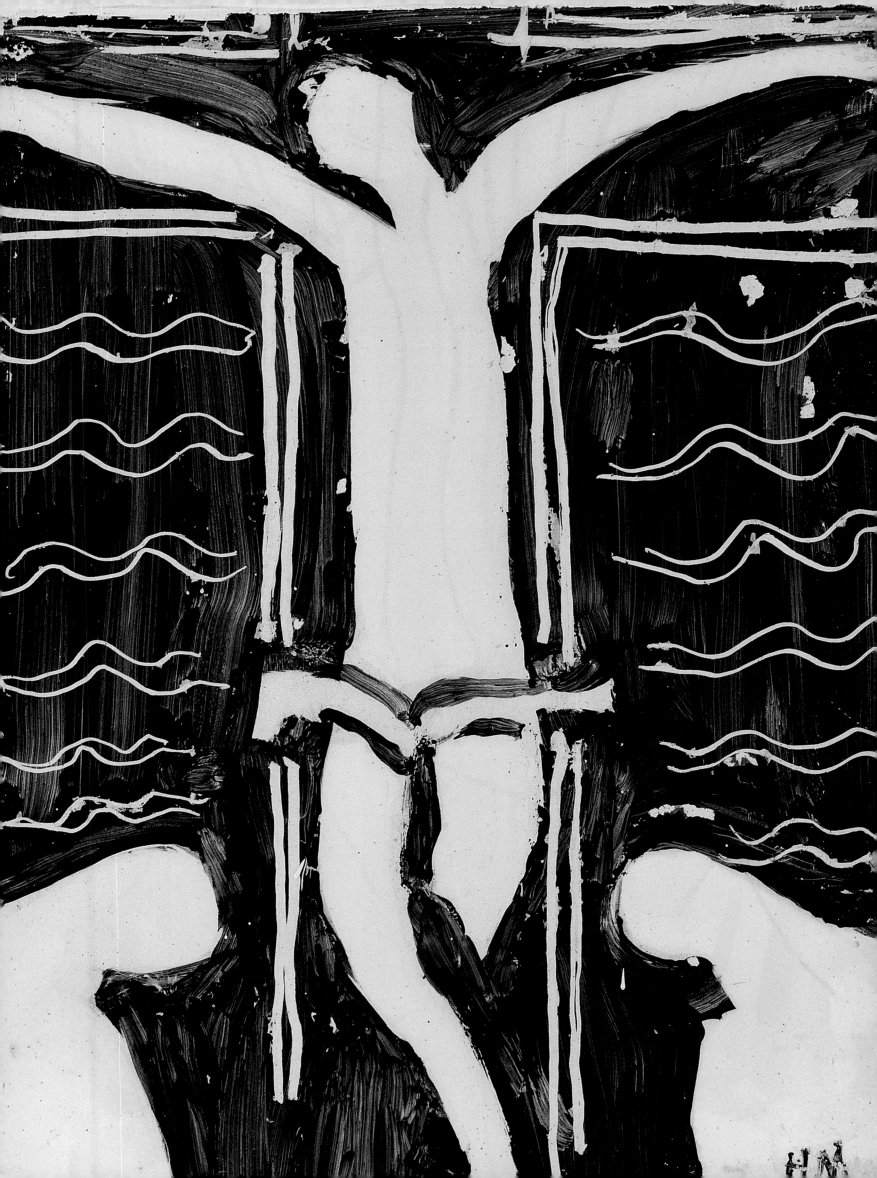

The Holy-water Stoups

Three doorways lead into the chapel. They are defined by the category of people using them, helping to organise the use of space and to classify and ritualise entrances and exits during services.

Visitors or worshippers coming through the door on the Route de Saint-Jeannet, having gone down the steps, enter the chapel through a door situated to the right of the *Way of the Cross*; their first view is of a religious space whose central axis ends in the *Tree of Life* window. A small corridor leading from the garden, to the left of the high altar, is reserved for the nuns. During services the priest, having donned his vestments in the sacristy, reaches the altar via the door located to the right of the *St Dominic* panel.

Each entrance to the chapel has its own holy-water stoup. These are usually located inside the church, but here they are installed outside. Having dipped his fingers in the holy water, worshippers can make the sign of the cross, invoking God the Father and absorbing the blessed spirit.

Matisse designed the three holy-water stoups and chose their colours. The blue bowls surrounded by blue ceramic petals were then made by the ceramicist-sculptor Andrée Diesnis; Matisse encouraged her work, and in 1952 also commissioned the fountain now in the sacristy of the chapel.[65]

The Garden Pond

At Matisse's request, a pond was constructed near the chapel, containing aquatic plants and goldfish. The pond reflects the artist's appreciation of natural harmony, and its shape echoes his taste for fluid forms and lines, which also dominates the interior of the chapel and can be found in particular in the play of coloured light from the windows, dappling the walls and floor, and in the transparency of the fish embroidered on the altar cloth. It is not surprising, therefore, that during his research, on 5 October 1948, Matisse wrote from Venice to Brother Rayssiguier to say he was considering another window, named the *River of the Water of Life, Clear as Crystal*.[66] When Matisse abandoned the project for the *Water of Life* window, he 'wanted to retain the memory of living water with a pond located on the south side of the southern façade of the chapel', in which the rhythm of the window arches and the bell tower would be reflected.[67]

[opposite]
The goldfish pond in the garden of the chapel

[following pages]
The nuns' entrance with one of the ceramic holy-water stoups

The entrance to the sacristy and its ceramic holy-water stoup

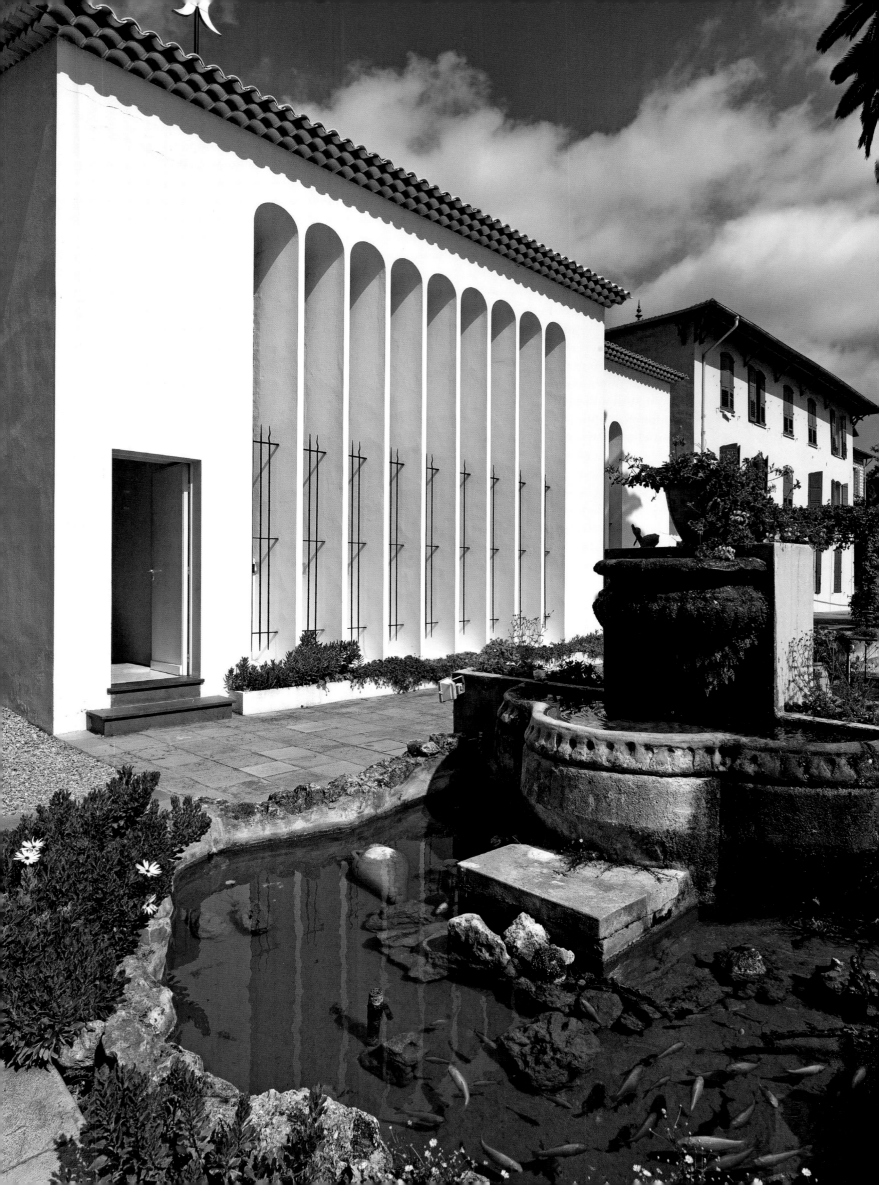

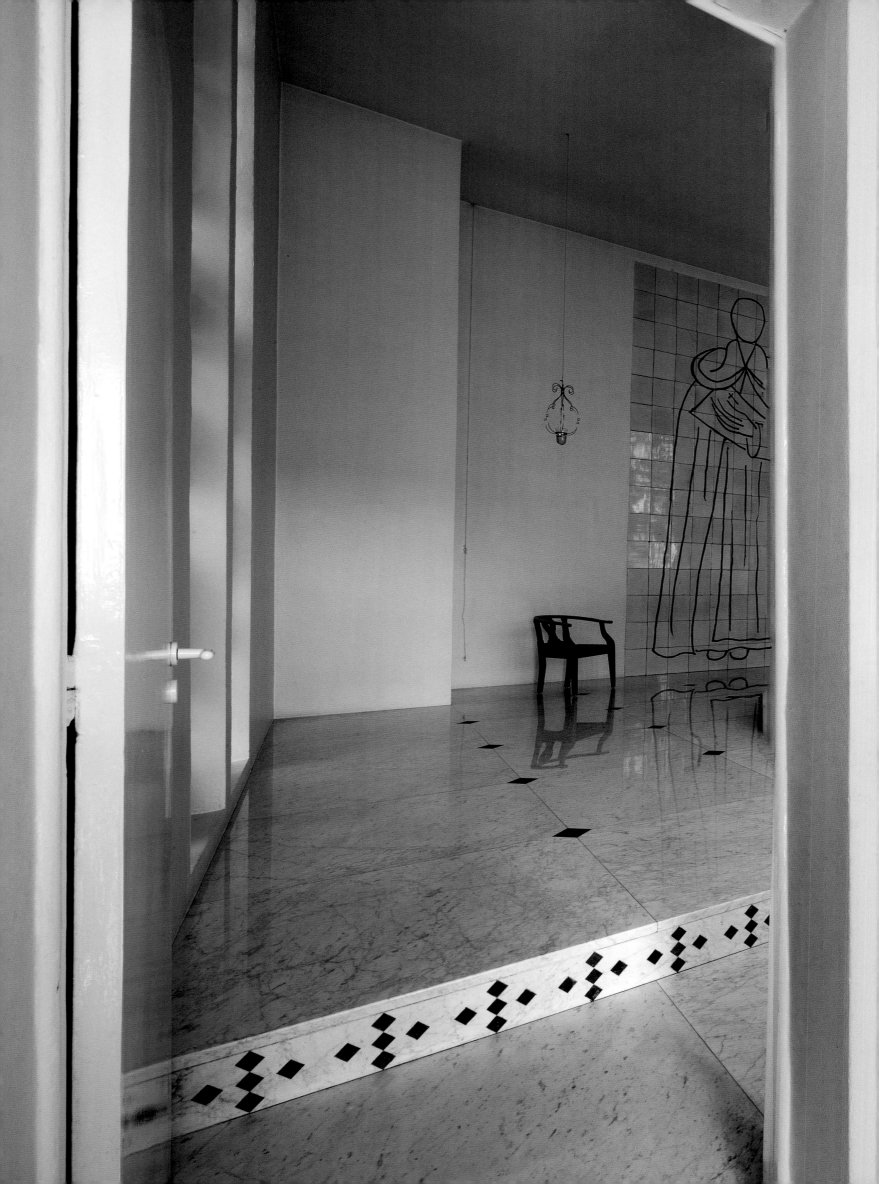

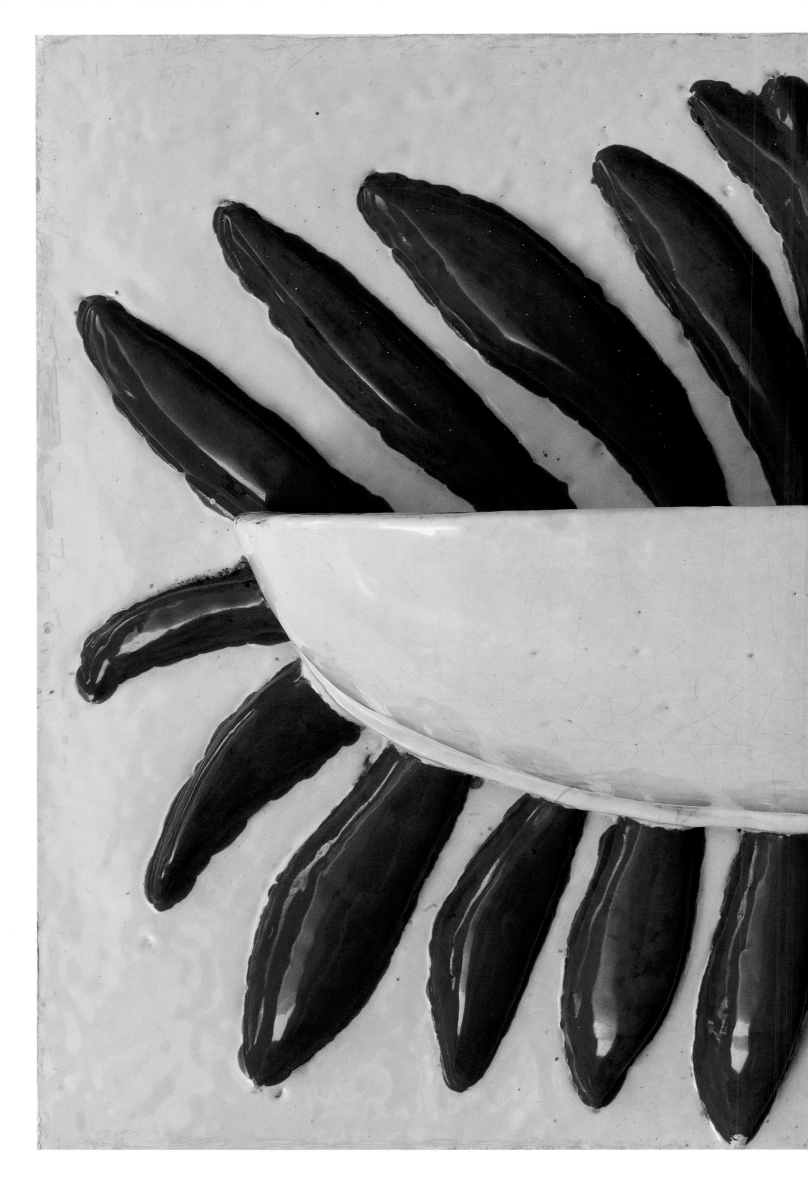

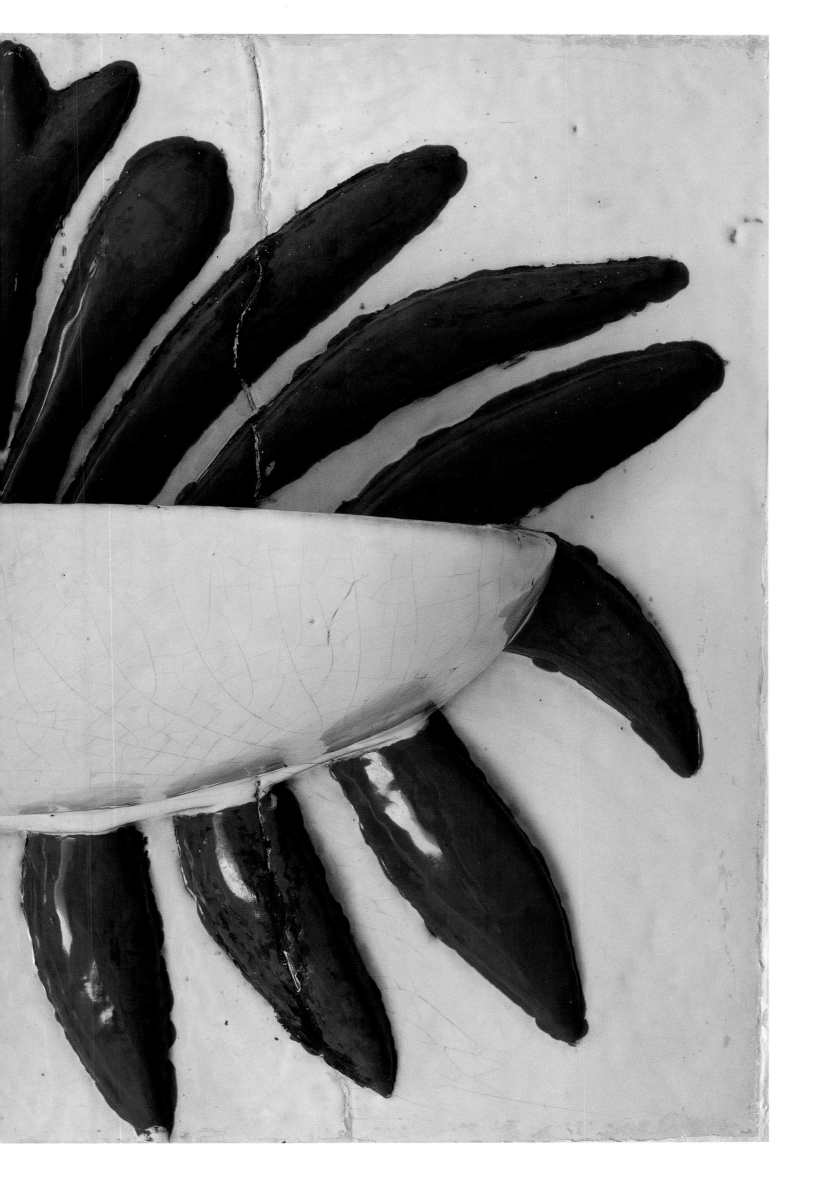

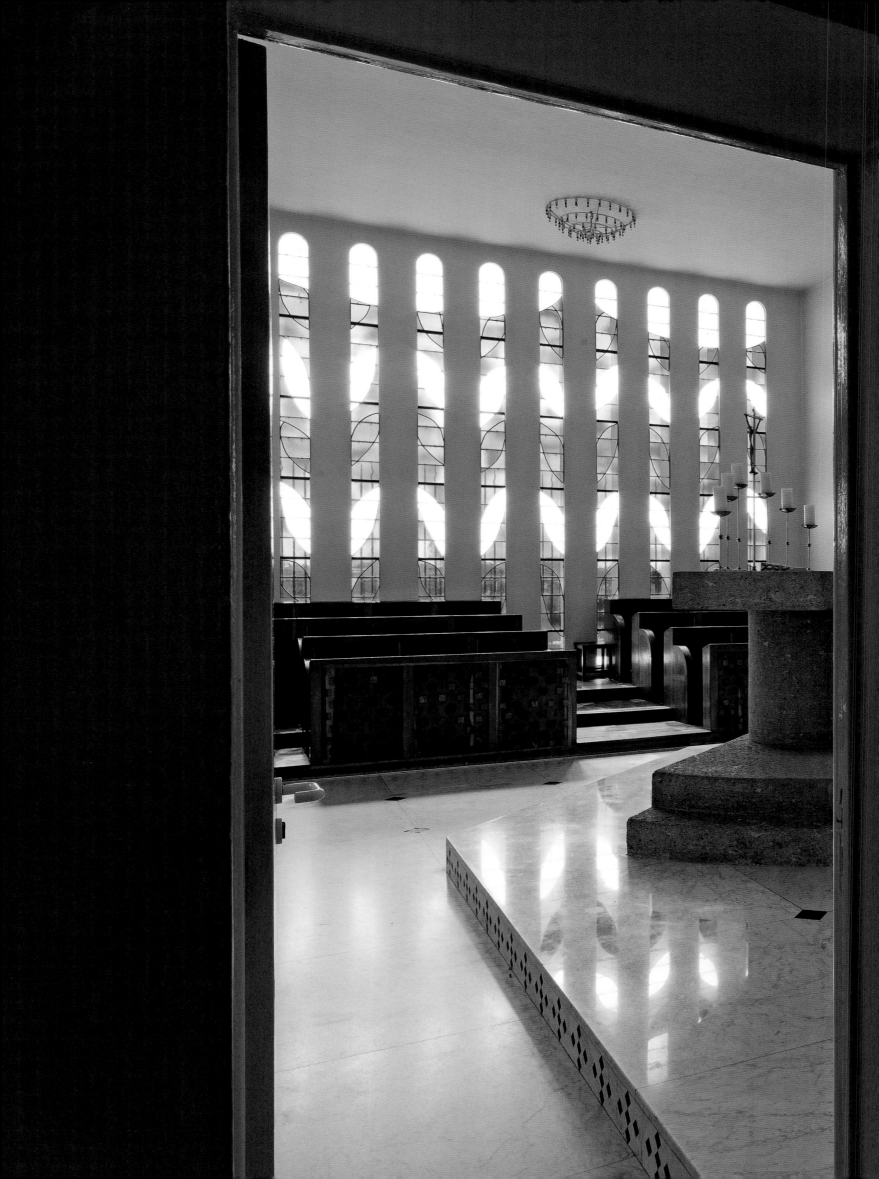

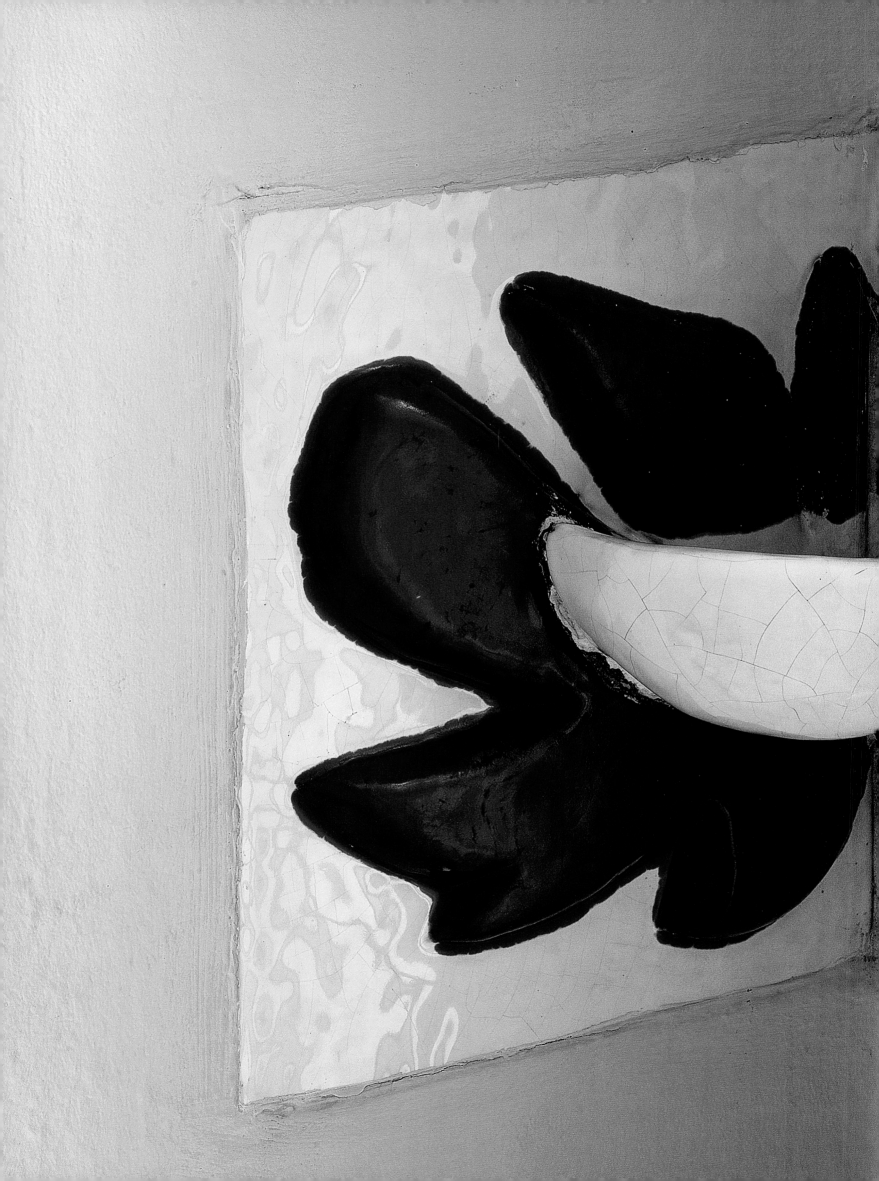

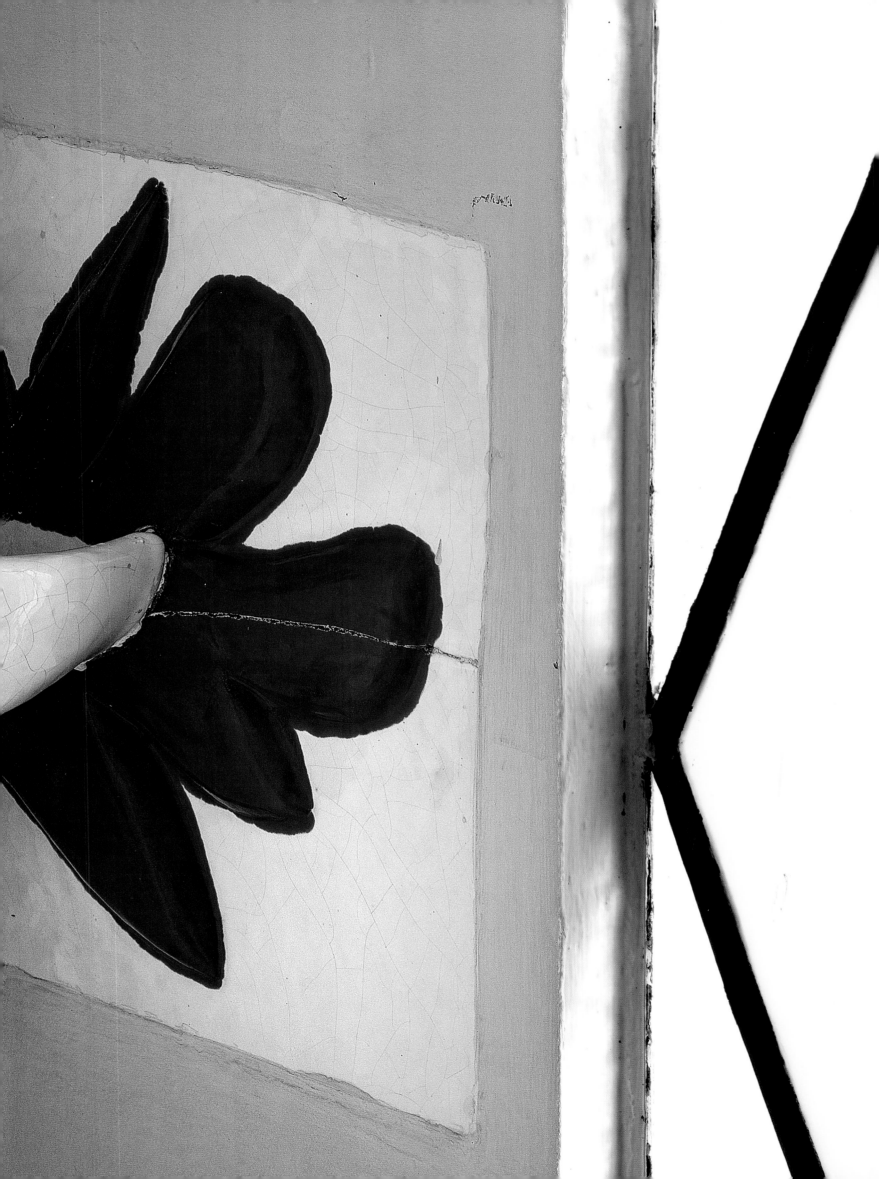

3
A Creation of Light

I should like visitors to the chapel to experience a lightening of the spirit. And, even if they are not believers, I should like them to feel that they are in an environment in which the spirit rises up, where thought grows clearer and where emotion itself is made lighter. The benefits of the visit will easily become clear, there should be no need to bang one's head against the ground.[1]

The Chapel of the Rosary is constructed around light, reflecting the mystical position occupied by light in Dominican doctrine, and the symbolic role of light in the teachings offered to the congregation. The windows of the chapel act as a support for the word of God, a dazzling mediator between man and divinity. Historically, stained-glass windows have been used to represent divine light – soaring up towards the vault, which becomes a symbol for heaven. Matisse uses light in a different way. He transforms the spatial impact of the chapel by designing windows that stretch from floor to ceiling, thus creating continuity between the symbolic space of the chapel and the natural world outside. The chapel is thus integrated into its environment and benefits from the changing light from the sun as the day goes by.

The Spirit of the Stained-glass Windows

Matisse worked long and hard on the windows of the chapel in Vence, developing the subjects and patterns over a number of stages. He delved deep into the details of glass-making techniques, and also the techniques for assembling stained glass; this was done as part of his plan for the organisation of the interior space of the chapel and the building's appearance from outside. Traditionally, interior light has been admitted to religious architecture by enlarging apertures, raising the height of buildings and using coloured window glass. The chapel in Vence, however, is modest in size and is also built against a hillside on the side of the road to Saint-Jeannet; only one side, therefore, was available for the inclusion of windows: along the central bay and behind the high altar. Matisse was to base his design on panels lit both from outside by the sun and by the luminous quality of their colours. For the artist, the colours were felt to contribute to the raising of hearts and voices. After attending High Mass at the Sainte-Chapelle in Paris, Matisse wrote to Brother Rayssiguier on 24 October 1948: 'In our building, it is important that the spiritual elevation of hearts and minds should come quite naturally from the lines and colours, in the simplicity of their eloquence… '[2] He did not think it necessary to provide an organ – an opinion he alluded to in a letter to Father Couturier written on 16 October 1948, saying 'It was designed simply as a chapel.'[3] The simplicity of the chapel provided the artist

with the opportunity to express himself through a variety of media.
'This is the way simple colours can act on private emotion, more powerfully
because they are simple. Blue, for example, accompanied by the glow of
its complementaries, acts on emotion like a loud bang on a gong.'[4] The
transcendent glow of the colours makes the windows a vibrant source of
emotion. Matisse was looking back to a childhood memory of creating
a stage set based on an image of the eruption of Vesuvius. He rediscovered
this intense play of light in the chapel.

As in his paintings of the Vence period, Matisse used the interior space
as well as the exterior space of the chapel – the windows in his paintings are
themselves like stained-glass windows, attracting and holding the attention
with their brightness. In the chapel, the windows blend the reality of the
space in an extraordinary manner. As the atmosphere changes with the time
of day, according to the cycles of nature, it acts as a reminder of the forces
of life and creation, stimulating emotion. The chapel becomes a place for self-
discovery. The play of light – opacity contrasted with transparency – reflects
private thoughts that can either retreat into themselves or open themselves to
the outside world. The religious and the secular can mingle in this peaceful
place. During his voyage to Tahiti in 1930, impressed by the reflection of the
sky and the clear waters of the lagoons, Matisse had felt that the horizon
could disappear and the sky and the earth merge. The consistency of the
elements, he saw, depended on light. He seems to have experienced a
revelation of unity, outside his usual boundaries, and this is what he was
aiming to convey with his creation of the chapel. The same idea can be
found in his painting The Silence that Lives in Houses (1947), in which the
figures are reading a book with blank pages; the book contains the light of
the canvas.[5]

The design of the windows in the Chapel of the Rosary is also connected
with a unique stage in the artist's career. Matisse's creativity saw a renewal,
and his sense of interpretation a vital expansion, in the technique of making
cut-outs from painted paper. 'With the creation of these cut and coloured
papers, I seem to be moving happily into the unexpected. I have never,
I believe, felt as calm as I do when making these paper cut-outs. I know,
however, that people will not realise until much later how completely what
I am doing today chimes with the future.'[6] The technique opened new
horizons to the artist, giving him the chance to create large compositions
and to piece them together as he saw fit. Matisse covered the walls of his
apartment at the Régina with projects, including the different phases of the
designs for the windows in the chapel, and surrounded by all his projects and
experiments, he could immerse himself in his work completely. 'When I go
into the chapel, I feel that my whole being is there – at least everything
that was best when I was a child.'[7] Dreams and the unexpected thus gain
admission to the chapel. The colours blue, yellow and green mingle and
merge as the sun shines through them. A ray of light projects violet
iridescence onto the walls. The way the colours change according to the
time of day gives life to the walls of the chapel and increases the feeling
of space.

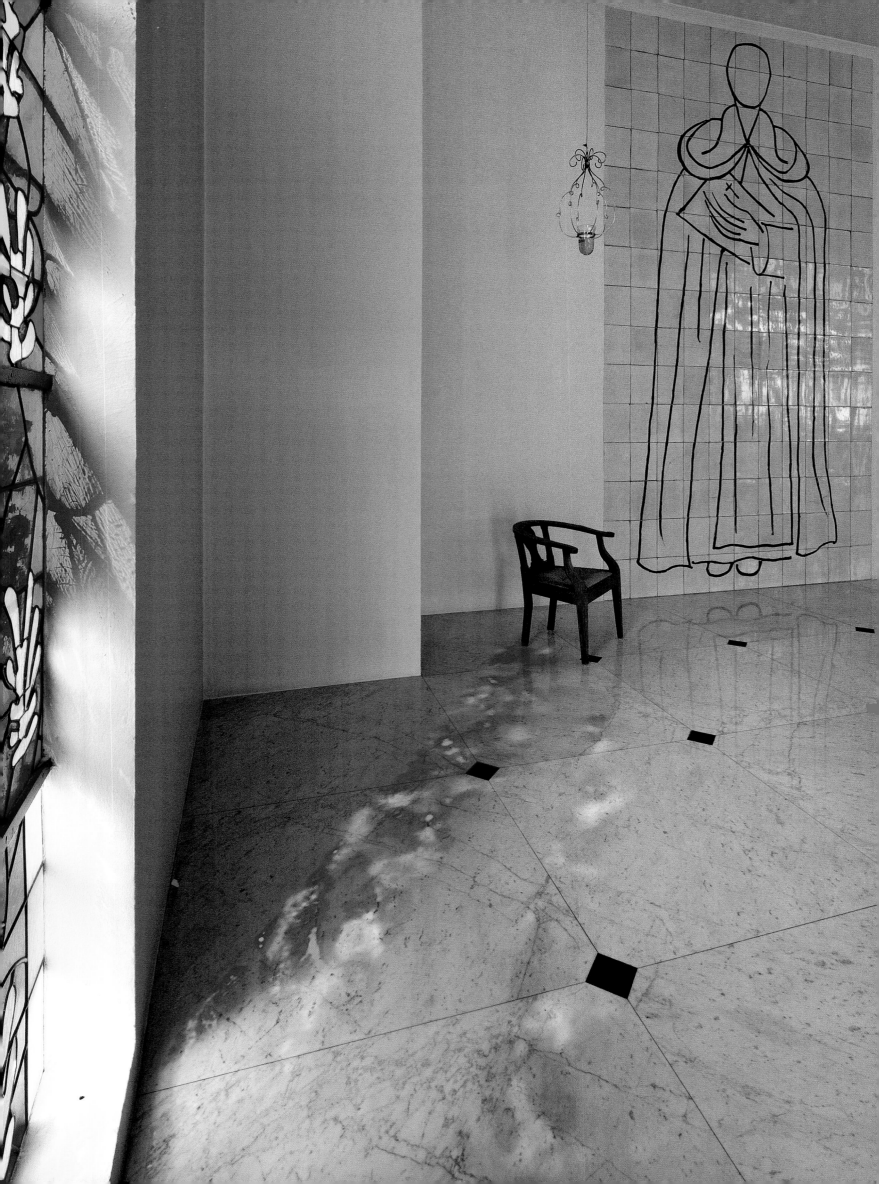

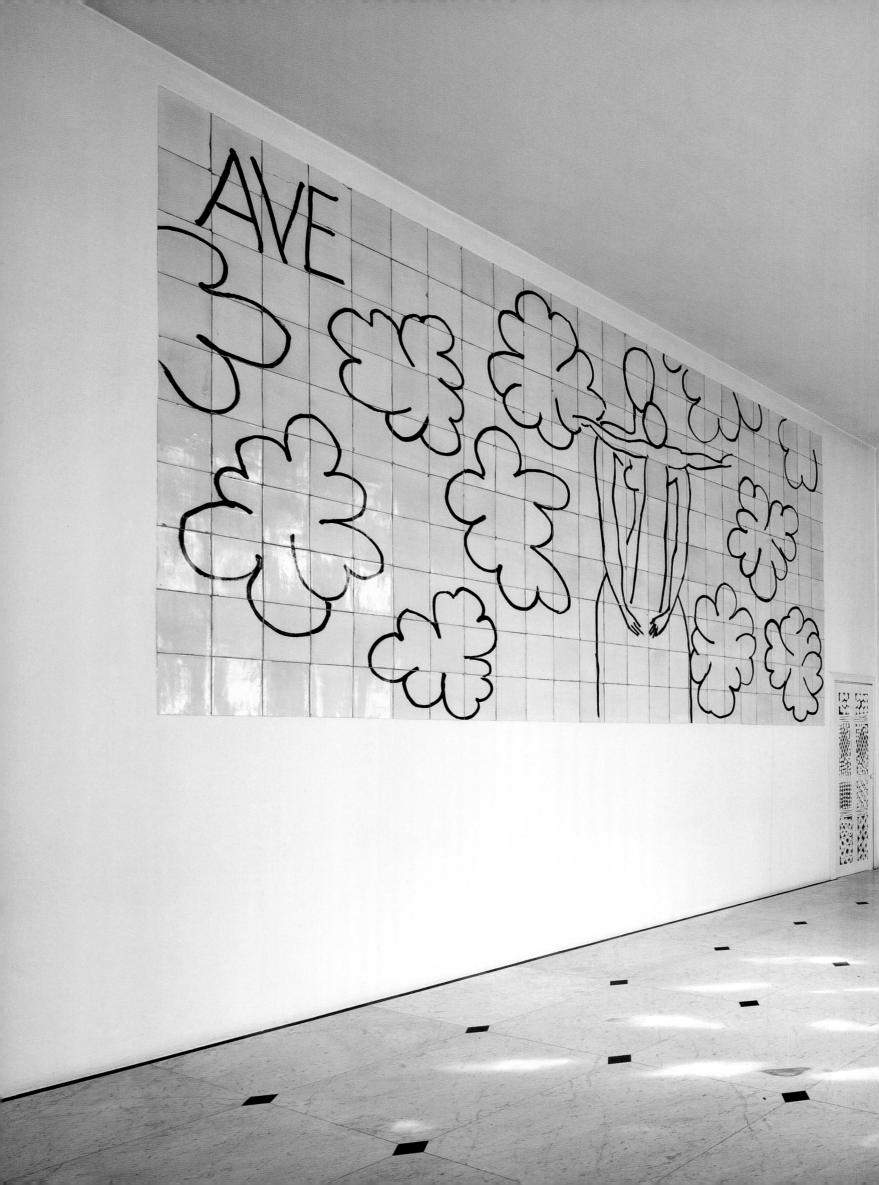

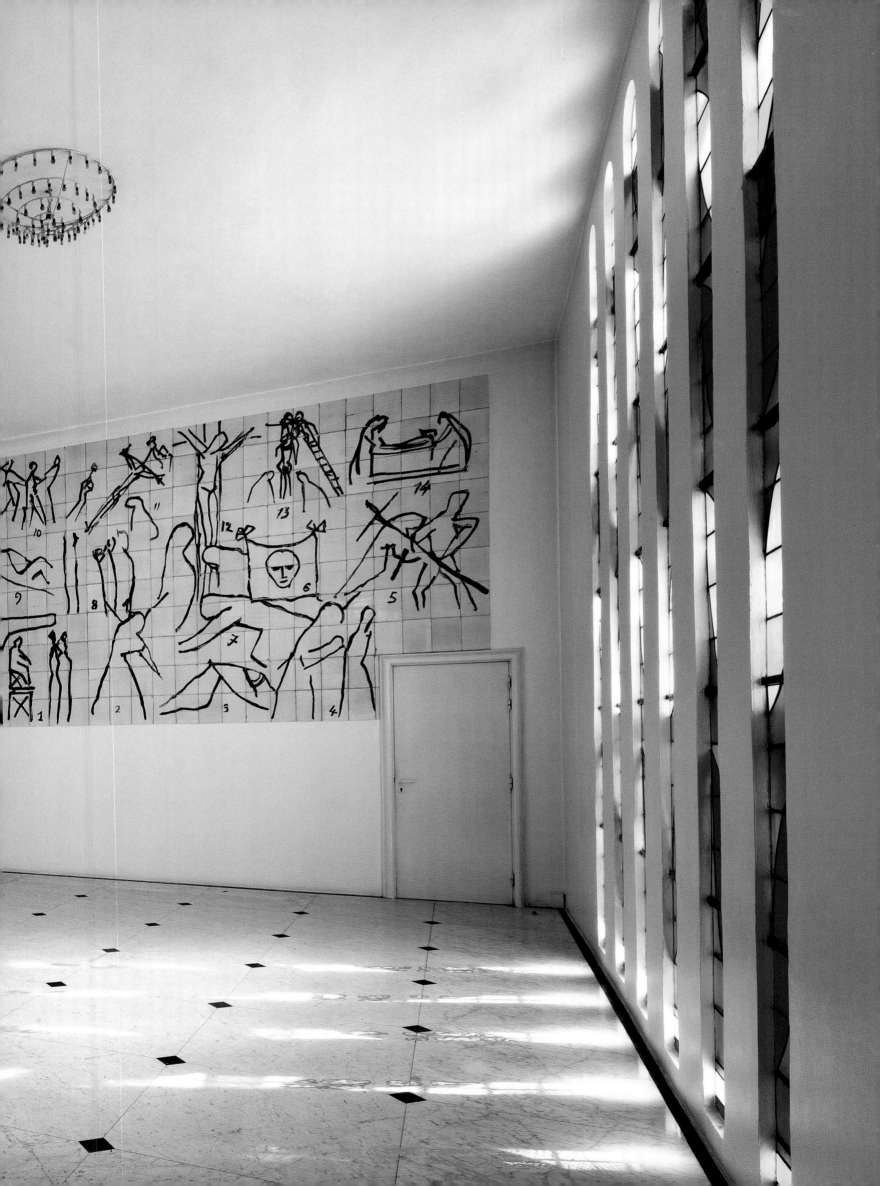

The colours from the stained-glass windows reflected on the marble floor of the chapel

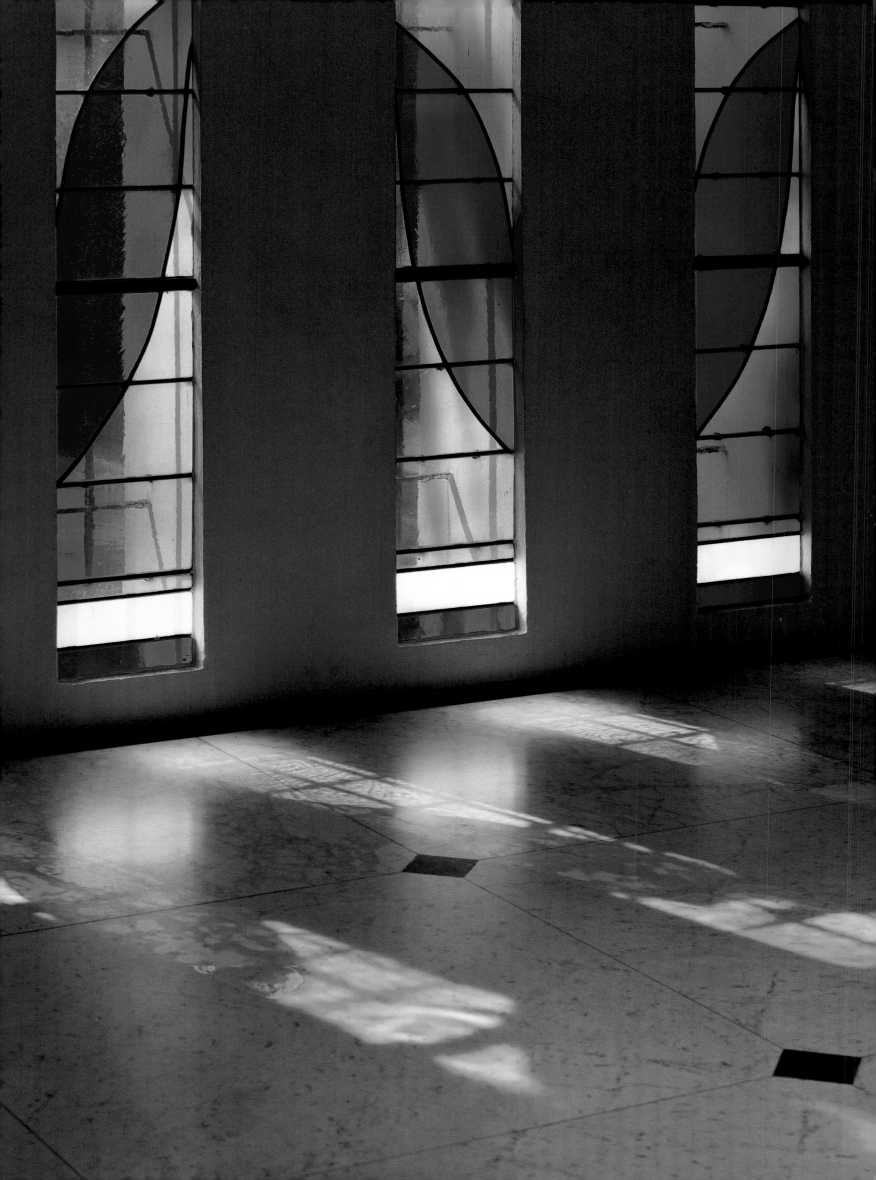

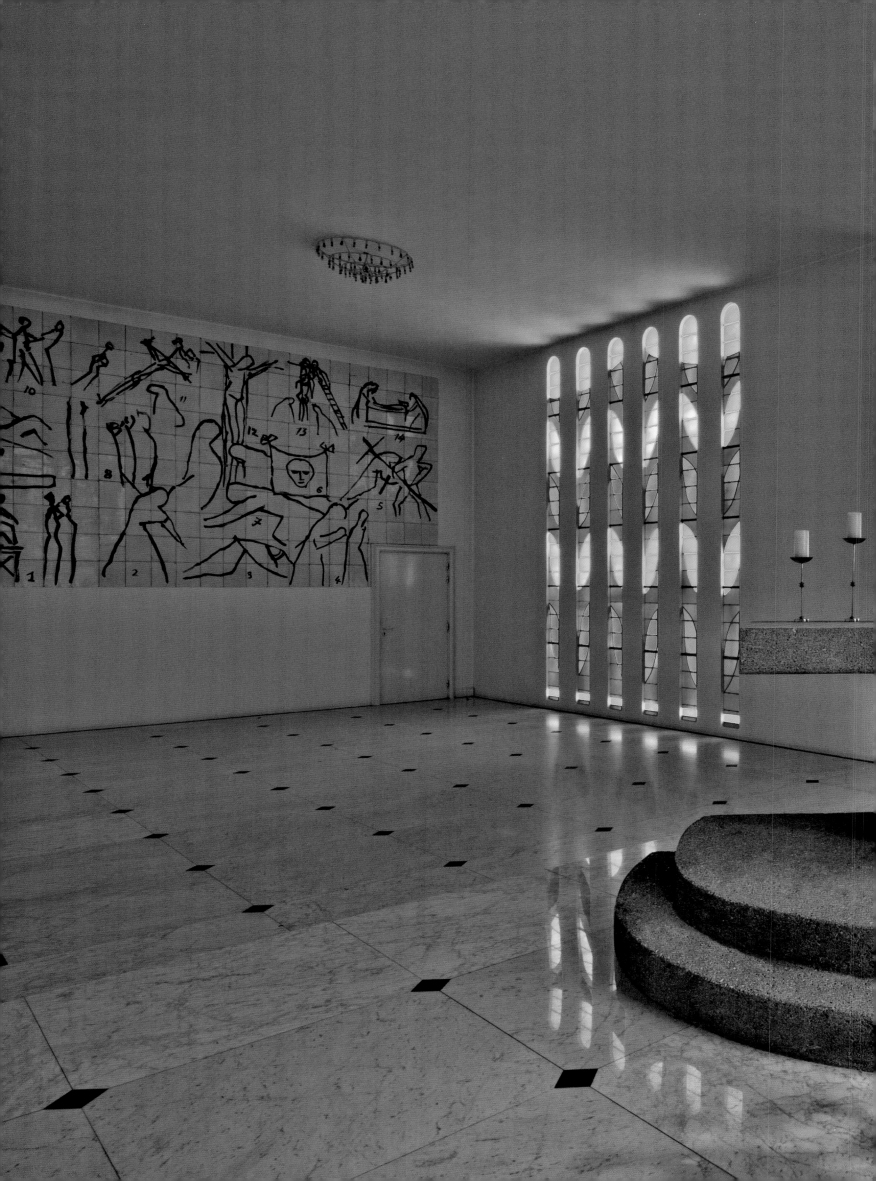

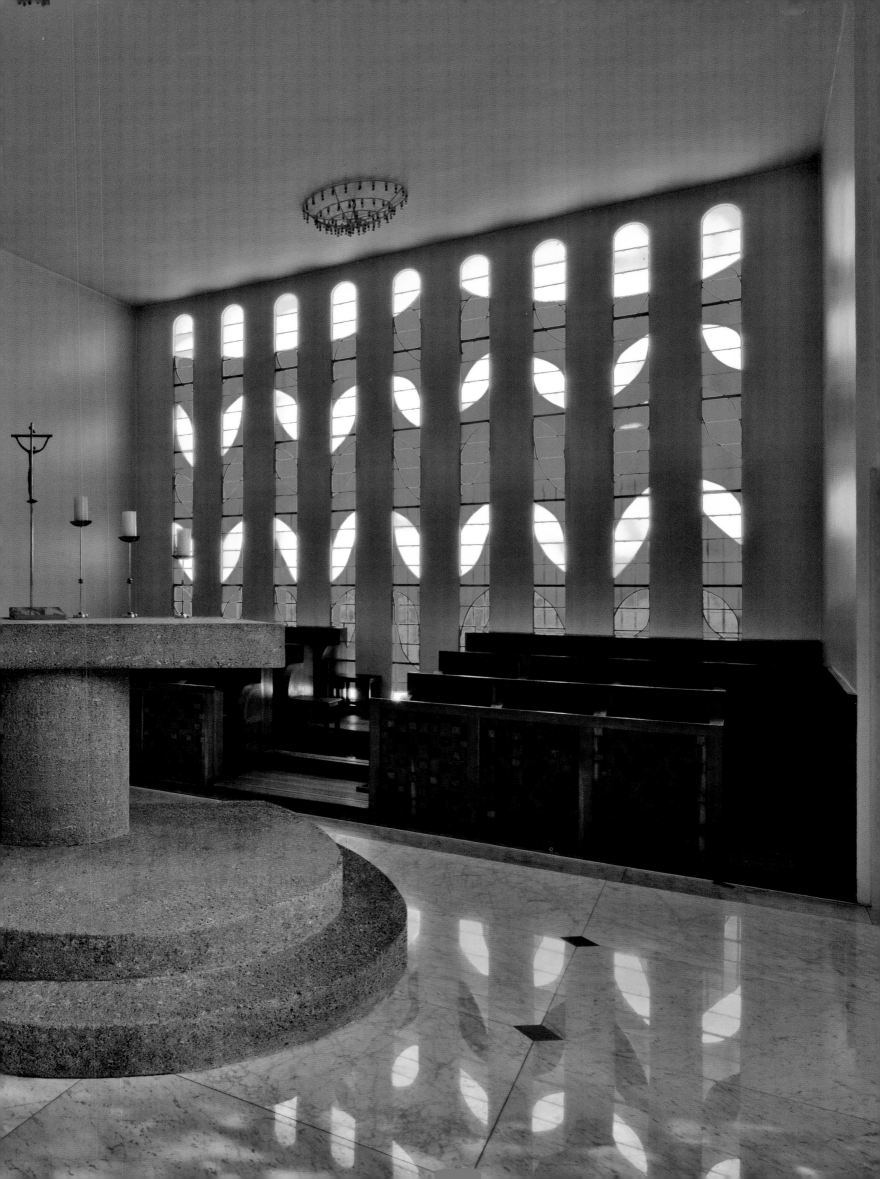

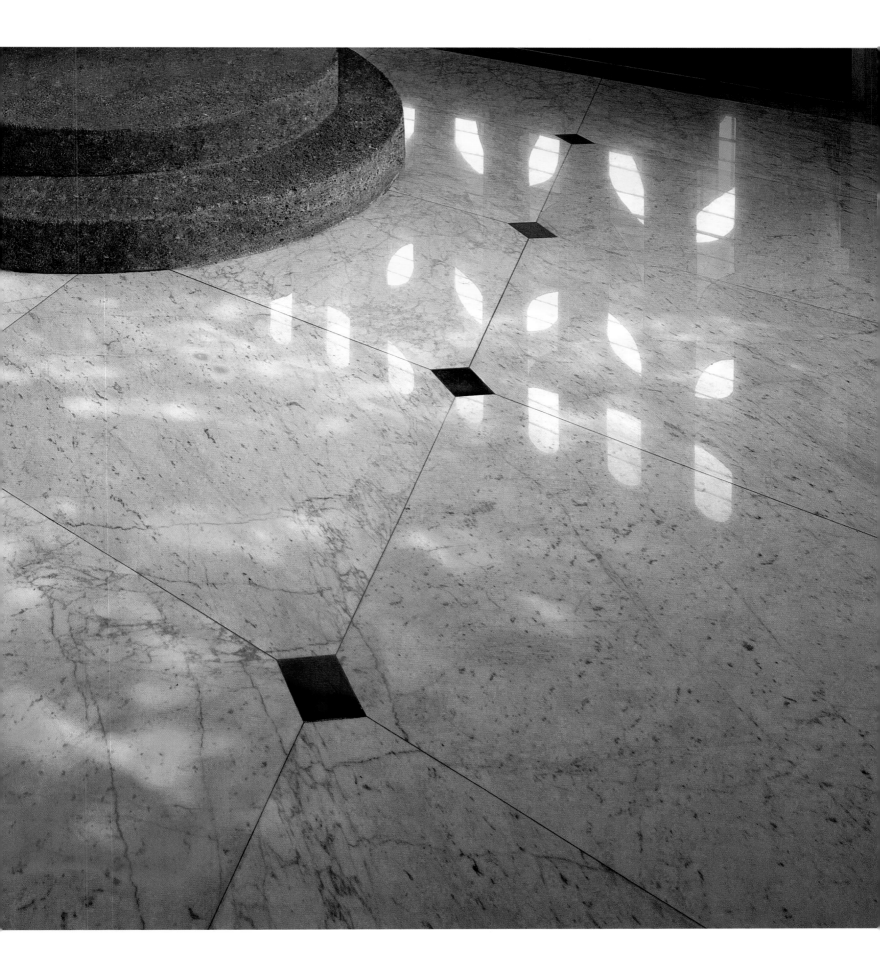

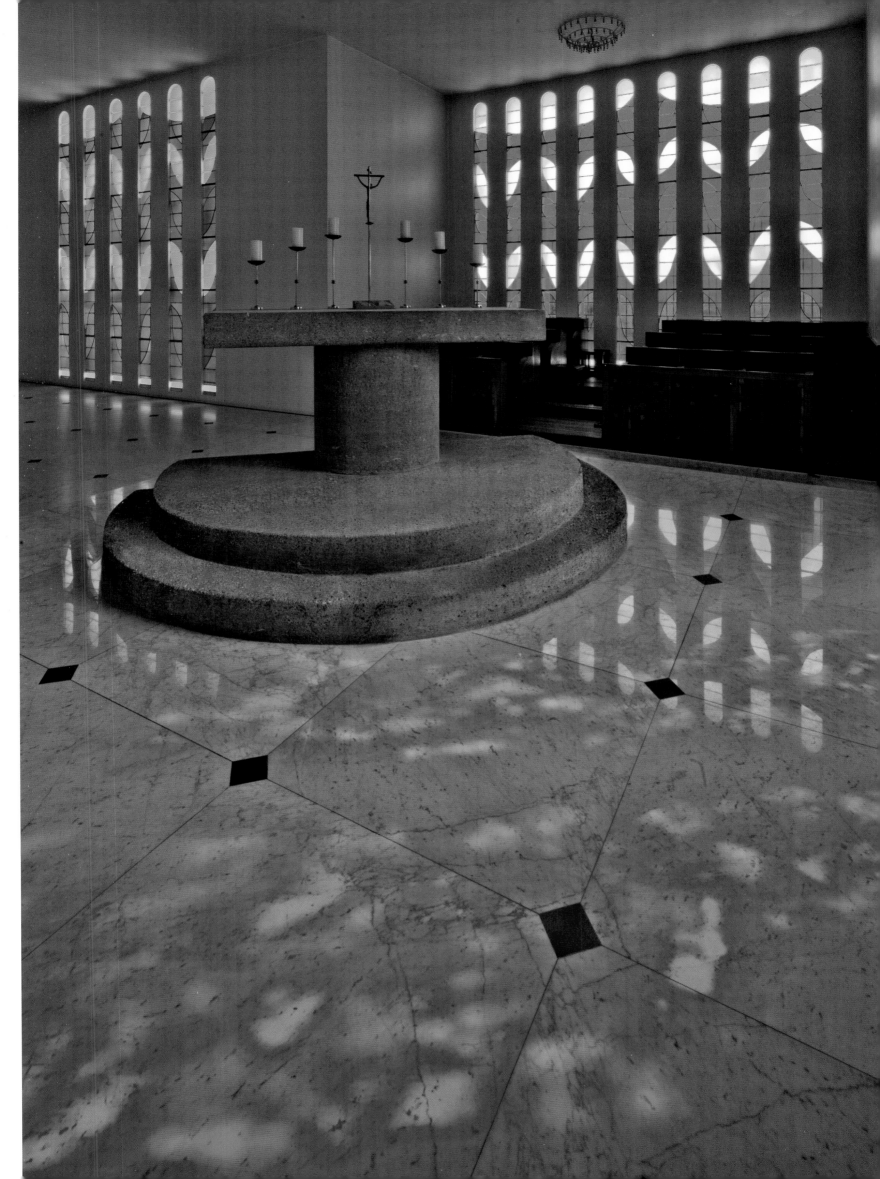

Transparency and Opacity

With the creation of the windows in the chapel, Matisse achieved his aim to use colour to generate light and space. Ultramarine blue, bottle green and lemon yellow combined in each window to introduce a dialogue with the black and white drawings on the ceramic panels: 'I have to juggle with two forces and hold them in a meaningful equilibrium, the colour of the windows on the right side and the black and white all over the left side.'[8] The contrast between the opacity and transparency of the different colours of glass was also the outcome of deliberate choice. '[The] yellow's lack of transparency blocks the spectator's mind, holding him in the chapel, [allowing him then] to go through the blue and green glass and get lost in the neighbouring gardens ... The yellow is matt and is thus only translucent, whereas the blue and green are transparent, therefore completely clear.'[9] The transparency of the blue and green glass allows a glimpse of the landscape outside.[10] The yellow glass, opaque and intense, represents the dazzle of divine light.

Unexpectedly, the sun's rays diffused through the three colours of the windows create a magenta glow in the white atmosphere of the chapel, like a reminder of the presence of God, which is traditionally symbolised by the red lamp left continually burning in churches. 'I have tried to achieve a balance of power; the blues, greens and yellows of the windows produce a light in the interior which is not strictly any of the colours employed, it is the living product of their harmony, of their reciprocal relationship.'[11] In spite of the difficulties he encountered during the decoration of the chapel,[12] Matisse ultimately succeeded in imposing his vision, which, depending on the time of day, unites the coloured reflections from the windows with the 'black line drawings'[13] of *St Dominic*, the *Virgin and Child* and the *Way of the Cross* on the panels of large white ceramic tiles.

Matisse drew on an ensemble of themes and colours for the windows – the six in the side aisles, the nine behind the nuns' pews and the main window behind the high altar – all of which came from the same fund of inspiration.[14] Through effects provided by the windows, Matisse transcends space and light, creating a spiritual space. The light coming through the main window and the aisle windows reminded Matisse of a 'whole orchestra of colours' on the floor and the white walls of the chapel.[15]

Beyond the spiritual space created within the chapel, the interplay of the window colours and their different levels of transparency give the landscape glimpsed through them the appearance of a separate reality, beyond the real world. 'This is how when you look from inside out, through the glass, a figure coming and going in the garden only a metre or so from the window looks like a figure from a world quite different from the world of the chapel.'[16]

'It could be said that art imitates nature: through the type of life that makes the work of art the work of a creator... The work will seem as fruitful, and be blessed with the same inner tremor, the same glowing beauty as is possessed by the works of nature.'[17]

[following pages]

The stained-glass windows along the choir

The stained-glass windows in the nave

Details of the *Tree of Life* window

The stained-glass window must have the effusiveness of an organ voluntary, there should be no need for words.[18]

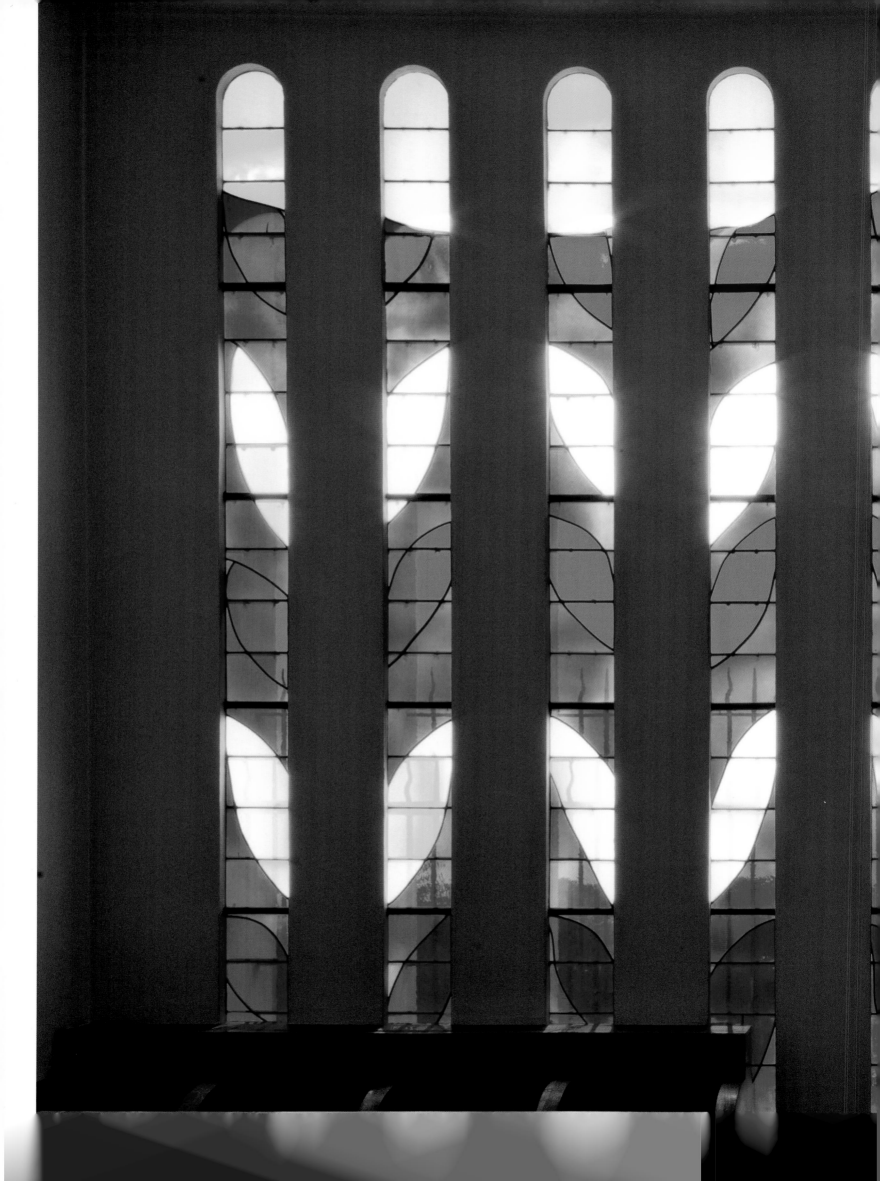

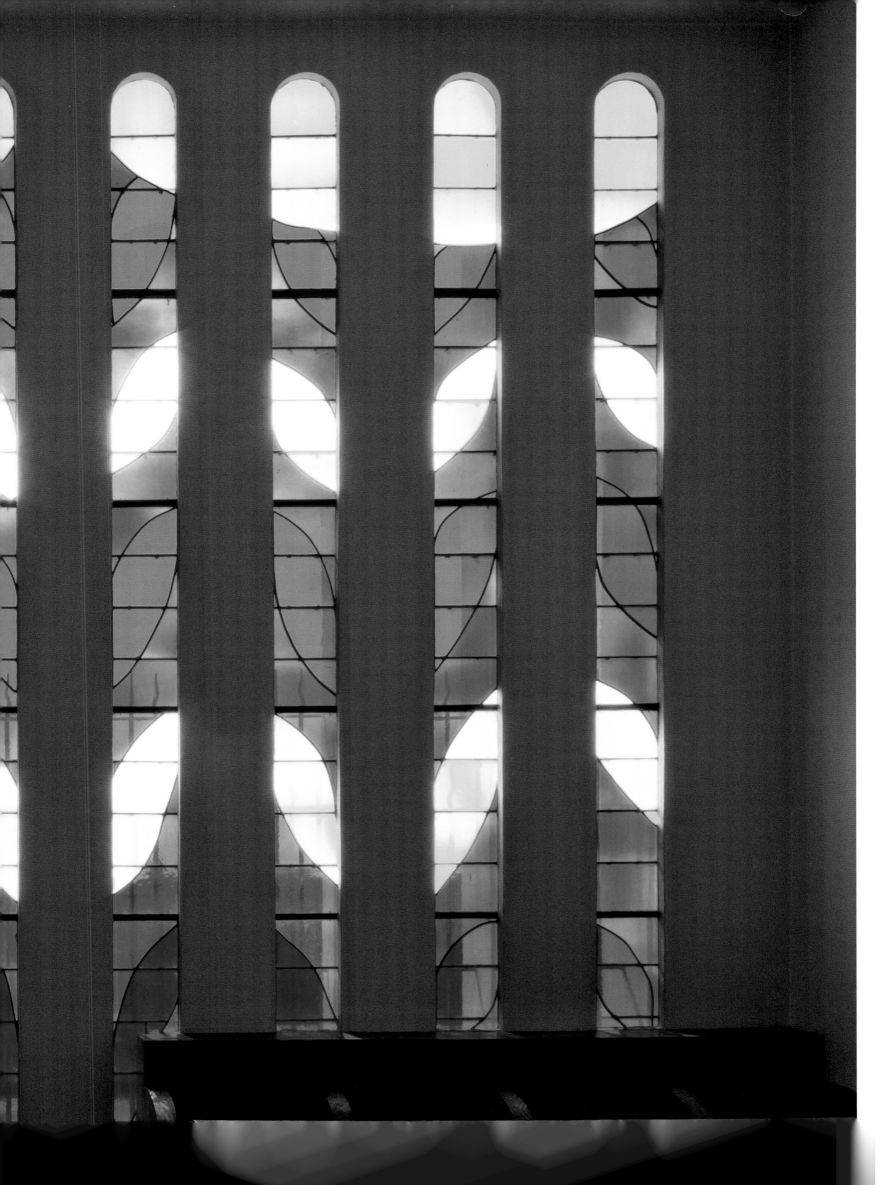

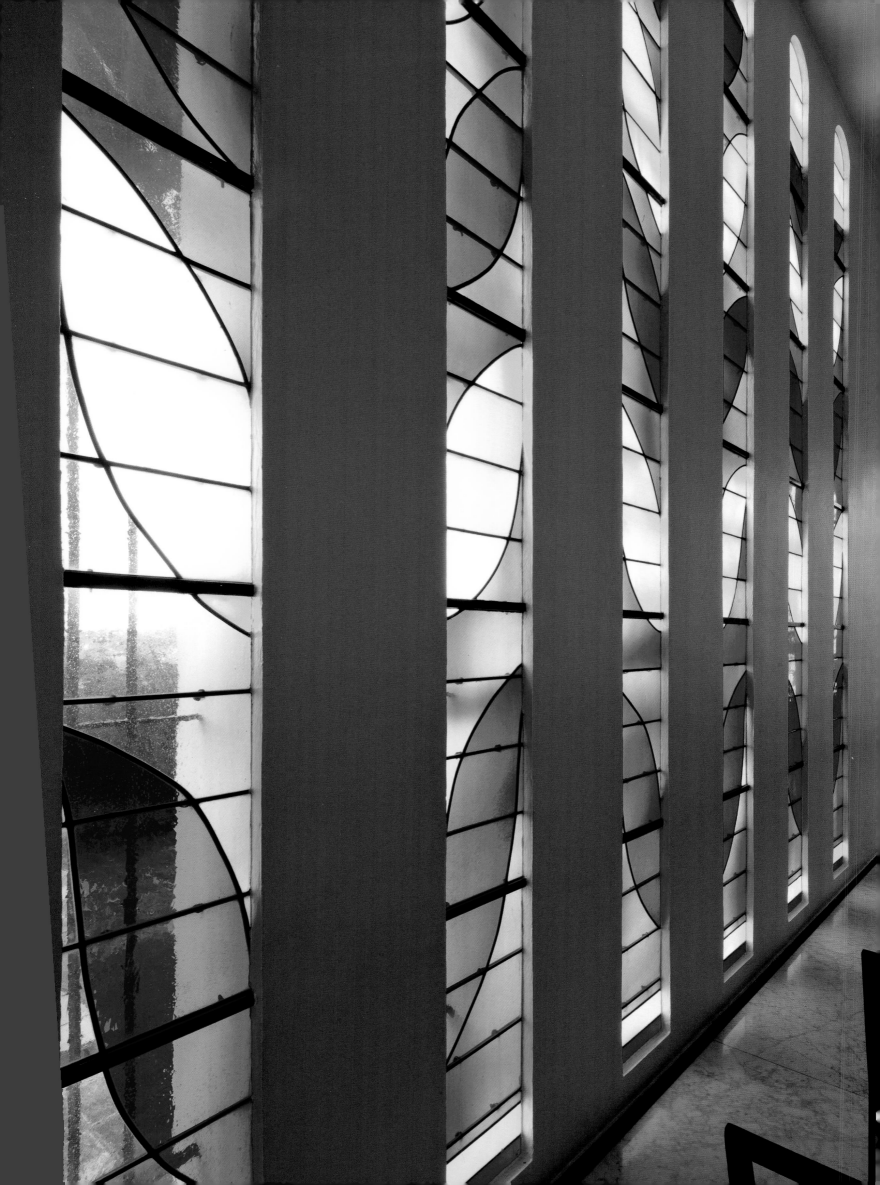

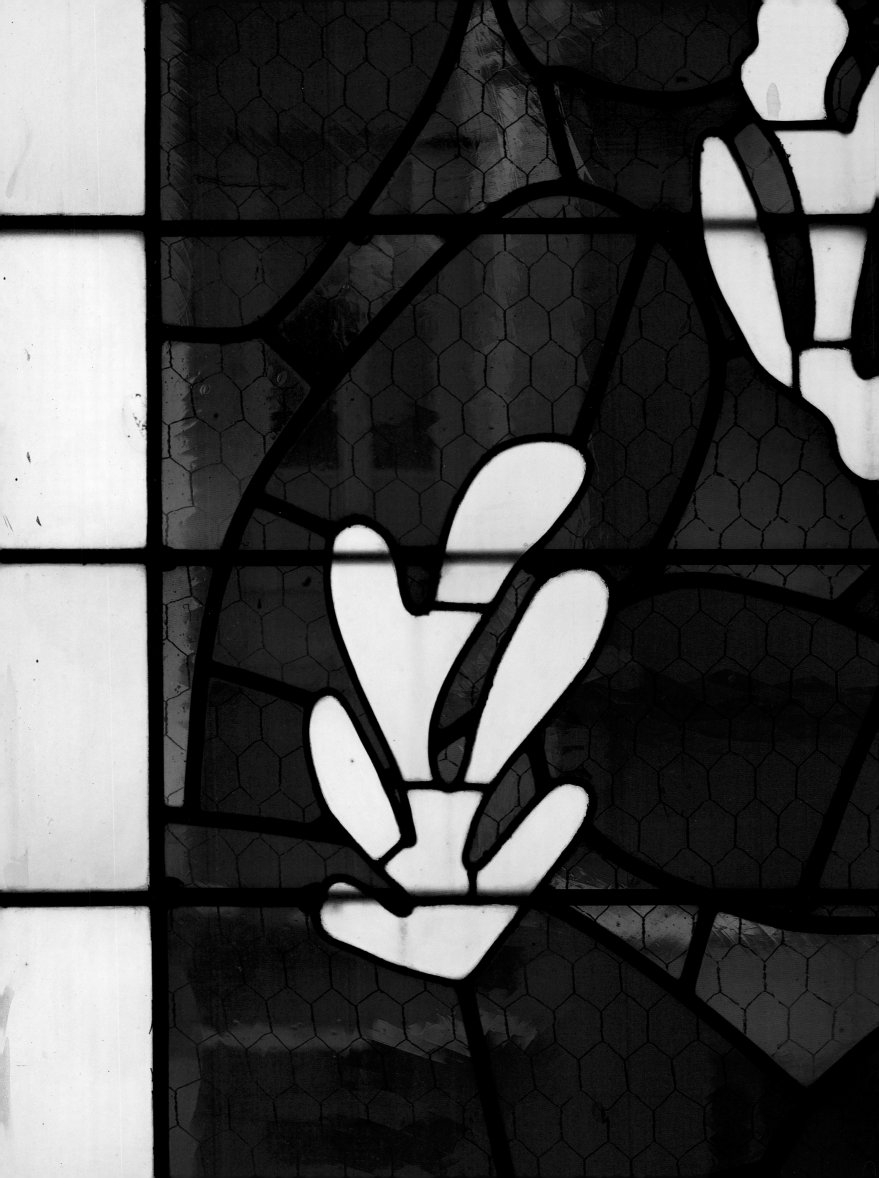

The Tree of Life Window

No figures, just the outline of forms.[19]

When the visitor enters the chapel, his or her gaze is held at once by the luminosity of the *Tree of Life* window, placed behind the high altar in a double arched window. Before deciding on the final pattern of the window, Matisse, as usual, made some preliminary studies and experiments, exploring various sources of inspiration. Two compositions in cut paper followed. Matisse eventually abandoned these, pursuing his wish to simplify forms and symbols. The first composition, designed in early 1948, was titled *Celestial Jerusalem*, and was to be the counterpart to another window depicting a swarm of bees, *Les Abeilles*. His vision of the ideal city of the future, descended from heaven, where justice and fraternity would prevail as described in the Apocalypse, is composed of geometric coloured surfaces in which five hues harmonise: red, mauve, yellow, green and blue. In 1949 Matisse went to work on a new composition, the *Pale Blue Window*. In this, plant forms stand out from geometric surfaces, reminders of Matisse's voyage to Tahiti. Matisse realised, however, that he had not paid enough heed to the technical constraints inherent in the setting of stained glass. He thus designed a new composition, in which the plant forms became yellow cactus flowers, a prickly pear with blue fleshy leaves symbolising the way life resists drought and death: 'a succulent plant mentioned in the Apocalypse: it lives and flowers in the dry desert and bears fruit there.'[20] The feeling of life inspired by plants in general is a feature of Matisse's work. In the forms and structures of foliage, fruit or flowers he finds the energy that enlivens his line. Observation and the power of motion give the forms created by his line a feeling of vitality. The finished work celebrates the artist's spiritual bond with nature; he gives it a new, unique identity. 'On a prickly pear no two leaves are alike, they are all different in shape; yet each one cries out: prickly pear.'[21]

Matisse remained close to the historical representation of the theme. The *Tree of Life* is presented as if it were a curtain, the curve of its hang can be seen at the top of the window. This decorative idea recalls the medieval tradition of the garden enclosure, and also the intensity and brightness of the colours of richly decorated tapestries.[22] Through this curtain-like design, the intimacy of the interior of the chapel is preserved.

In his journal, *Se garder libre*, Father Couturier records evidence of the considerable pains Matisse took with the windows: 'When for the second time Matisse abandoned the big cartoon for the window behind the altar in Vence … it was obvious that he had no new idea, did not know at all what he was going to do. "I shall probably apply a spot of colour and everything else will follow." He always insisted loudly (but like a manual labourer, unsystematically) on the "living and vital unity, organic, of the work of art in progress." '[23]

In the journal, Father Couturier also quotes Matisse as saying: 'I wanted to create a spiritual space in small premises', adding his own comment: 'Matisse is [thinking of] an infinite space … '[24] This search for the liberation of perspective is expressed through the lightening of forms and symbols. The whole concept of the chapel is a response to this requirement. Thus, according to the light, a visual space is created. The reflection of the window on the marble creates a delicate, fleeting reality through the re-echoing of the colours. This unexpected effect gives the chapel a mysterious and meditative quality, which opens the space and the spirit in a symbolic manner, adding to the transcendental and spiritual emotion the chapel can inspire.

[following pages]
The *Tree of Life* window, a complete view and details

It could be said that art imitates nature: through the type of life that makes the work of art the work of a creator ... The work will seem as fruitful, and be blessed with the same inner tremor, the same glowing beauty as is possessed by the works of nature.[25]

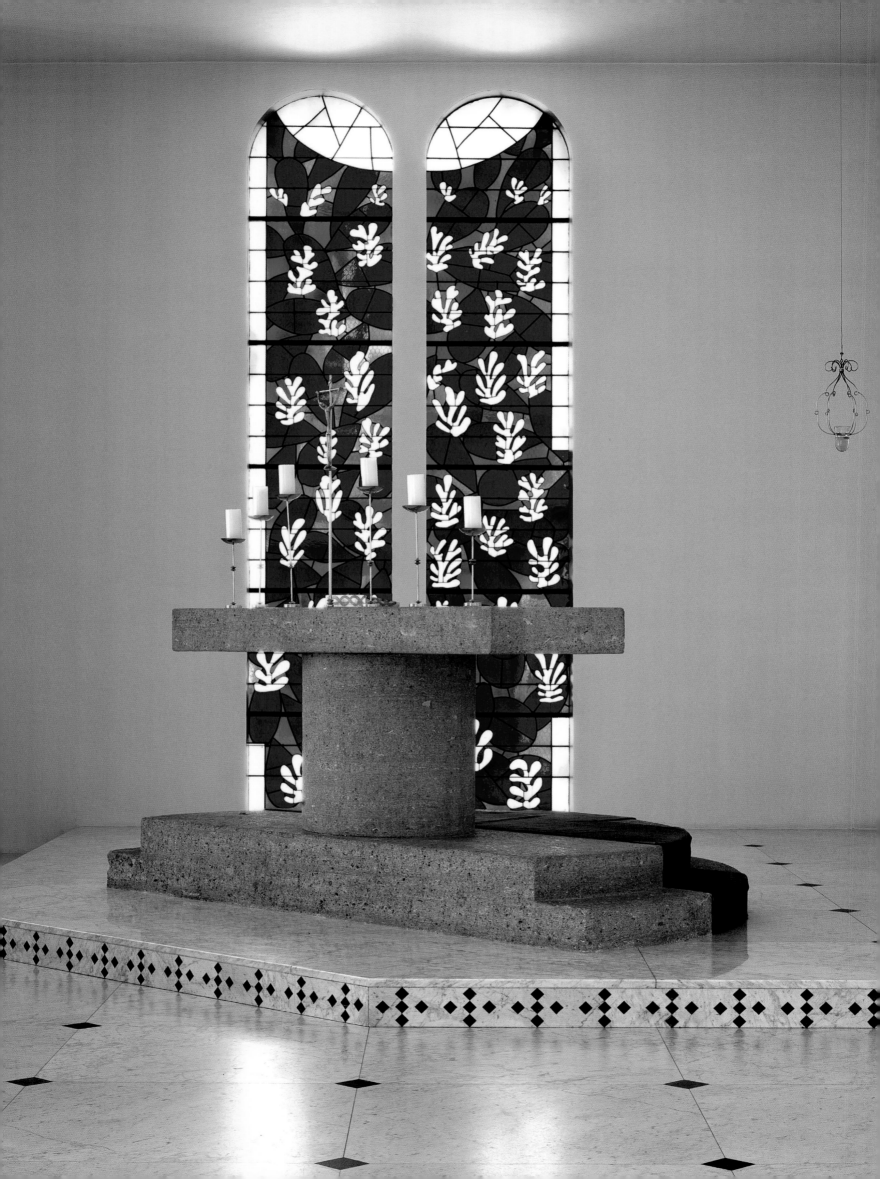

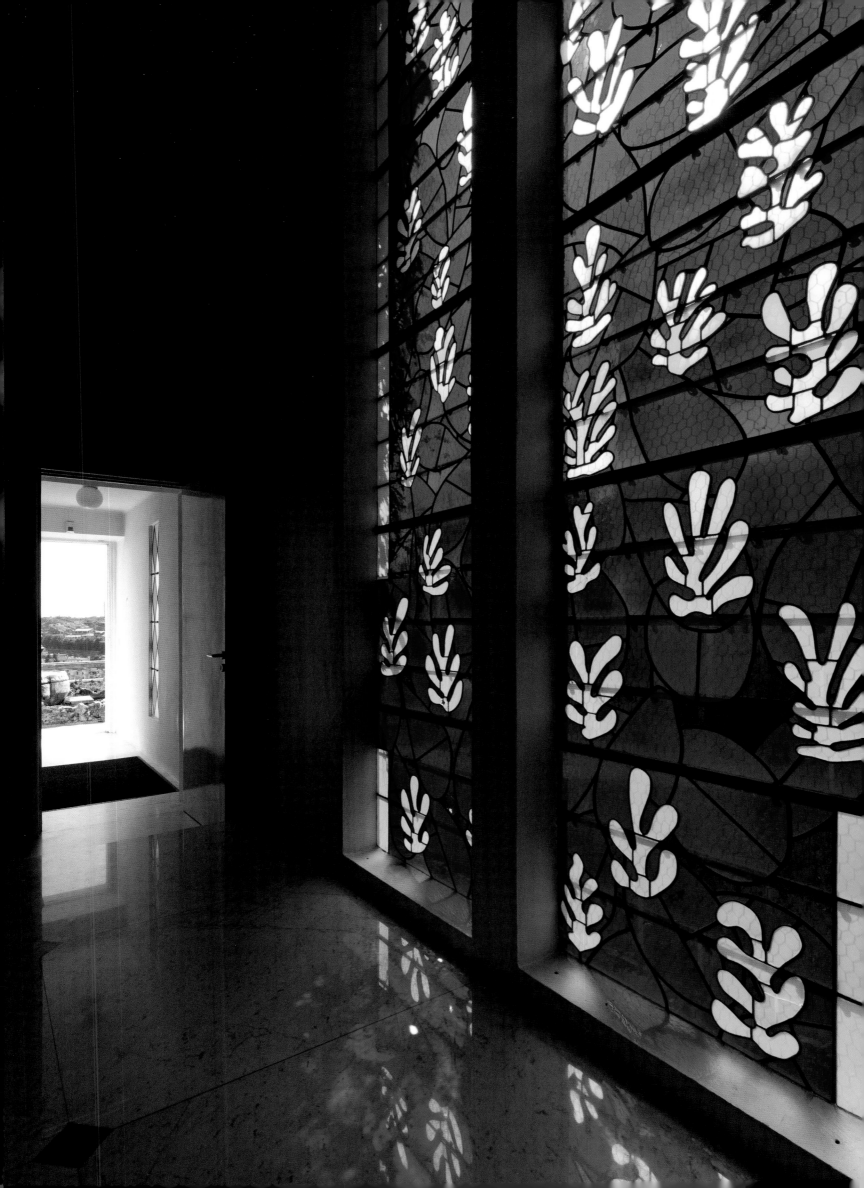

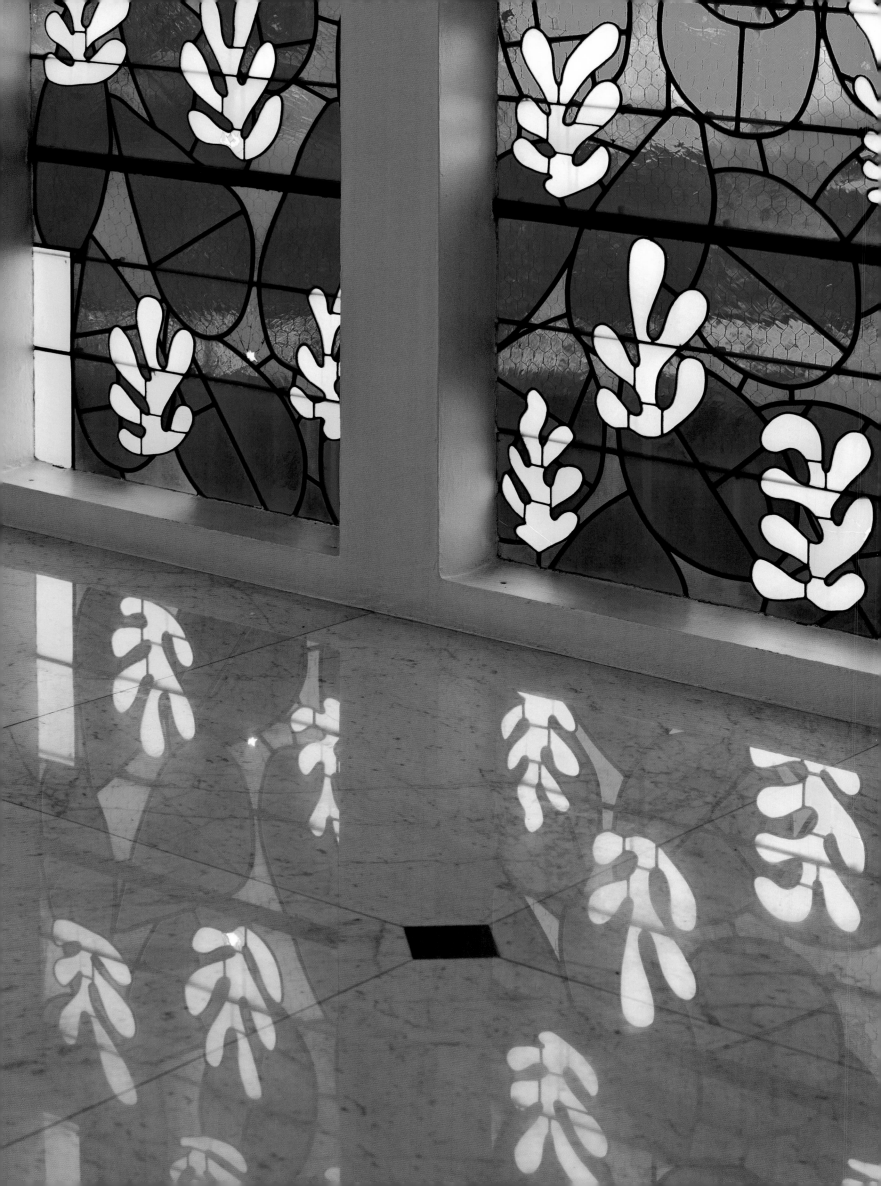

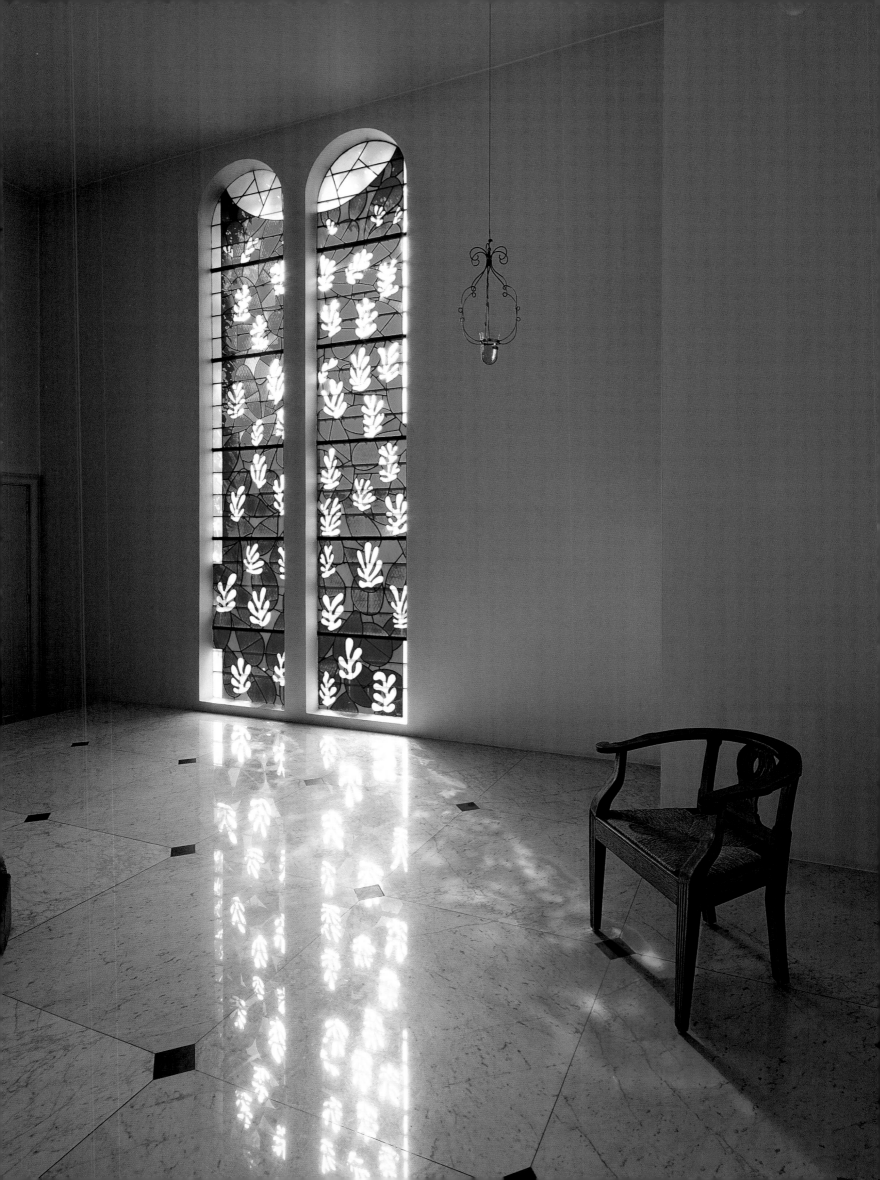

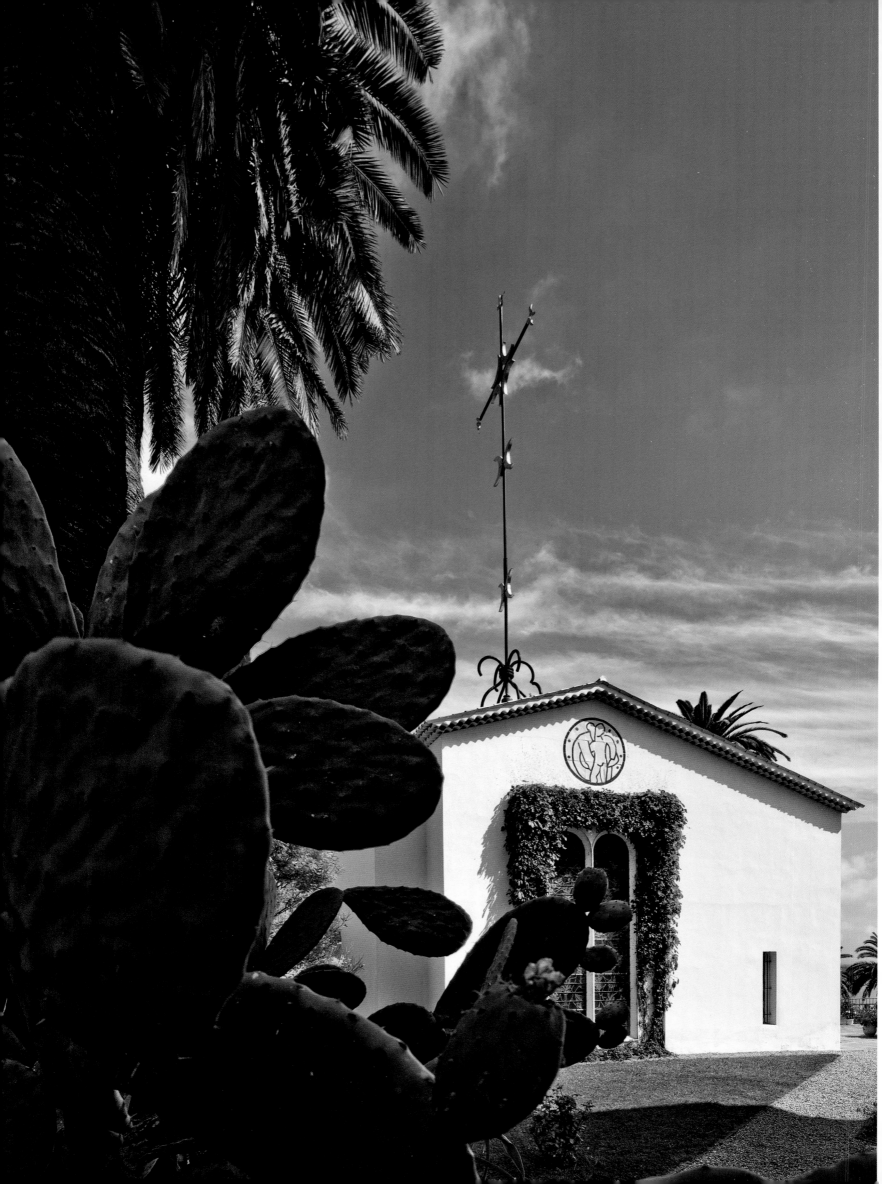

The Fish Window

At the entrance to the chapel, Matisse created a window with a symbolic message. It depicts a fish caught in a net. Looking upwards towards a blue star, the fish can be interpreted as representing the human being trying to free himself from material ties.

At the beginning of 1950 Matisse talked to Father Couturier about the possibility of making 'a white window with these items – at the top a blue star … below and behind the subject the suggestion of a net in front of a fish. I need a net to make squares. Can I symbolise Christ with a fish in front of a net – can the net symbolise the trials undergone by Christ?'[26] To create this window, Matisse worked on opalescent glass on which the lines of the net stand out. In a letter he protests to the glazier Paul Bony about the brightness of the glass, and expresses his hope that the windows can be finished in time for the inauguration of the chapel.[27]

During this period, Matisse also designed windows for other locations, for example *Chinese Fish* (1951) for the dining room in the villa of the publisher Tériade, and *The Vine* (1951), for the house of his son Pierre at Saint-Jean-Cap-Ferrat.

[opposite]
The northwest façade of the chapel with the campanile

[following pages]
The *Fish* window at the entrance for the congregation and visitors, detail and complete view

The work of art is the manifestation, the projection of self. My drawings and paintings are fragments of myself. Together, they constitute Henri Matisse. The work represents, explains, perpetuates … An artist must thus force himself from the start to express himself totally, in full … If he is sincere, human and creative, he will always find an echo in subsequent generations.[28]

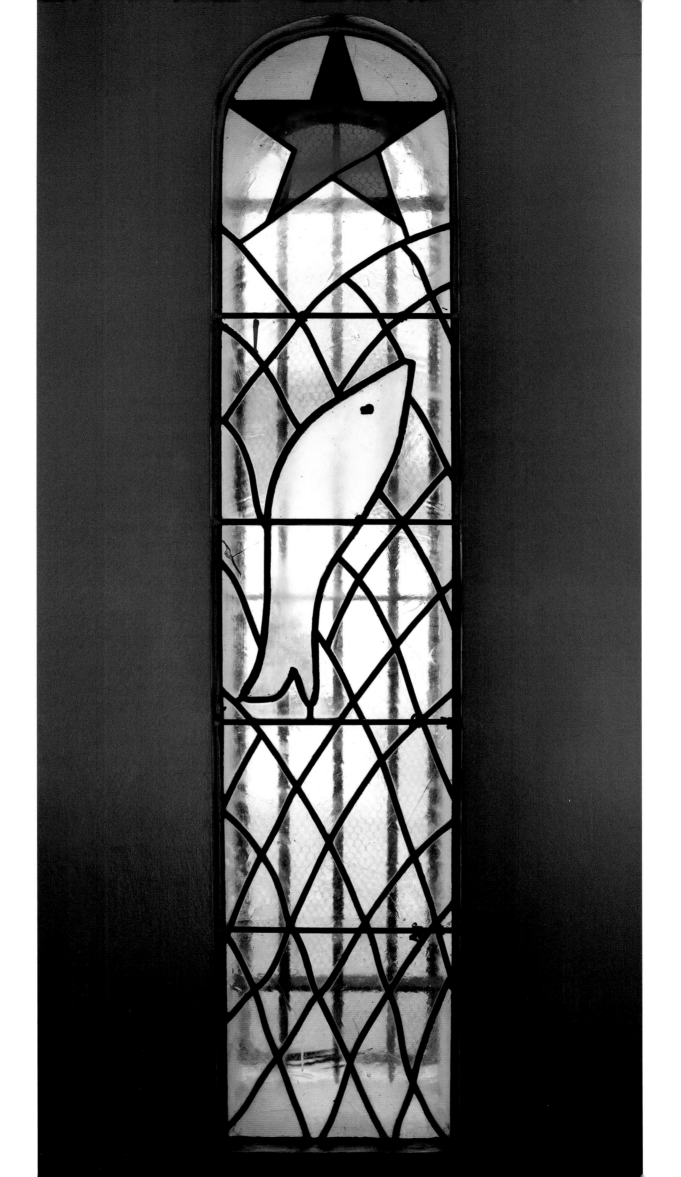

The Priest's Vestments

The chasubles, stoles and maniples worn by the priest play an important part in the decoration of the Vence chapel. These priestly garments are all of different colours, designed for different seasons in the church calendar – from Advent to Whitsun. With his body language and in his sacerdotal garb, the priest plays an important part in the interior of the chapel.

Matisse asked Father Couturier about tradition as it related to vestments: 'I need your advice about liturgical vestments. What colour are chasubles?'[29] The priest replied: 'The colours of the different chasubles are: white, green, red, violet and black. Also, if you like, for the most important festivals, gold.'[30] On 12 November 1951 Father Couturier assured Matisse that he could feel completely free in his design of the chasubles: 'The liturgical regulations do not specify any special kind of ornamentation.'[31]

Armed with this information, Matisse made a great number of studies in cut paper, producing 22 full-scale models for six chasubles. Each study is composed of the front and back of the chasuble, with its accessories: stoles, maniples, offertory bags, chalice cloths and purses in colours corresponding to the liturgical season: white, black, green, red, violet and pink.[32] Matisse styled the back and front of each chasuble with a central division consisting of a decorative vertical band surmounted by a cross. He returned to the world of familiar shapes for the decoration of these vestments. Always mindful of the criteria of liturgy and tradition, he created a new group of motifs inspired for the most part by plant and animal forms, in particular by the waterweeds of the lagoons of Tahiti. Memories of his voyage to Tahiti cover the vestments 'in the form of obsessive images: coral, fish, birds, jellyfish, sponges'.[33] Stars, fish, palm leaves and ears of wheat also take on symbolic meaning. The motifs are designed to open out on the priest's shoulders and accompany his movements; symmetry is provided by the central motif and the cross placed on the front and back of the chasuble. Greatly simplified, these designs belong to the group of 'signs' through which Matisse expresses what he termed 'fundamental truth'. Describing this idea, he stated: 'There exists … a fundamental truth to be released from the appearance of the objects to be represented. This is the only truth that matters.'[34] Matisse gives each of his vestments the power and depth to create emotion. The direct relationship between liturgical meaning and emotion gives the celebrant who is wearing the vestment during a service the symbolic value of sacred time.[35]

The amply cut chasuble has a relationship with the space of the chapel. It becomes an animated link between the colourful compositions in the windows and the graphics of the panels depicting *St Dominic*, the *Virgin and*

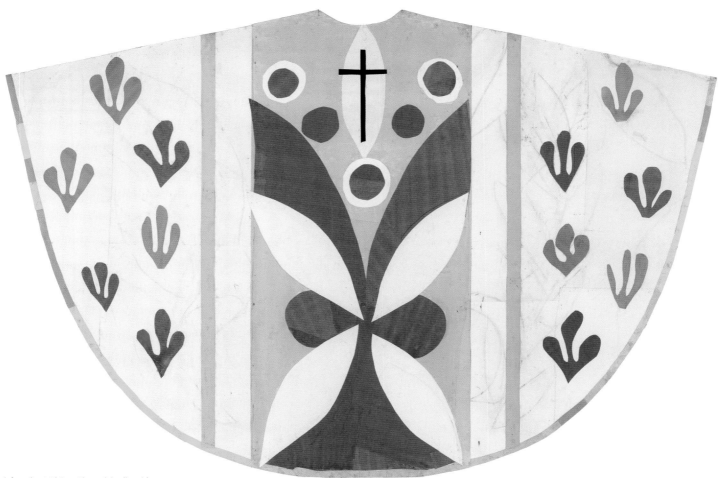

Model for the White Chasuble (back)
Study for the Ecclesiastical Vestments of the Vence
Chapel, 1950–52
Cut coloured paper, glued and mounted on canvas
Musée Matisse, Nice

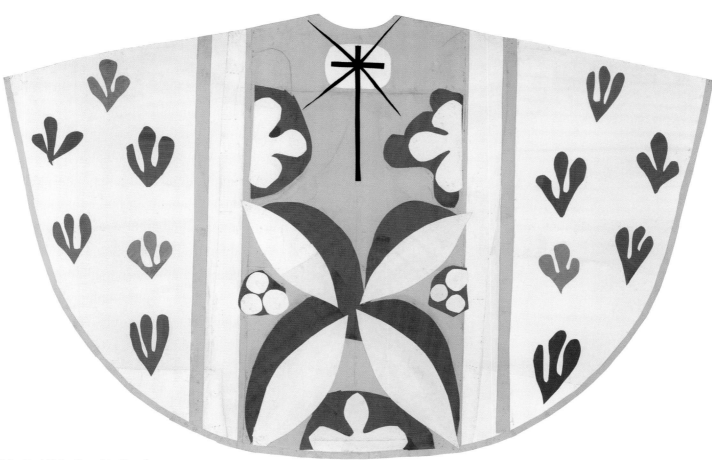

Model for the White Chasuble (front)
Study for the Ecclesiastical Vestments of the Vence
Chapel, 1950–52
Cut coloured paper, glued and mounted on canvas
Musée Matisse, Nice

173

Model for the Pink Chasuble (back)
Study for the Ecclesiastical Vestments
in the Vence Chapel, 1950–52
Cut coloured paper, glued and
mounted on canvas
Musée Matisse, Nice

Model for the Pink Chasuble (front)
Study for the Ecclesiastical Vestments
in the Vence Chapel, 1950–52
Cut coloured paper, glued and
mounted on canvas
Musée Matisse, Nice

[following pages]

**White Chasuble, Ecclesiastical
Vestment (front and back)**
Silk
Chapel of the Rosary, Vence

**Pink Chasuble, Ecclesiastical
Vestment (front and back)**
Silk
Chapel of the Rosary, Vence

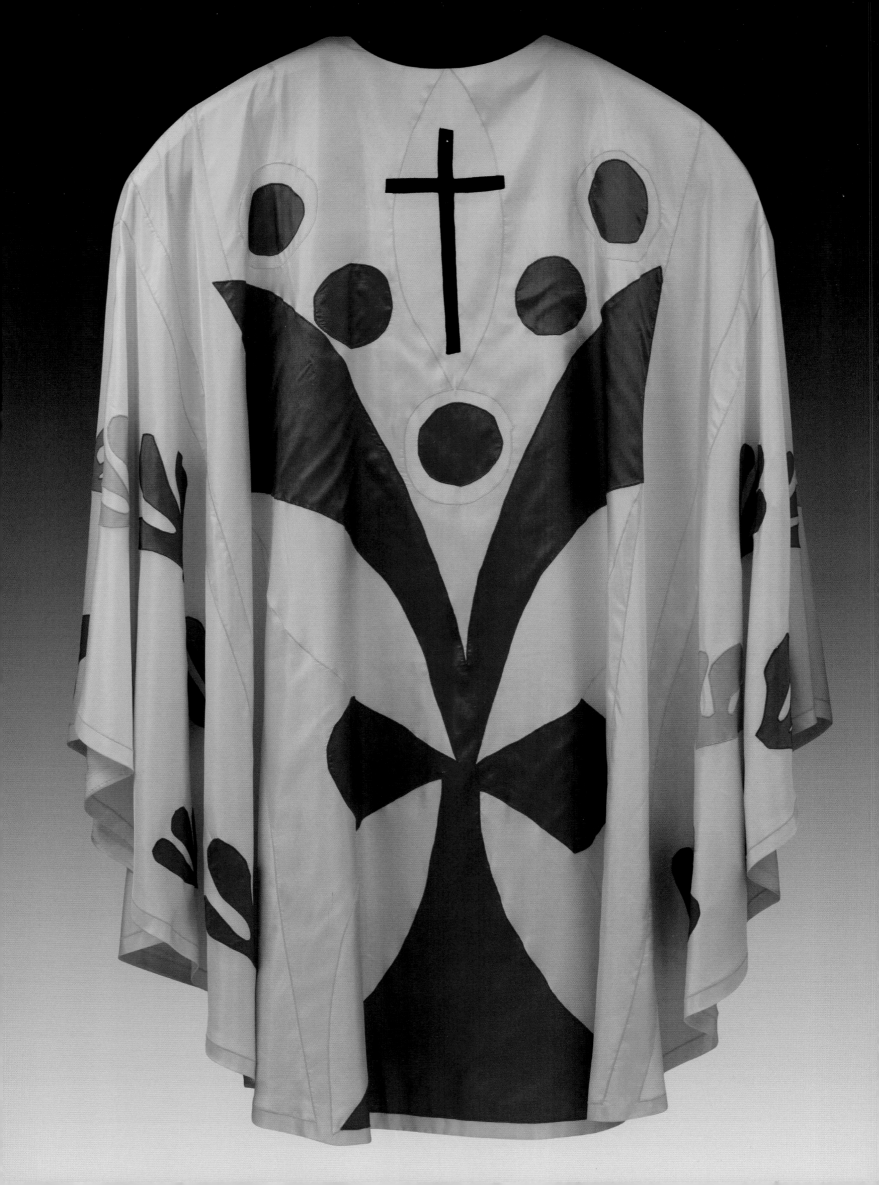

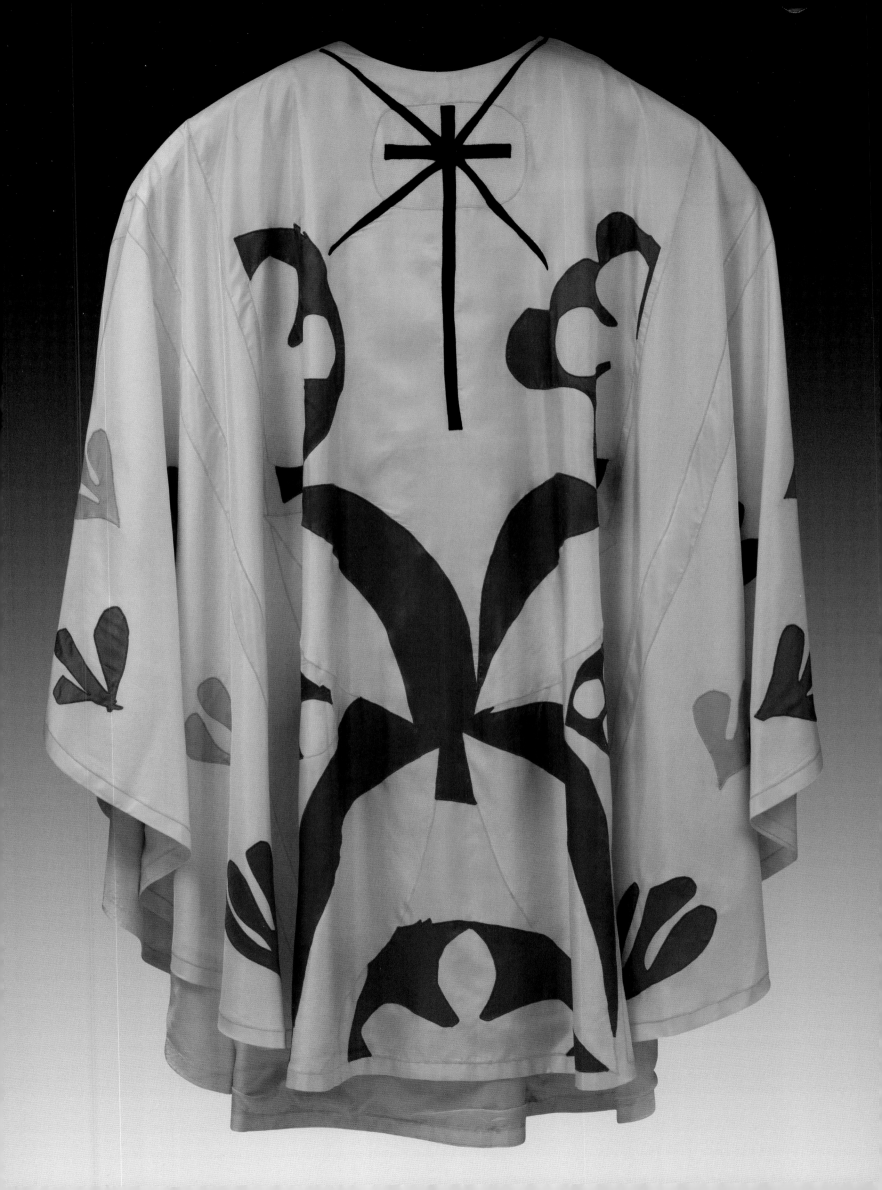

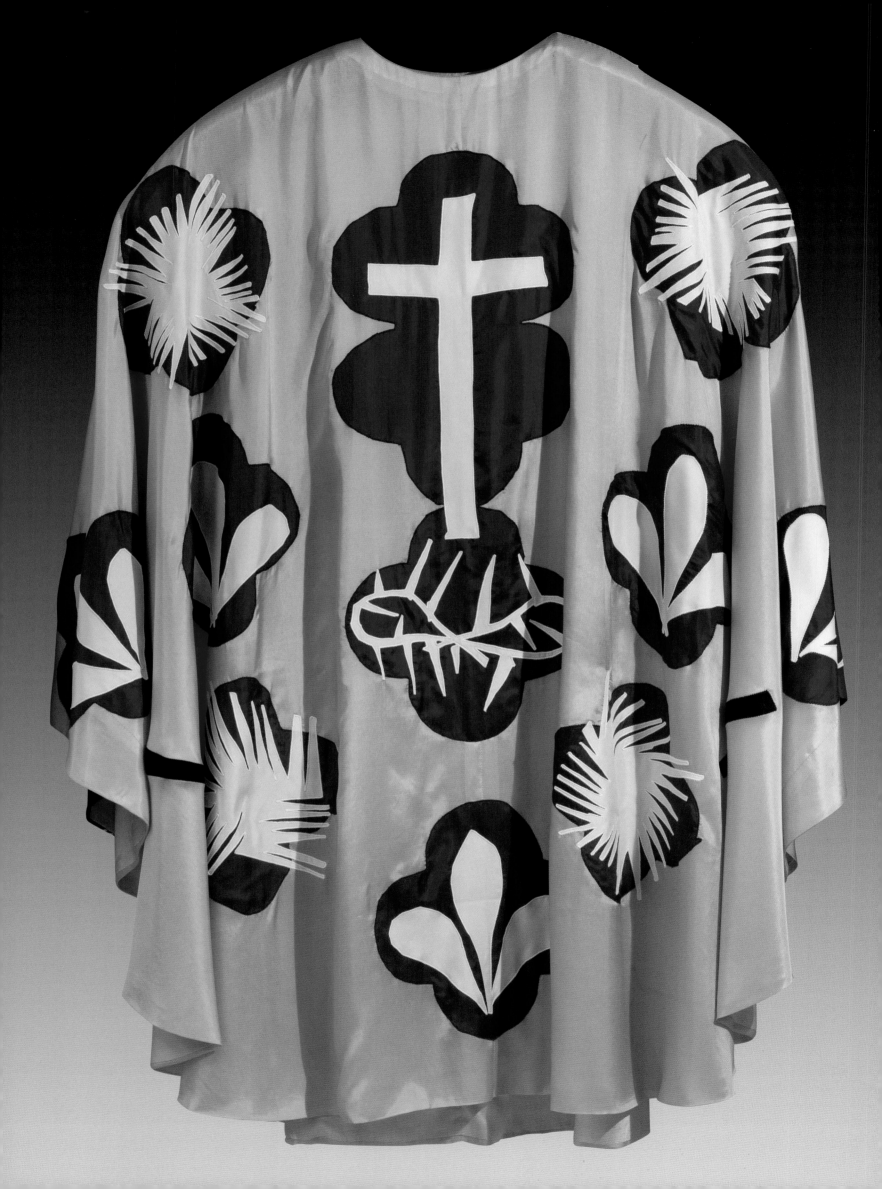

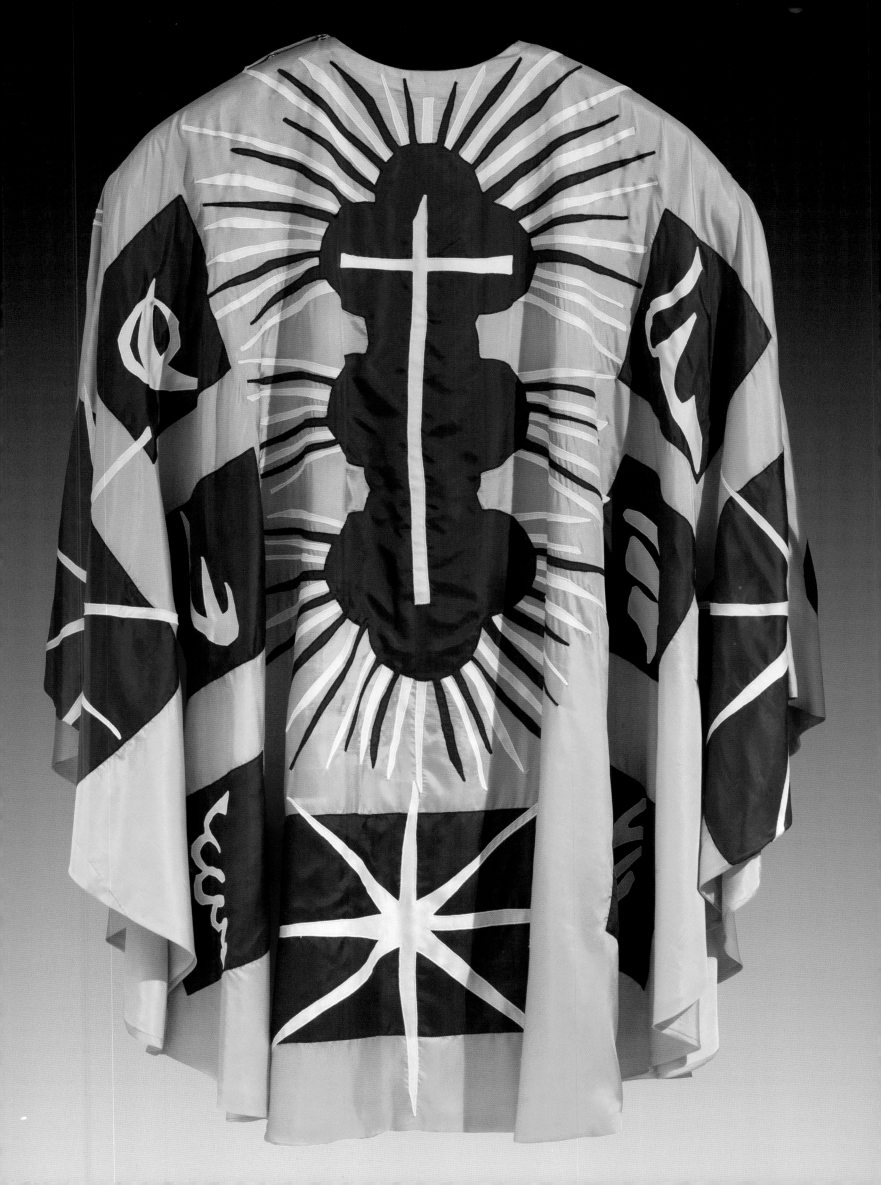

Child and the *Way of the Cross*. The vestment is no longer simply a decorated item of clothing – it creates a new dimension within the chapel. The colours start to move and life is injected into it, as Matisse wished.

The vestments were made using various fabrics chosen for their colour rather than for their texture, forming a kind of patchwork. Matisse supervised the transfer of his designs very carefully in the studio of applied art belonging to the Dominican nuns in Cannes; some vestments were also stitched by the congregation of Crépieux-le-Pape.

Six of the vestments are now kept in the sacristy of the Vence chapel. The colours have faded over the years, but in order to return to the original colours, and inspired by their experience of the creation and manufacture of the original priestly garments, Sister Jacques-Marie and Lydia Delectorskaya, Matisse's former assistant, decided to have a new set made, using the cut-paper patterns that are in the Matisse archives in Paris, and with the financial support of the Maeght family.

A Light in the Darkness

I believe that one day easel painting will cease to exist because of changing habits. Mural painting will continue to exist. Colours gather you in more and more. This blue enters your soul. That red affects your blood pressure ... It's the concentration of tone. A new era is opening.[36]

The role that each colour plays in calling forth particular emotions is one of the most important features of Matisse's work. The artist produced a number of designs for the windows of the Chapel of the Rosary, varying the layout of the forms and the associations of colours in the search for an incandescent light effect.

The cut-paper model entitled *The Bees* (1948) was one of these studies, made by Matisse as a design for the windows on the southwest wall of the chapel.[37] In this composition, squares of yellow, red and blue form two arcs upon which the bees are placed. Formed of black and white squares recalling the colours of the Dominican nuns' costumes, and echoing their reputation for hard work, the bees fly about in a bright field of flowers, in a scene that is both poetic and symbolic. The warm colours and the subject of this first attempt were, however, abandoned.[38] Matisse was looking for something more serene than the *Bees* window, and eventually opted for a design whose brightness would encourage meditation. He used colour to support his new vision of a place of worship.

Today, another dimension is added to Matisse's carefully designed colour effects: the possibility of seeing the chapel lit up at night. Illuminated inside for certain services, concerts and lectures, the chapel now stands out, glowing in the landscape of Vence.

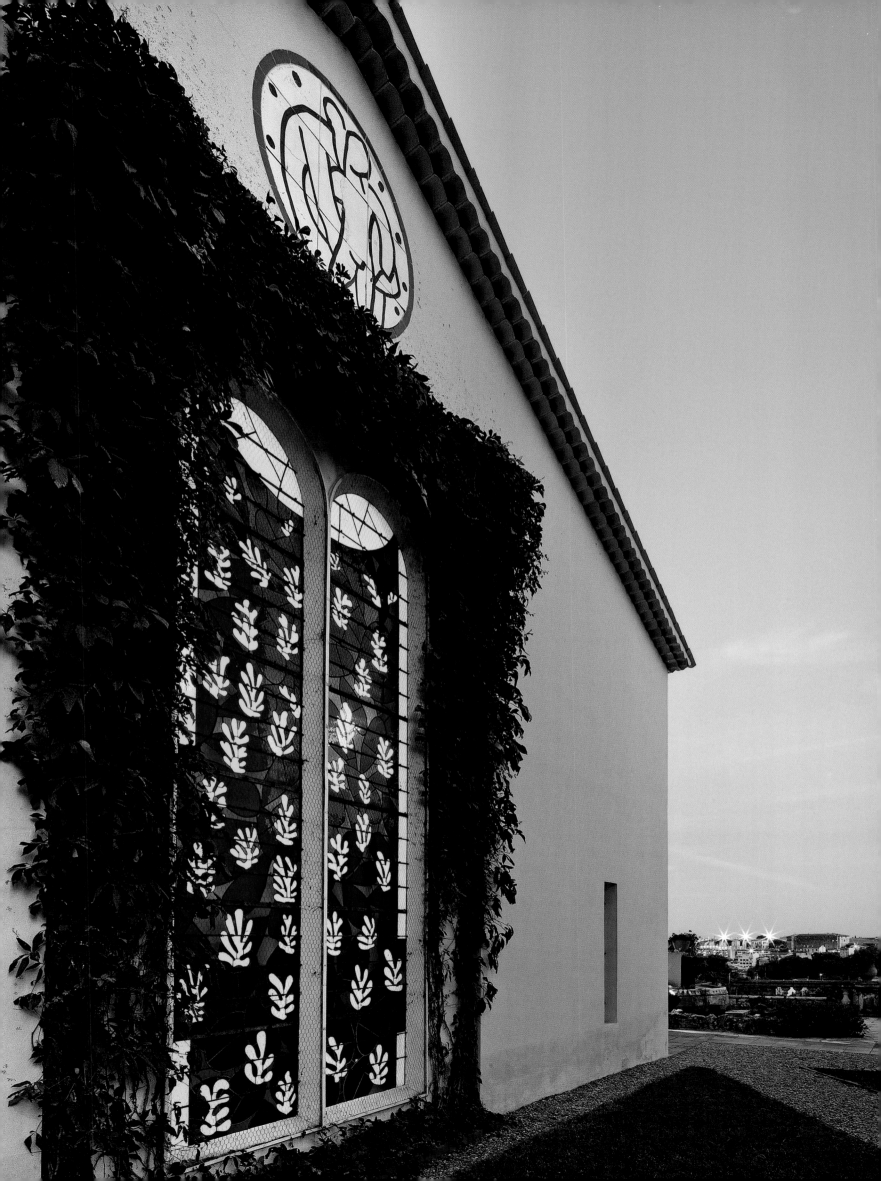

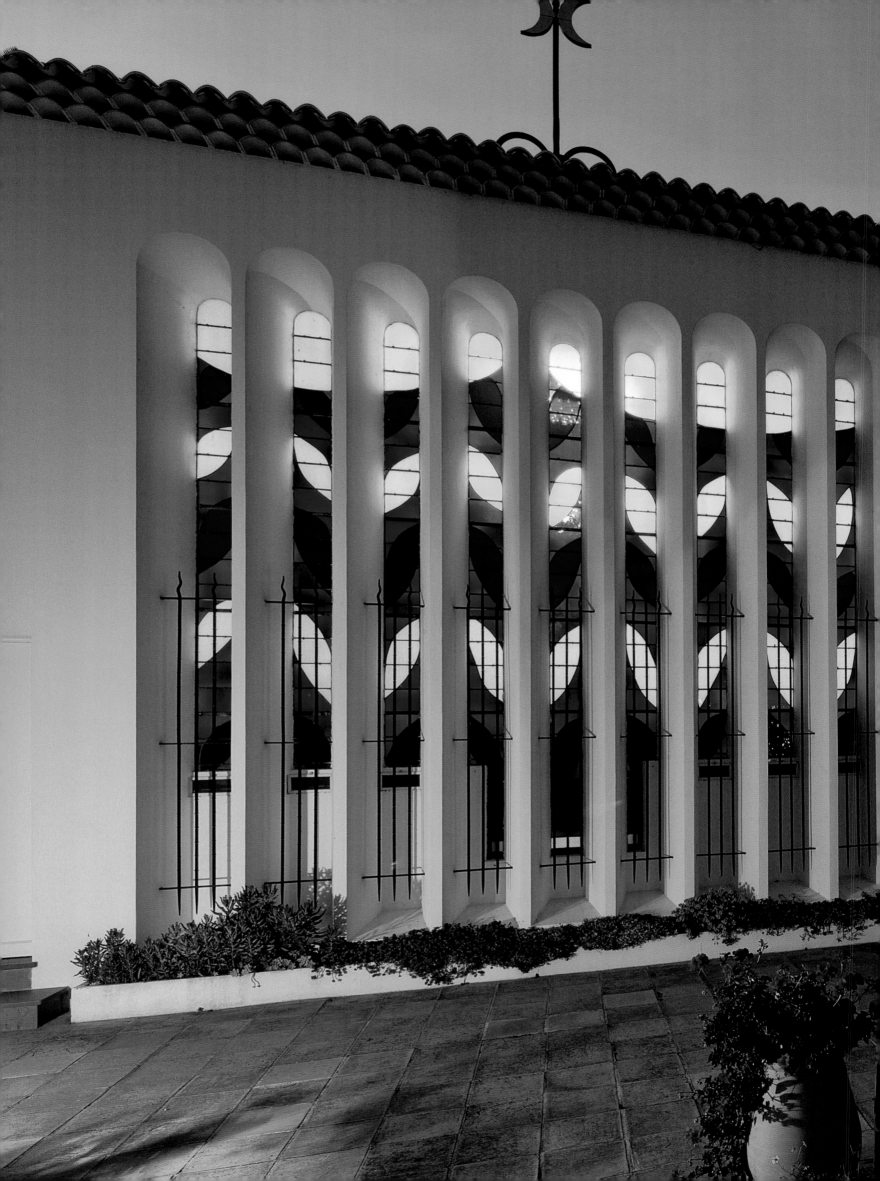

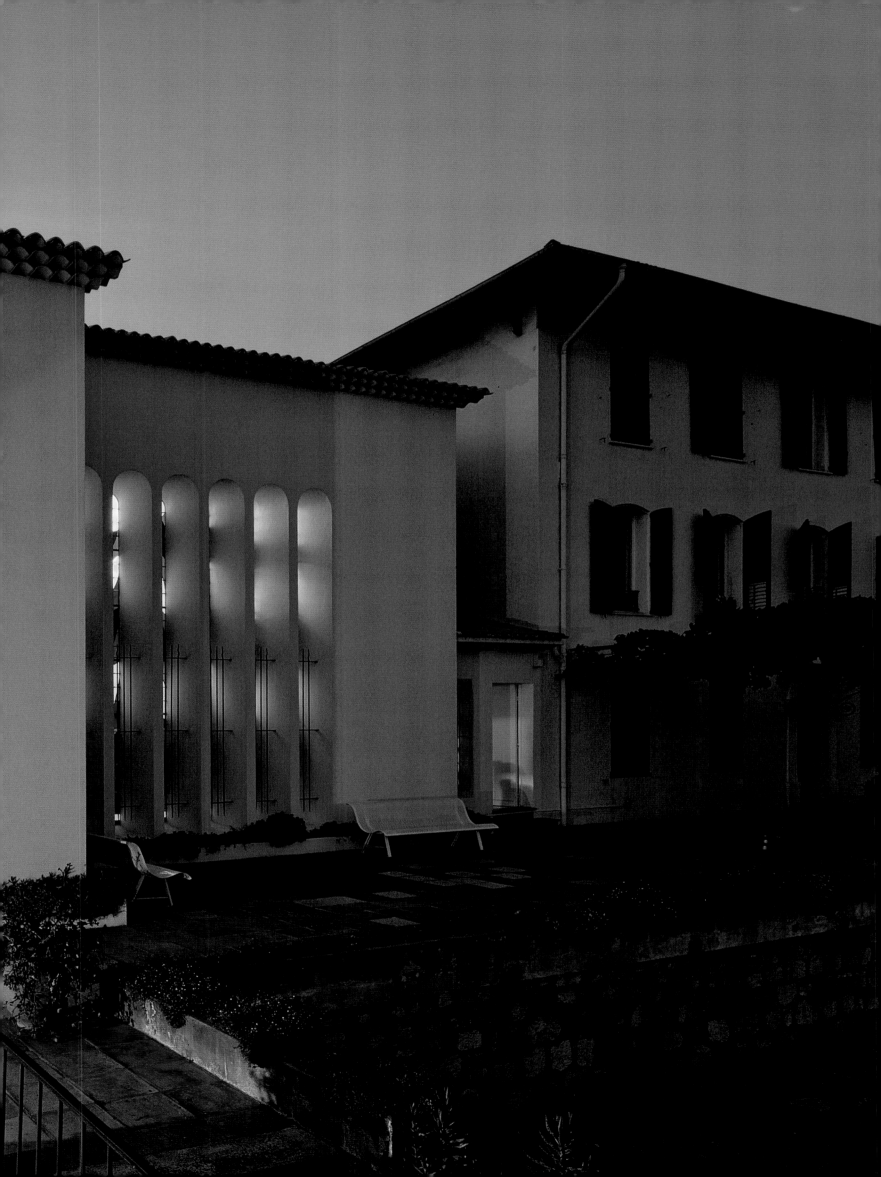

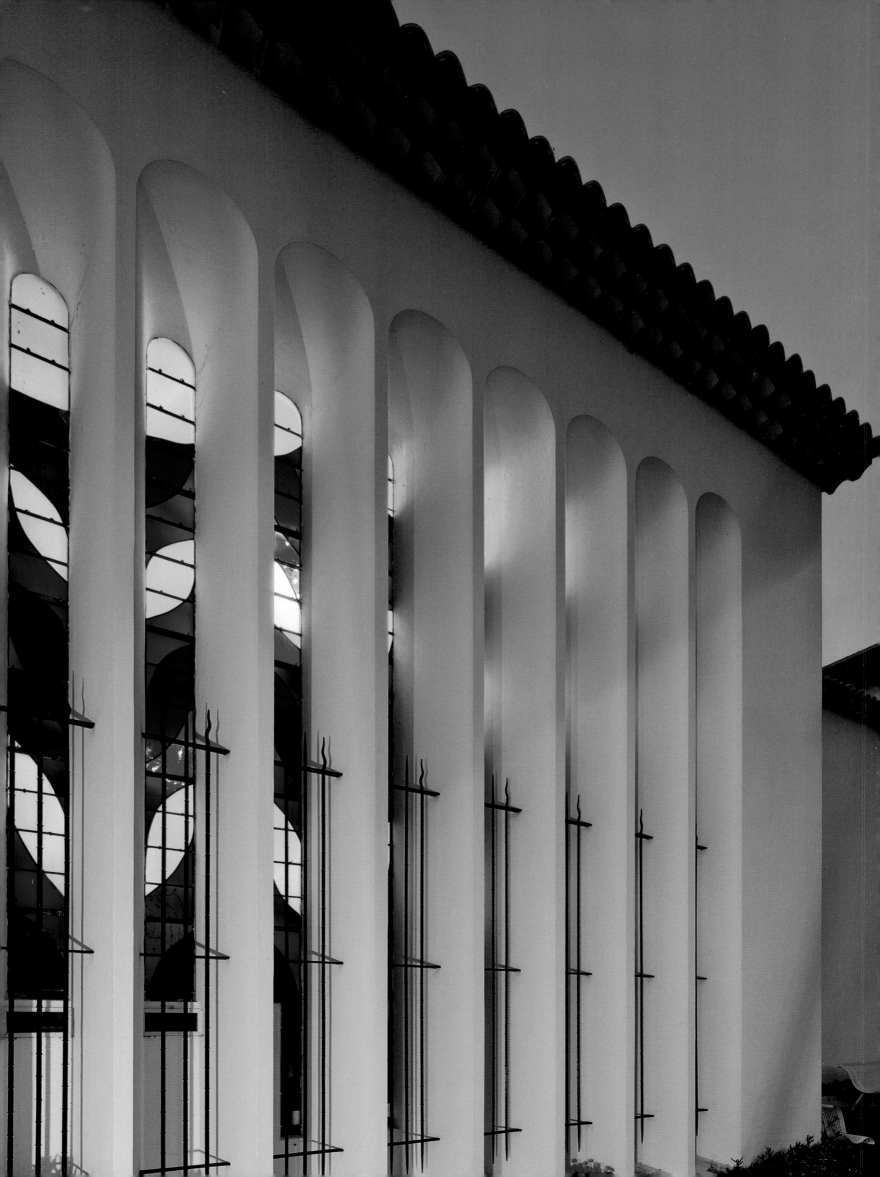

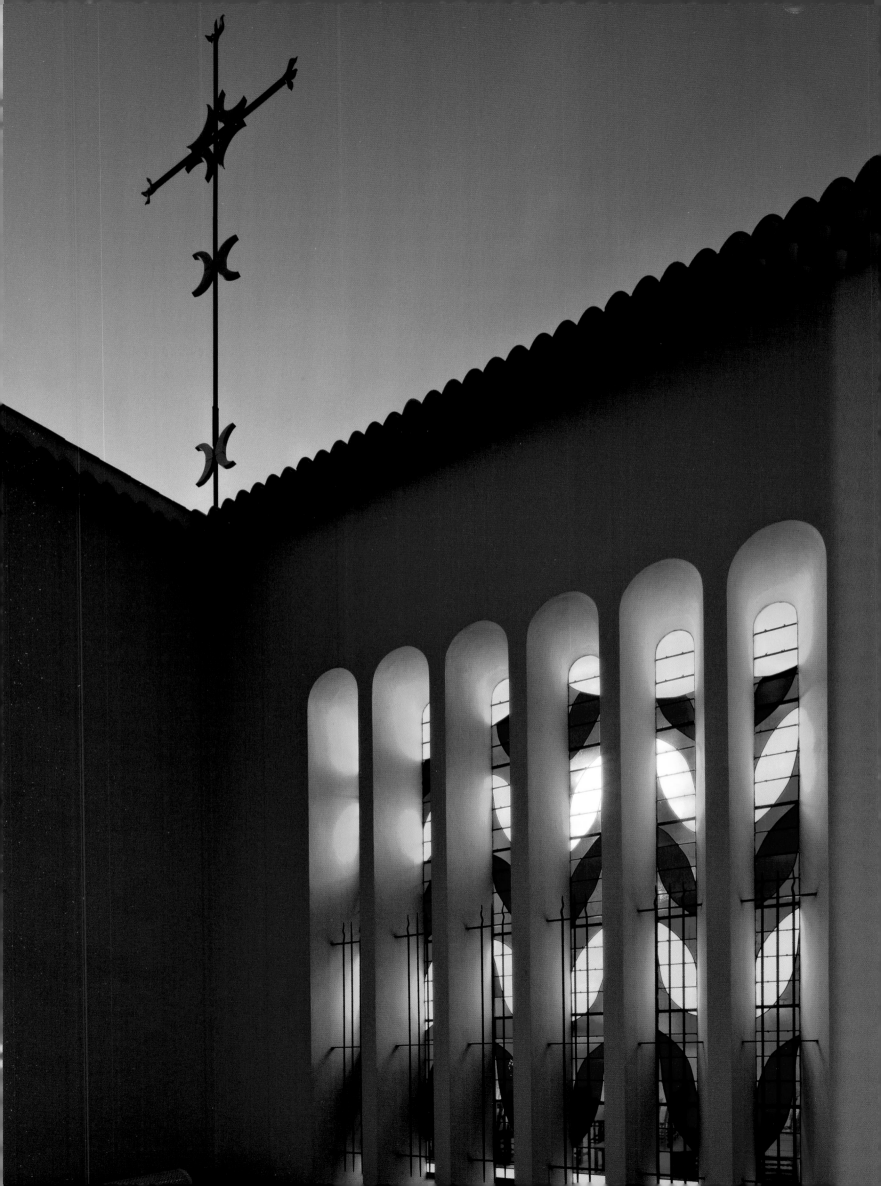

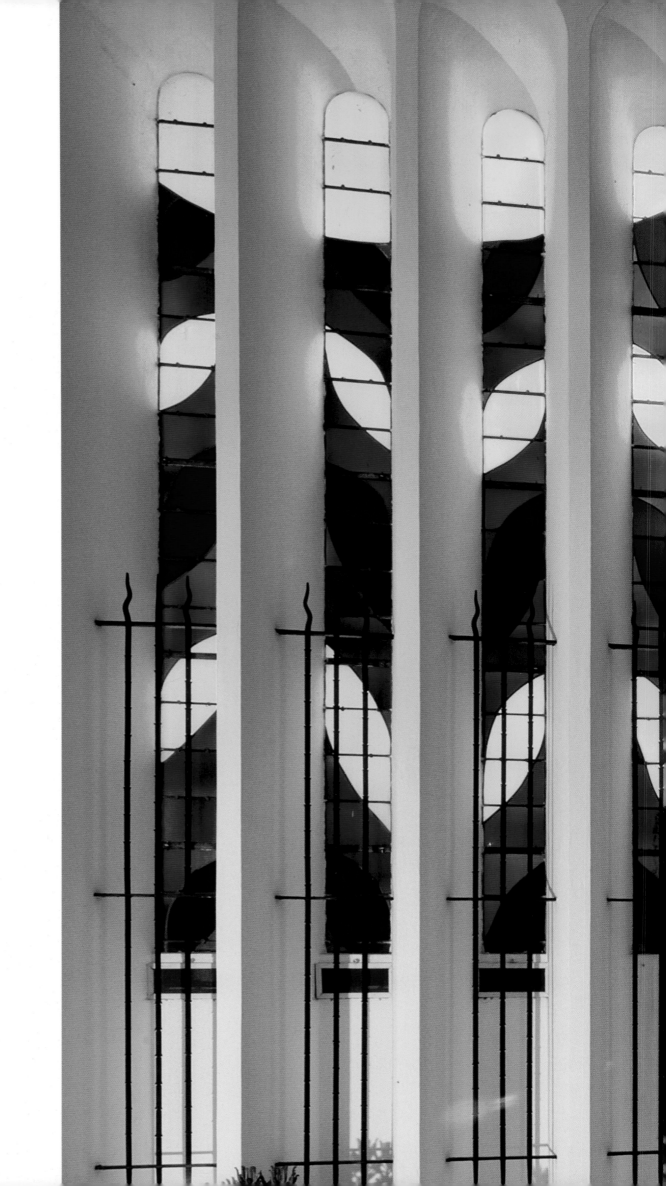

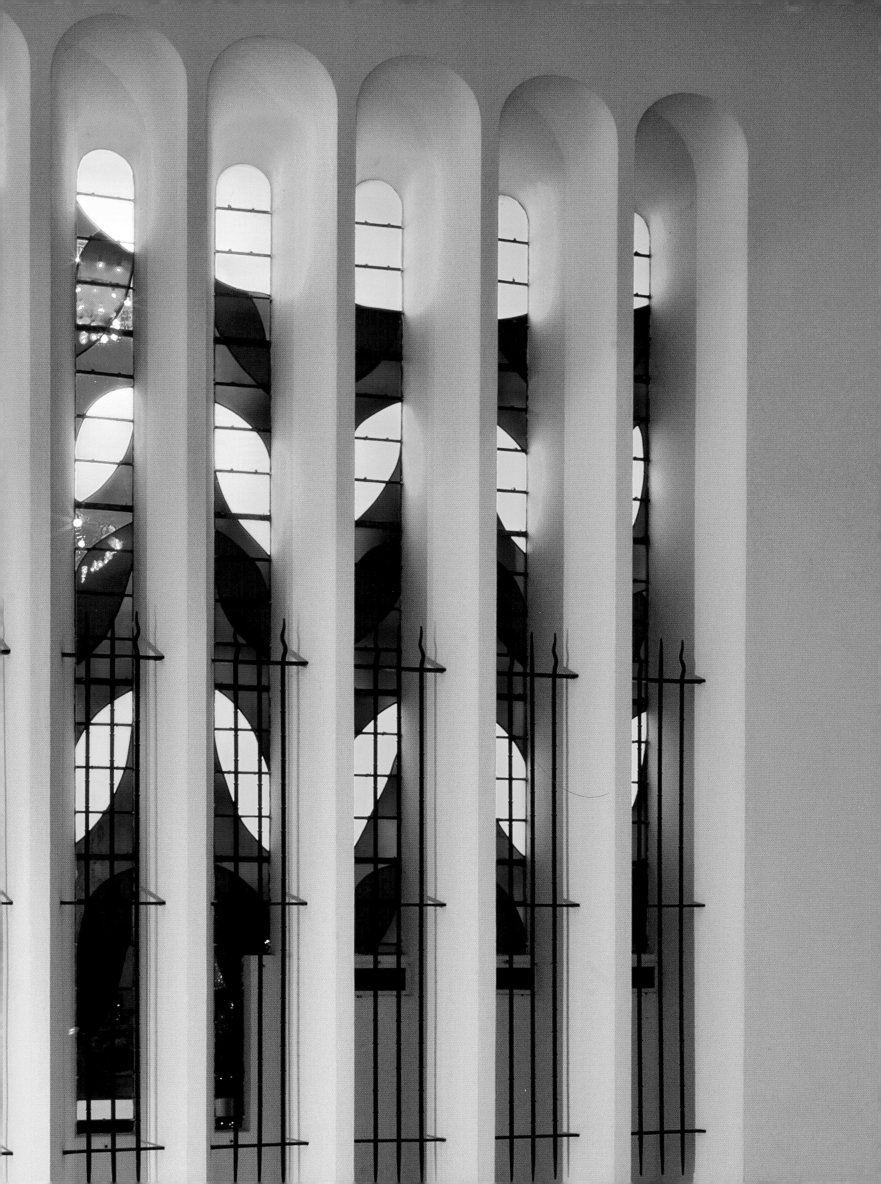

Only slowly did I manage to divine the secret of my art. It is a meditation on nature, on the expression of a dream which is consistently inspired by reality.[1]

CONCLUSION

The Chapel of the Rosary: A Place of Worship, Art and Life in Today's World

The Vence chapel today provides a place of worship for the Dominican nuns, as well as being a place of worship open to visitors. It represents the special link that developed between Matisse and the Dominican nuns, and in particular with Sister Jacques-Marie, who lived until 2005.[2] When designing the chapel, the artist bore the nuns' presence in mind from the start: 'I regarded the black and white of the nuns' vestments as one of the design elements of the chapel; as for music, to the loud sound of the organ, however attractive – if explosive – I preferred the sweetness of female voices murmuring Gregorian chant in the trembling, multi-coloured light of the windows.'[3] For similar reasons, the altar, as already noted, is placed at a diagonal in order to face the nuns' pews as well as the nave, where the congregation sits.

Matisse considered his chapel to be a gathering place, but also a personal space that would respect the privacy of each person. The space is like that of a house. The artist designed the steeple to resemble the smoke from a hearth. 'A spire with its bells would be heavy on the chapel – it should be like a plume of smoke rising up, narrow and light in the tranquillity of evening.'[4] The spire is slender and out of proportion with the dimensions of the building; it can be seen from afar, a landmark in the landscape around Vence. The roof, made of blue and white lacquered tiles, recalls the design of Matisse's cut-paper work *The Wave* 1952).[5] The curling smoke, the clouds and the blue sky are all mingled in a contemporary interpretation of traditional themes, binding the cross and the moon into a symbolic whole, which has become universal.

For Matisse, creating different decorative elements for the chapel in the intimacy of his apartment in the Régina encouraged him to give his work a homely character. He took as his model for the congregation's chairs those that surrounded him at home, while the armchair he designed for the officiating priest was to be found on a heap of boxes; this can be seen in some of the photographs of his Régina apartment.

'I made this chapel with the sole intention of expressing myself *in depth*. I was able to express myself wholly, in form and colour. The work was an education for me.'[6]

The chapel aimed to be a work that would, through its artistic expression, provide a fresh view of religious tradition, while simultaneously respecting this tradition. It departed from allegorical representation in the manner of Chagall's biblical images, or symbolic representations such as Picasso's *War and Peace* (1951–52). The space welcomes the visitor and offers an indefinable experience – something in the order of a universal mysticism, created by Matisse 'for the great family of man, to whom through me something of the fresh beauty of the world is revealed.'[7]

A Work of Hope

As if I were to produce a big composition ... As if I had all my life before me, another life entirely ... in some kind of paradise where I should paint frescoes ... [8]

Through his work, the painter is able to feel that he has gone beyond himself, and beyond his own existence. As Matisse said: 'An artist is an explorer. He must start by seeking himself, watching himself at work. Later he should not restrain himself and, above all, should not be easily satisfied.'[9]

The freedom to design in his own way, according to his own thoughts and feelings, helped Matisse to view art and artistic creation as a source of hope, as he explained from the start: 'With the constant belief in the importance of my determination, the certainty of being on the right road, in a place where I felt really in my element and not faced with a blocked horizon as I had experienced in my former life ... '[10]

In all his work, Matisse strives to convey a vital energy. The chapel in Vence, the climax of a lifetime's work, bears the hallmark of this vital energy, injected into it by the artist himself. The energy gives the chapel a kind of separate existence, and, with the constant change of light and perspective brought about by the passing hours, the chapel becomes a sundial, part of the reality of time and spirit.

The production of such a work of art suggests an endless supply of energy, which in turn evokes the idea of redemption beyond the constraints and boundaries of the material world. 'Only the plastic form has true value, and I have always been of the opinion that a large proportion of the beauty of a painting is derived from the struggle the artist has had to overcome his limited means of expression.'[11] 'In art, the truth, reality begins when you lose complete understanding of what you are doing, what you know, and the energy that remains within you grows stronger the more it is opposed, compressed, squeezed.'[12]

An Artist's Chapel

The Vence chapel is a unique work, designed and completed at a singular moment in the history of religion in France. The Dominican Order's programme of specially commissioning artists who had no formal connection with any religious orthodoxy to design and decorate buildings resulted in contributions by contemporary artists with very diverse styles. Allowing a free hand to artistic expression in religious edifices aroused a certain amount of criticism, but it was also a means of stimulating a vast amount of interest in these places. In this wave of architectural and decorative renewal, the Chapel of the Rosary in Vence is exceptional because it is the work of a single artist. Matisse's design thus offers remarkable coherence compared with some other examples, and this homogeneity reinforces its power and spiritual impact. The visitor's gaze does not wander. One's emotions are not distracted by a mixture of sensations produced by the work of different artists. The power of Matisse's art reigns supreme, opening up the mind and spirit to the possibility of transcendence. The chapel in Vence welcomes the scores of visitors and worshippers it attracts from many cultures and from all over the world.

[following pages]
The interior of the chapel, showing the view from the altar

[following pages]
Details of the nuns' pews

I went to see the chapel in Vence. It is all joy and clarity, youth. Visitors … are worthy, enchanted and charming. Your work filled me with courage – not that I am lacking in courage, but I've used all mine up. This chapel is a magnificent testimony – that much is true. Thanks to you, life is beautiful once more. Thank you.

Letter from Le Corbusier to Matisse, Roquebrune-Cap-Martin, 24 August 1951

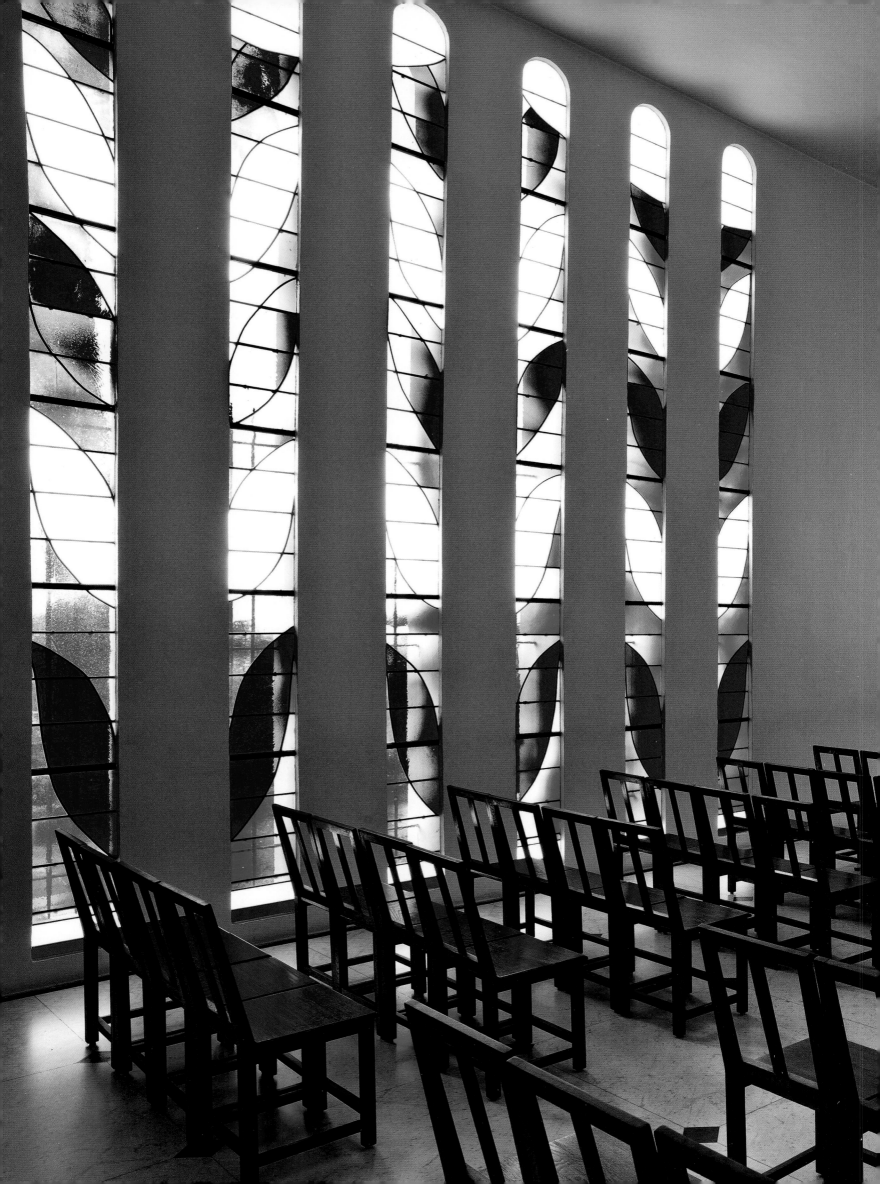

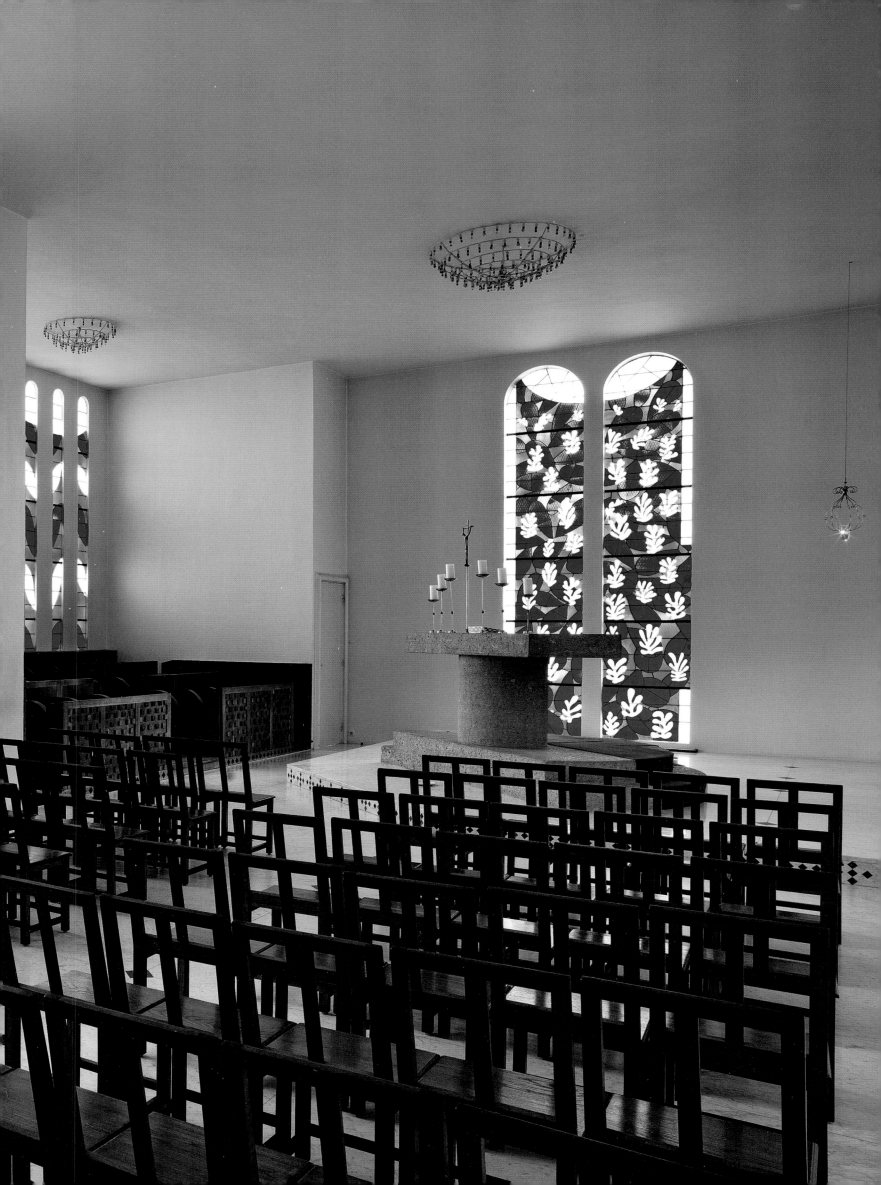

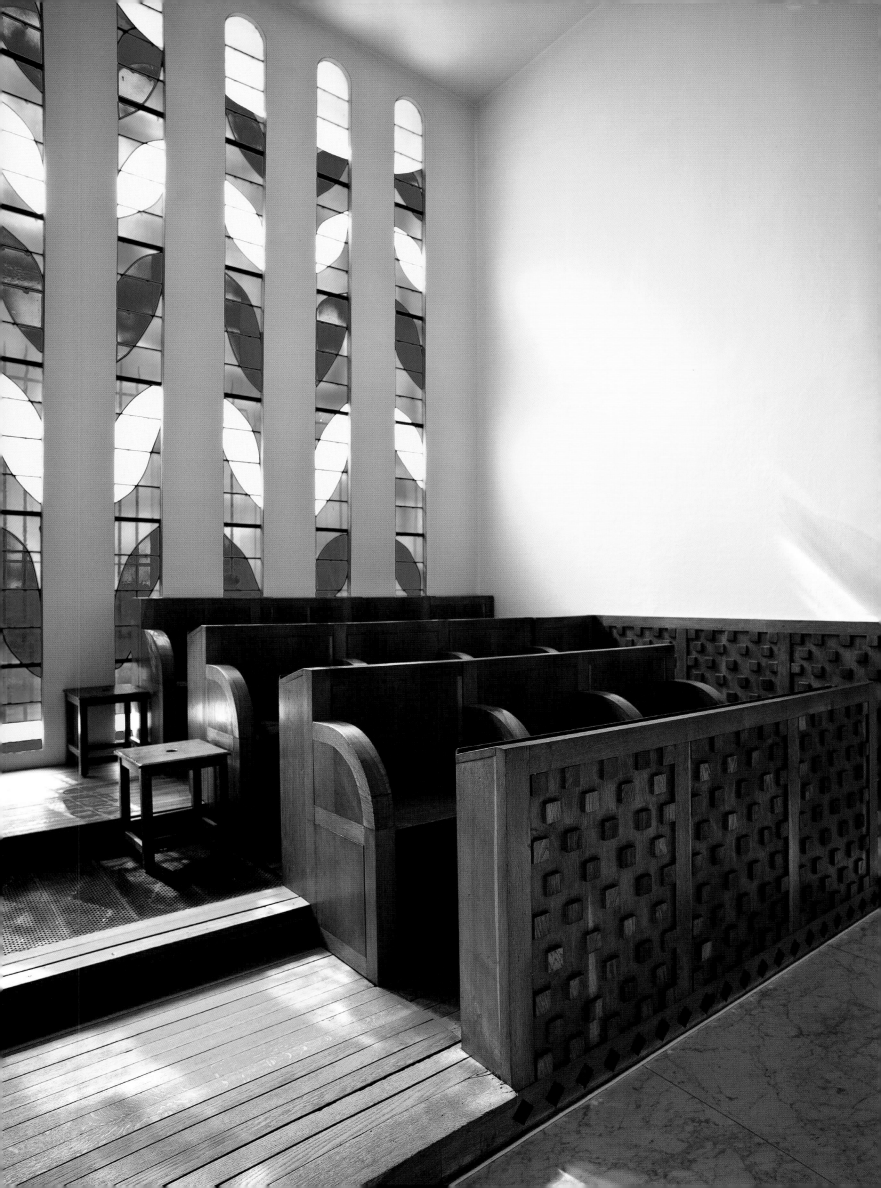

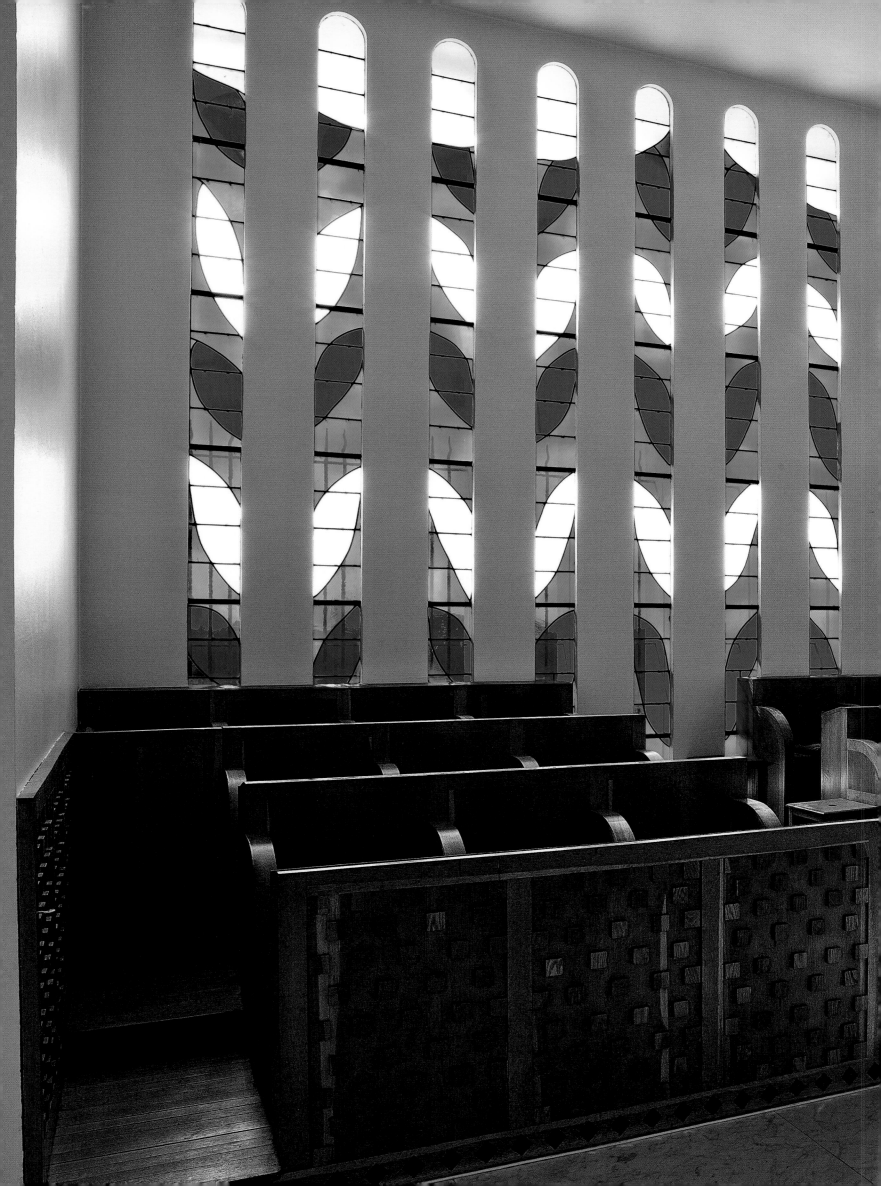

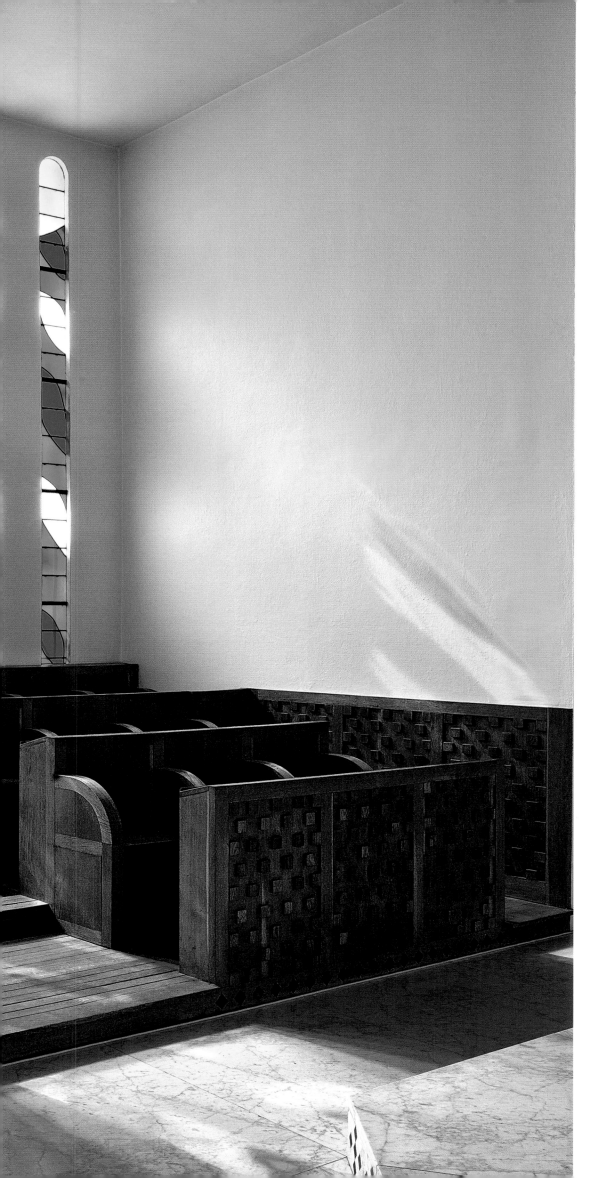

[this page]
The nuns' pews

[following pages]
A complete view and details of
the roof of the chapel, covered
with glazed tiles

The campanile, a complete view
and details

197

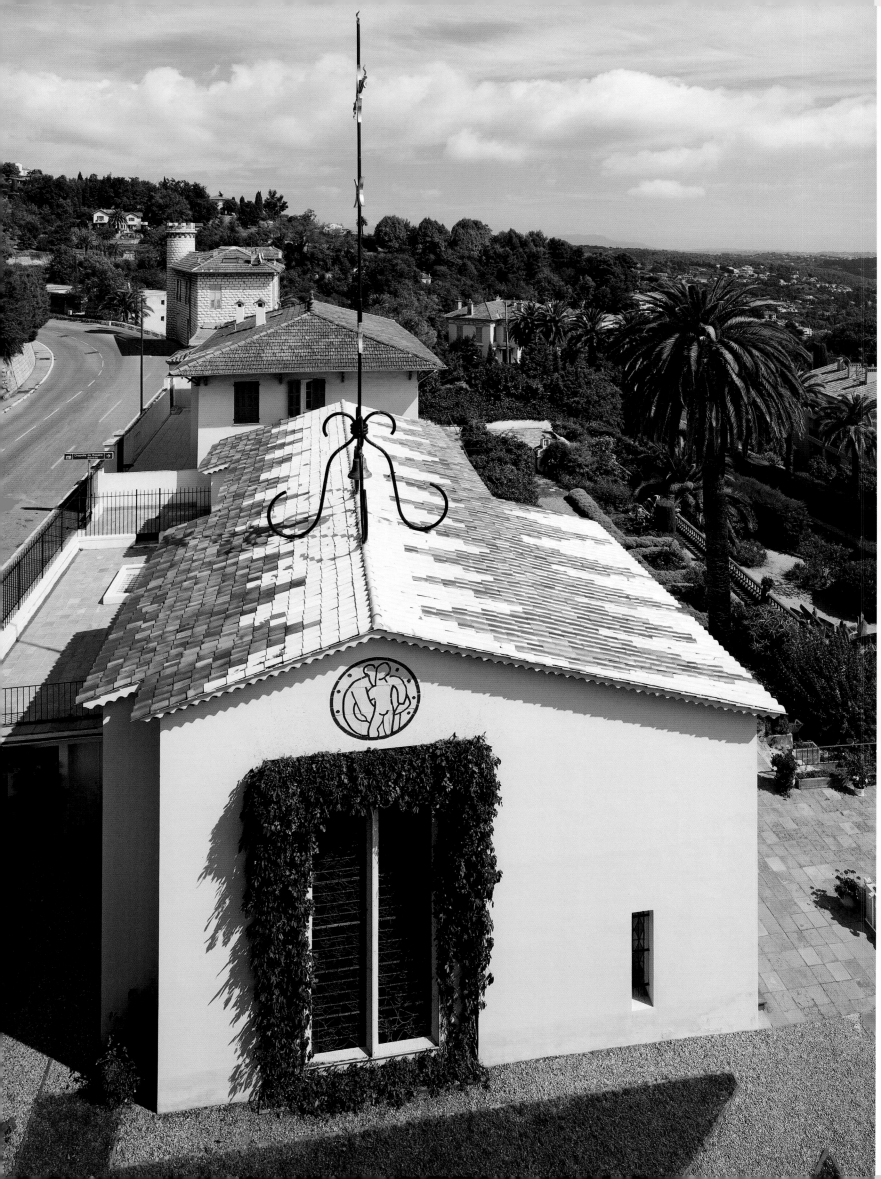

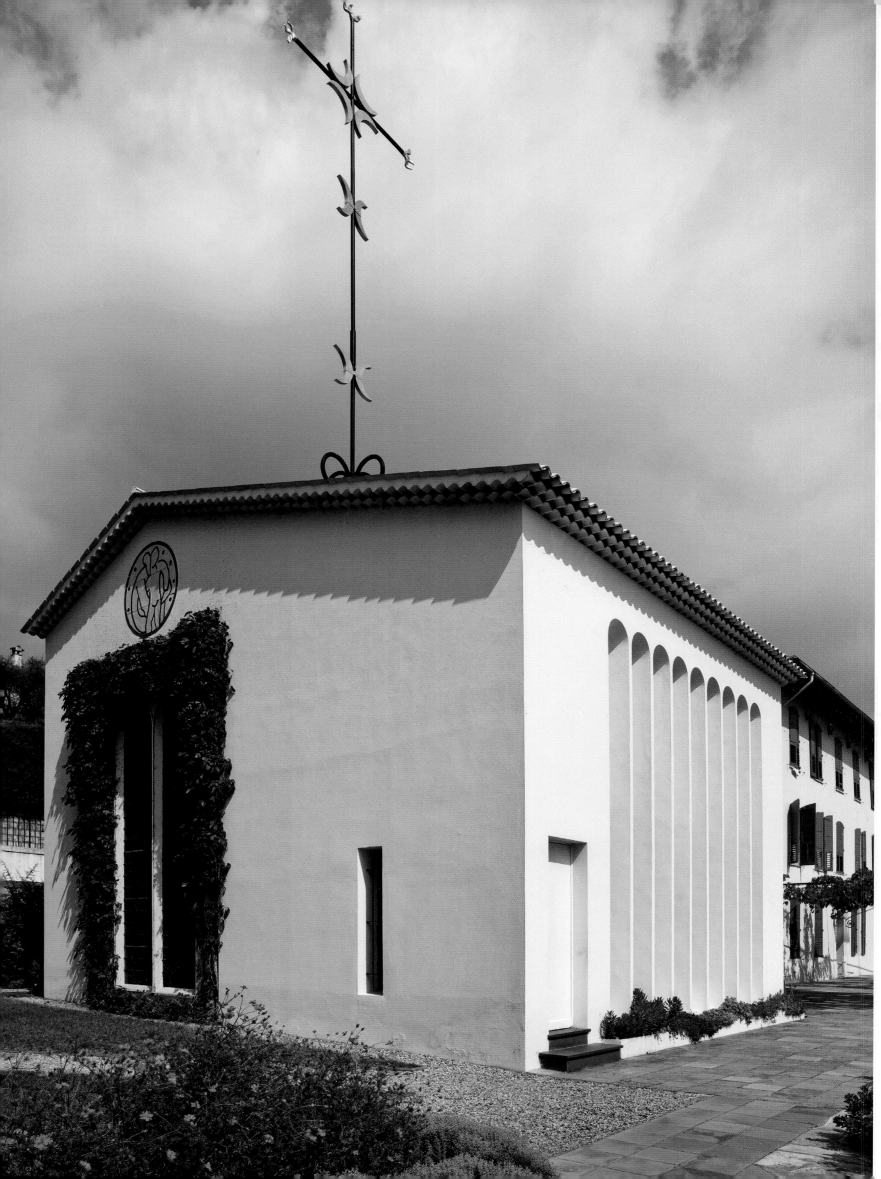

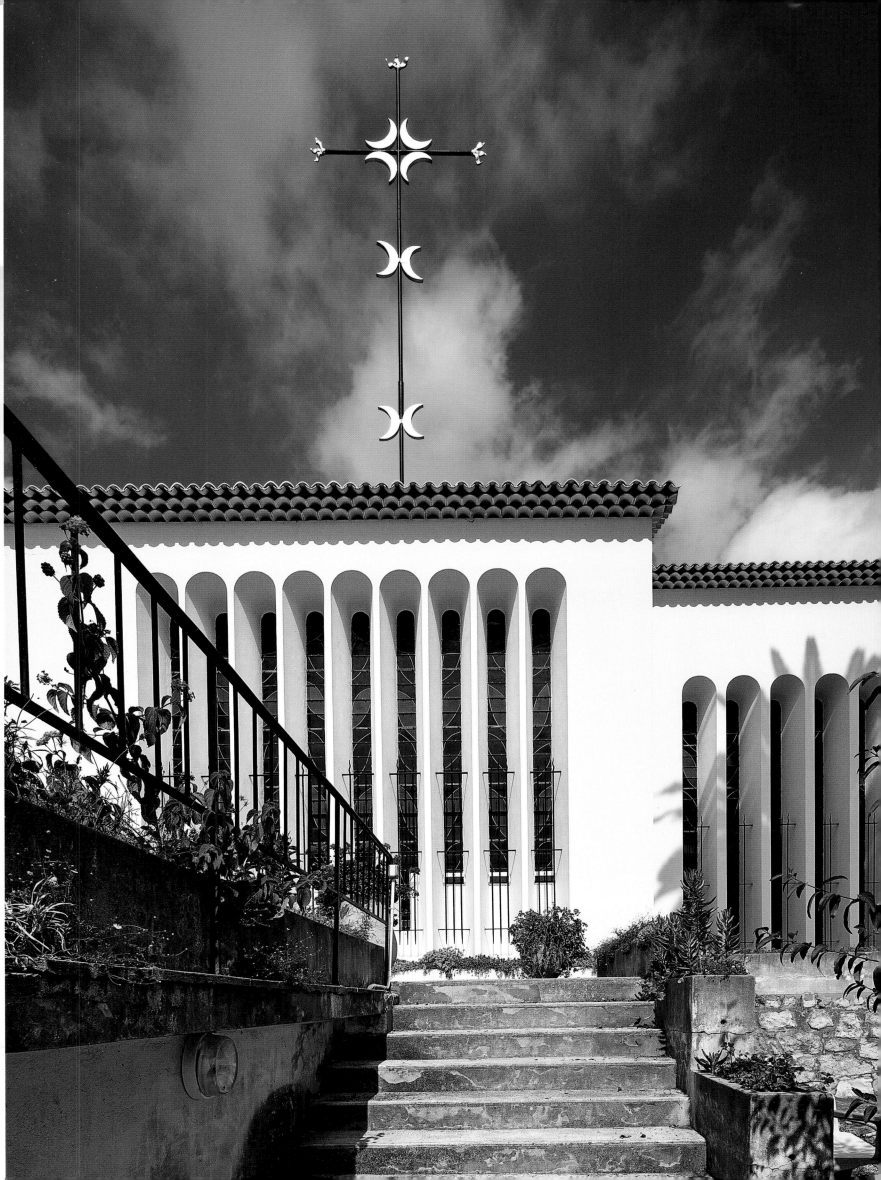

A Brief Chronology
of Matisse's Later Years

Henri Matisse was born on 31 December 1869 in the town of Le
Cateau-Cambrésis in the north of France, and spent his childhood in
Bohain-en-Vermandois in Picardy. He lived in Nice from 1918 until his death
on 3 November 1954, and a large proportion of his work was done there.
He regarded the chapel of the Dominican nuns in Vence as the climax of his
career. The following illustrated biography of the artist's life from 1930
onwards shows the way in which Matisse, in a spirit of constant renewal,
approached the work of his later years, and in particular his development
of large cut-paper compositions.

Self-portrait, 1944
Lithograph on paper
Musée Matisse, Nice

1930 Matisse leaves for Tahiti at the end of February, travelling via New York and San Francisco, intending to stay for six months. He returns with a host of photographs and about 40 drawings. Fascinated by the United States, especially by New York and other American cities, he visits three times during this year. He sits on the jury of the Carnegie Prize, awarded that year to Picasso. At the end of the year, Dr Alfred Barnes commissions Matisse to create a large-scale decorative scheme for the Barnes Foundation in Merion, Pennsylvania.

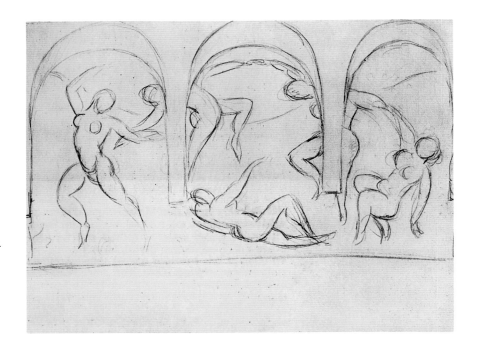

La Danse (Paris)
Study, 1930–31
Pencil on paper
Musée Matisse, Nice

1931 On his return to Nice, Matisse rents a studio at 8 Rue Désiré-Niel, where he plans to create his large decorative piece, *La Danse*, for the Barnes Foundation. The illustrations to Mallarmé's *Poésies*, produced for Editions Skira during the same year and published the next, derive a great deal from Matisse's visit to Tahiti.

1932 A second version of *La Danse* is produced because of incorrect measurements.

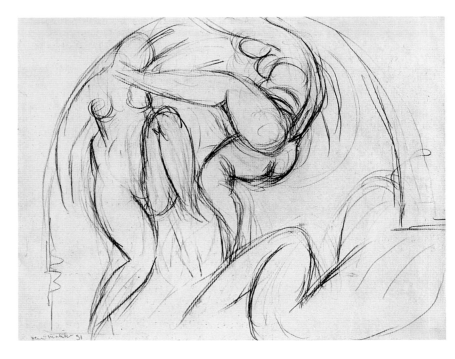

La Danse (Merion)
Study for the left-hand panel, 1931
Pencil on paper
Musée Matisse, Nice

1933 Matisse travels to Merion for the installation of *La Danse*.

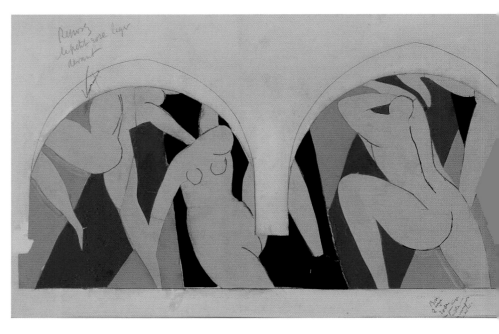

La Danse
Study for the etched engraving, c. 1935
Cut coloured paper
Musée Matisse, Nice

1934–35 Lydia Delectorskaya becomes Matisse's model and then his assistant.

Memories of his travels in the South Seas appear in the artist's work, particularly in the two versions of *Window in Tahiti*.[1]

Oceania, the Sea
(After the original *découpages* of 1946, Musée départemental Matisse, Le Cateau-Cambrésis)
Silk-screen stencilled print on linen, printed by Zika Ascher, London, 1948, no. 25/30.
Musée Matisse, Nice.

Oceania, the Sky
(After the original *découpages* of 1946, Musée départemental Matisse, Le Cateau-Cambrésis)
Silk-screen stencilled print on linen, printed by Zika Ascher, London, 1948, no. 10/30.
Musée Matisse, Nice

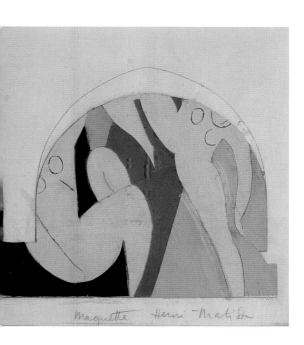

Léonide Massine commissions Matisse to design the décor and costumes of *Rouge et Noir* (*L'Etrange Farandole*) for the Ballets Russes. Raymond Escholier accepts the first version of *La Danse* for the Musée d'Art Moderne de la Ville de Paris. Matisse presents his painting *Three Bathers* by Cézanne to the Musée des Beaux-Arts de la Ville de Paris.

1938 In January Matisse buys an apartment in the former Hôtel Régina in Nice, on the Colline de Cimiez, moving in at the end of October. On 4 February he is made an Officer of the Légion d'Honneur.

1939–40 The declaration of war is partly responsible for the events of this period. Matisse spends a month at Rochefort-en-Yvelines, before returning to Nice on 18 October. He returns to Paris at the end of April 1940 and cancels a planned trip to Brazil. Unable to return to Nice, he and Lydia Delectorskaya leave for Bordeaux and Ciboure, where they stay for more than a month, until the armistice. Matisse returns to Nice on 29 August and is able to start work in September; he proceeds with the painting *Nymph in the Forest*, begun in 1935.

Nymph in the Forest
1935–42
Oil on canvas
Musée Matisse, Nice

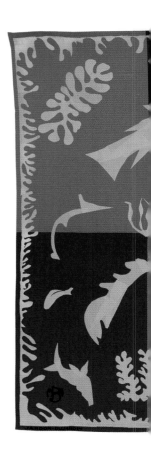

Portrait of a Woman (Subject 01)
Nice, February 1942
Charcoal and blending stick on paper
Musée Matisse, Nice

1941 In January ill health necessitates Matisse's urgent admission to the Clinique Saint-Antoine in Nice, then his transfer to the Clinique du Parc in Lyons. After a long convalescence, during which his conversations with Pierre Courthion provide some distraction, he leaves Lyons for Nice on 22 May and starts work again on the series *Thèmes et Variations* and the illustrations to the *Florilège des Amours de Ronsard*. He corresponds with Montherlant and Aragon and is visited by them in December.

1942 A nurse, Monique Bourgeois (later to become Sister Jacques-Marie), comes to look after Matisse during the nights.

Because the Régina is threatened with occupation by the Germans, at the end of June Matisse moves to the Villa Le Rêve in Vence. He paints interiors with windows opening out onto the landscape. He also works on the plates for Montherlant's *Pasiphaé*, and on the cut-paper decorations for his book *Jazz. Thèmes et Variations* is published by Editions Fabiani.

Jazz – The Lagoon (plate XVIII), 1947
Stencilled plate after the collage and the *découpages* of Henri Matisse, Tériade, Paris, 1947
Musée Matisse, Nice

Matisse spends the whole year in Vence. In the summer he works on the illustrations to Baudelaire's *Les Fleurs du Mal*. His daughter, Marguerite Duthuit, and Madame Matisse are arrested for crimes connected with the Resistance. *Pasiphaé* is published by Editions Fabiani.

In the early part of the year, the artist decorates a door for the Anchorena family. From July to November, assisted by Lydia Delectorskaya, he prepares for his retrospective at the Salon d'Automne. At the same time, he works on the cartoons for the *Oceania* wall hangings: *The Sky* and *The Sea*. In December Galerie Maeght in Paris hosts an exhibition of the artist's work.

Polynesia, the Sea, 1948
(After the original *découpages* of 1946. Musée national d'art moderne, Centre Georges Pompidou, Paris)
Tapestry, wool, low warp, Manufacture nationale de Beauvais
Musée d'Orsay, Paris, on loan to the Musée Matisse, Nice

In April Matisse finishes his decorative piece *Léda*. This year sees the beginning of Hélène Adant's photo-reportage of the painter, which is to continue until his death. Matisse holds his first exhibition in Nice, at the Palais de la Méditerranée, organised by Aimé Maeght, and the film *Henri Matisse*, by François Campaux, is released. *Lettres portugaises* by Marianna Alcaforado, illustrated by Matisse, and *Visages*, with a text by Reverdy, are both published.

1947

On 16 January Matisse is made
Commander of the Légion d'honneur.
After spending a year in Paris, he moves
back to Vence where he lives from April
1947 to June 1948. He creates a series of
'interiors', and *Jazz* is published by Tériade.

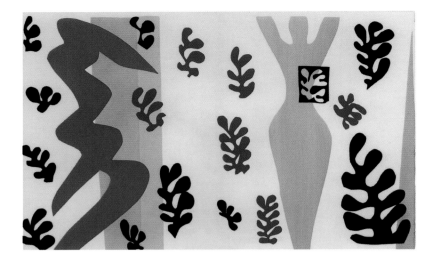

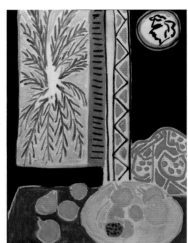

Jazz – The Knife Thrower (plate 15), 1947
Stencilled plate after the *collages* and on the
decoupages of Henri Matisse, Tériade, Paris,
1947
Musée Matisse, Nice

Still-life with Pomegranates,
Vence, 1947
Oil on canvas
Musée Matisse, Nice

The Bees
(First model for the window in the nave
of the Chapel of the Rosary, Vence), Vence,
1948
Cut coloured paper
Musée Matisse, Nice

1948

In April a retrospective exhibition opens in
Philadelphia. Matisse works on the creation
of the Chapel of the Rosary for the
Dominican nuns in Vence. On 30 December
he returns to the Régina; its spacious
interior is better suited to the large format
of his designs for the chapel.

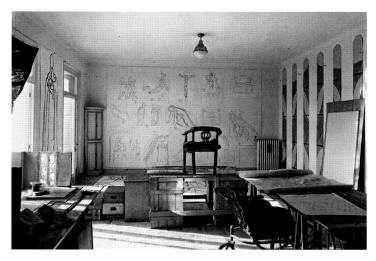

An exhibition of Matisse's work is held in February at the Pierre Matisse Gallery in New York, and from June to September at the Musée national d'art moderne in Paris. On 12 December a ceremony is held for the laying of the first stone of the chapel in Vence.

HÉLÈNE ADANT
The Big Studio
Studies for the Vence chapel, Le Régina, Nice, c. 1949–50
Photograph
Photothèque du centre de documentation, Musée Matisse, Nice

LUCIEN HERVÉ
The Big Studio
Studies for the *Way of the Cross* and *St Dominic,* Nice, 1949
Photograph
Photothèque du centre de documentation, Musée Matisse, Nice

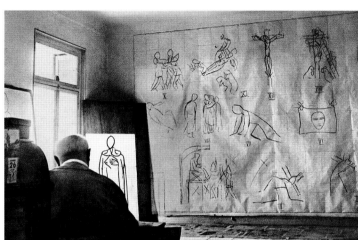

1950

From January to March, an exhibition organised by the Union méditerranéenne pour l'art modern (UMAM) is held at the Galerie des Ponchettes in Nice. Matisse is commissioned to make a ceramic statue of St Dominic for the Chapelle d'Assy. He creates large cut-paper compositions. The *Poèmes* of Charles d'Orléans are published. Models of the chapel in Vence are displayed at the Maison de la Pensée française in Paris. Matisse shares the first prize with Henri Laurens at the 25th Venice Biennale.

Creole Dancer
Nice, 1950
Coloured cut paper
Musée Matisse, Nice

1951

Matisse works on the creation of the chasubles for the Vence chapel, as well as on a window and a ceramic panel for the dining room of the publisher Tériade. On 25 June, the Chapel of the Rosary is inaugurated, but the artist is unable to be present. A retrospective exhibition is held at the Museum of Modern Art, New York.

Tree (Plane Tree)
Nice, 1951
Pen and Indian ink on parchment, corrections in white gouache
Direction des Musées de France, gift of the wife of Jean Matisse, 1978, on loan to the Musée Matisse, Nice, inv. D.78.1.2.

Large Head – Mask
Nice, 1951
Brush and Indian ink on paper
Musée d'Orsay, Paris, on loan to the
Musée Matisse, Nice

The Wave
Nice, c. 1952
Cut paper
Musée Matisse, Nice.

In March, Matisse finishes *The Sadness of the King.* This year he also produces the series of *Blue Nudes.* He remains in Nice in the summer, and works on large cut-paper compositions: *The Pool*, *The Parakeet and the Mermaid* and *Flowers and Fruits*. On 8 November, the Musée Matisse in Le Cateau-Cambrésis is inaugurated.

1952

The Sadness of the King
Nice, 1952
Cut paper
Musée national d'art moderne,
Centre Pompidou, Paris

Large Acrobat
Nice, 1952
Brush and Indian ink on paper
Musée d'Orsay, Paris, on loan to the
Musée Matisse, Nice

Blue Nude IV
Nice, 1952
Cut paper
Musée d'Orsay, Paris, on loan to the
Musée Matisse, Nice

1953

An exhibition of cut-paper compositions is held at Galerie Berggruen in Paris, and of sculpture at the Tate Gallery, London. With a view to the creation of a museum, Matisse presents the Ville de Nice with the paintings *Still-life with Pomegranates*, *Creole Dancer*, *Oceania, the Sky* and *Oceania, the Sea*, and four drawings from the series *Thèmes et Variations*. He stays at Villa La Jonque in Vence until mid-October. On 16 October Marguerite Duthuit comes to spend six weeks with her father.

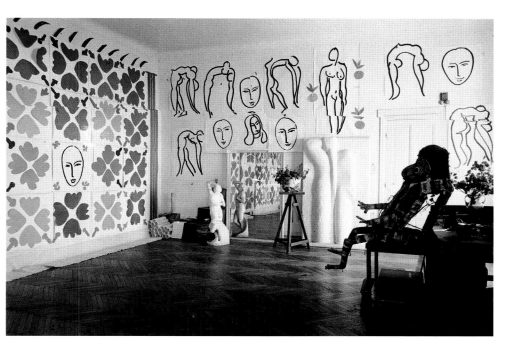

HÉLÈNE ADANT
The Big Studio
Le Régina, Nice, 1953
Photograph
Phototèque du centre de documentation,
Musée Matisse, Nice

1954

Apart from a brief summer visit to Vence, Matisse does not leave Nice. He dies there on 3 November, and is buried in the cemetery at Cimiez.

This biography of Matisse was drawn up by the Musée Matisse, under the guidance of Wanda de Guébriant of the Archives Matisse.

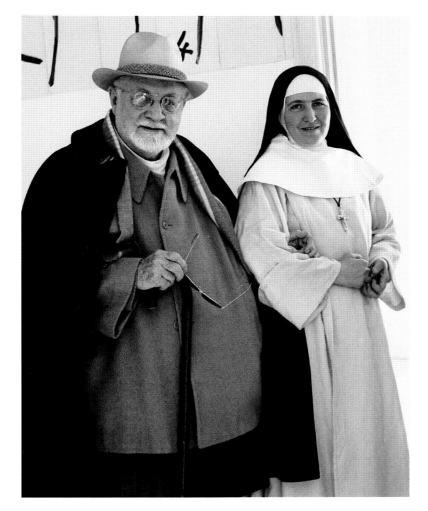

HÉLÈNE ADANT
Henri Matisse and Sister Jacques-Marie near the chapel in Vence
Photograph
Fonds Hélène Adant, Bibliothèque
Kandinsky, Centre Pompidou, Paris

Notes

Page 7

1 Comment by Henri Matisse, published in Chapelle 1951; Ecrits 1972, p. 258.

Introduction

1 Letter from Henri Matisse to André Verdet, 1954, quoted in Escholier 1956, p. 271; Ecrits 1972, p. 313, note 34.

2 Letter from Henri Matisse to Henry Clifford, Vence, 14 February 1948, published in English as the preface to Philadelphia 1948; and in French in Paris 1961; Ecrits 1972, p. 313.

3 Letter from Henri Matisse to Sister Jacques-Marie, Vence, 20 June 1945, in Jacques-Marie 1993, p. 165.

4 The window as a theme can be found in different periods of Matisse's work.

5 Tériade 1930; Ecrits 1972, p. 105.

6 Matisse's thoughts recorded in Gillet 1943; Ecrits 1972, pp. 289–290.

7 Verdet 1952; Ecrits 1972, p. 57, note 26.

Chapter 1

1 Jacques-Marie 1993, p. 15.

2 Jacques-Marie 1993, pp. 15–16.

3 Jacques-Marie 1993, p. 19.

4 Jacques-Marie 1993, p. 26.

5 Montherlant 1944.

6 Lydia Delectorskaya, model, studio assistant and secretary to Henri Matisse from 1932 to 1954.

7 Letter from Henri Matisse to André Rouveyre, 27 April 1947, in Percheron, Brouder 2002, p. 62.

8 Percheron, Brouder 2002, p. 62.

9 Percheron, Brouder 2002, p. 63.

10 Jacques-Marie 1993.

11 Matisse 1951; Ecrits 1972, p. 260.

12 Letter from Henri Matisse to Monsignor Rémond, Bishop of Nice, June 1951, read by Father Couturier at the inauguration of the Vence chapel, then published in *L'Art Sacré*, no. 11–12, July–August 1951; Ecrits 1972, p. 257.

13 The art historian Barbara Freed made a film about Sister Jacques-Marie: *Un Modèle pour Matisse: histoire de la chapelle du Rosaire à Vence*, 2007.

14 Message from Henri Matisse to the town of his birth, on the occasion of the inauguration of the Musée Henri Matisse in Le Cateau-Cambrésis (Nord), 8 November 1952; Ecrits 1972, p. 320.

15 Gustave Moreau told him: 'You are going to simplify painting'; Ecrits 1972, p. 81.

16 Letter from Henri Matisse to Raymond Escholier, 20 April 1941; Ecrits 1972, p. 283.

17 Matisse 1948.

18 Aragon 1971, vol. I, p. 16 (re-published Quarto Gallimard, 1998, p. 33).

19 Matisse 1943.

20 Matisse 1950.

21 Letter from Henri Matisse to Charles Camoin, 23 July 1944; Ecrits 1972, p. 292.

22 An early version of *La Danse* (initially intended for the Barnes Foundation, Merion, Pennsylvania) was purchased by Jean Cassou.

23 Matisse 1947.

24 Lejard 1951; Ecrits 1972, p. 264.

25 Reported by Rémond, in *L'Art Sacré*, July–August 1951; Ecrits 1972, p. 264.

26 Rémond, *ibid*.

27 Verdet 1952, p. 53; Ecrits 1972, p. 256.

28 Matisse 1947; Ecrits 1972, p. 238.

29 Reported by Régine Pernoud, *Le Courrier de l'UNESCO*, vol. VI, no. 10, October 1953; Ecrits 1972, p. 323.

30 Charbonnier 1960; Ecrits 1972, p. 267.

31 Letter from Henri Matisse to André Rouveyre, Nice, early June 1943, Ecrits 1972, p. 169; Finsen 2001, p. 269, letter 359.

32 'My contemplation cannot be simply admiration, it has to be active … ', letter from Henri Matisse to Sister Jacques-Marie, Vence, 20 June 1945, in Jacques-Marie 1993, p. 165.

33 Diehl 1954; Ecrits 1972, p. 65, note 37.

34 L. Aragon, 'Matisse-en-France', in Aragon 1971, vol. i, pp. 105–106 (re-printed Quarto Gallimard, 1998, p. 133, note 2); Ecrits 1972, p. 169, note 20.

35 Letter from Henri Matisse to André Rouveyre, early June, 1943, Nice; Ecrits 1972, p. 168; Finsen 2001, p. 269, letter 359.

36 Built between 1937 and 1946 and consecrated in 1950, the church of the Plateau d'Assy (in the Commune of Passy in eastern France) is a place of worship and artistic expression. It has been listed as a building of historic interest since 2004. Nine statues by Calder and other artists line the road leading to the Plateau d'Assy. Stretching for 15 km over the side of a hill, between the plain and the Domaine de Plaine-Joux, the sculptures have made Passy a museum in the heart of nature.

37 Church of the Sacré-Coeur, Audincourt (architect: Maurice Novarini), 1949–1951.

38 Pilgrimage chapel, dedicated to the Virgin of Notre-Dame-du-Haut, Ronchamp (architect: Le Corbusier), inaugurated 25 June 1955.

39 Church of Saint-Michel, Les Bréseux, Haut-Doubs, eighteenth-century. The first items of modern art to be installed in the church were the windows by Alfred Manessier (1948–50).

40 The magazine *L'art Sacré* was created by Joseph Pichard in July 1935. In 1937 it was taken over by the Dominican publishing house, Le Cerf, directed by Father Couturier and Father Régamey; it was devoted to contemporary religious art and the role of the artist.

41 Champlitte 2005, p. 7.

Chapter 2

1 Comments collated by Maria Luz and approved by Henri Matisse, published in XXe *Siècle*, no. 2, January 1952, 1951; Ecrits 1972, p. 246.

2 'It is not work that I have chosen, but work for which I have been chosen by destiny at the end of my journey … ', in Chapelle 1951; Ecrits 1972, p. 258.

3 Billot 1993, p. 10.

4 Billot 1993, p. 12.

5 Le Corbusier had designed the chapel of Notre-Dame-du-Haut at Ronchamp, 1950–55.

6 Percheron, Brouder 2002, p. 182.

7 Percheron, Brouder 2002, p. 183.

8 (*Le Bonheur de vivre*), The Barnes Foundation, Merion, Pennsylvania.

9 (*La Danse*), State Hermitage Museum, St Petersburg.

10 Matisse used the principle of the arcades for the ballet *Le Rouge et le noir (L'Etrange Farandole)* in 1938.

11 Notes to *La Danse* in Merion; Ecrits 1972, p. 137.

12 Conversation with Tériade, in Tériade 1929; Ecrits 1972, pp. 99–100.

13 Barr 1951, p. 280.

14 Auguste Perret drew up some plans for the Vence chapel in 1948; these plans incorporated sun screens on the stone walls of the façade. Matisse, Couturier, Rayssiguier 1993, pp. 16–17.

15 Billot 1993, pp. 15–17.

16 Rémond, in in *L'Art Sacré*, July–August 1951; Ecrits 1972, p. 264.

17 Barr 1951, p. 281.

18 Comments recorded by Rosamond Bernier, Bernier 1949; Ecrits 1972, p. 262.

19 *Zorah sur la terrasse*, Tangier 1912, oil on canvas; Pushkin Museum of Fine Arts, Moscow.

20 Matisse 1951; Ecrits 1972, p. 259.

21 Percheron, Brouder 2002, p. 233.

22 Percheron, Brouder 2002, p. 234.

23 Letter from Matisse to Rouveyre, 30 October 1941, in Ecrits 1972, p. 189; Finsen 2001, p. 68.

24 Letter from Henri Matisse to Pierre Matisse, 3 April 1942, Ecrits 1972, p. 190.

25 Letter from Henri Matisse to Pierre Matisse, 7 June 1942, Ecrits 1972, p. 190.

26 Statement reported by Gaston Diehl in *Peintres d'Aujourd'hui*, Comoedia-Charpentier collection, June 1943; Ecrits, p. 196.

27 Remark made by Henri Matisse and reported by André Verdet, in Verdet 1970, pp. 114–115; Ecrits 1972, p. 251.

28 Matisse 1939; Ecrits, p. 160.

29 *Maternité*, gouache on lino, 1939, reproduced in *Poésie 42*, no. V (of that year), no. 11 (of the series), November–December 1942, to illustrate the poem by Charles Cros. Reproduced in L. Aragon, 'Un personnage nommé La Douleur', in Aragon 1971, vol. I, p. 175 (reprinted Quarto Gallimard, 1998, p. 216).

30 Conversation between Brother Rayssiguier and Henri Matisse, 2 August 1949, in Matisse, Couturier, Rayssiguier 1993, p. 222.

31 'Thy will be done.'

32 Charbonnier 1960; Ecrits, p. 267.

33 *Femme à la gandoura bleue*, oil on canvas; Musée départemental Matisse, Le Cateau-Cambrésis.

34 *Katia à la robe jaune*, oil on canvas; Pierre and Tana Matisse Foundation Collection, New York.

35 *Femme aux perles*, oil on canvas; private collection.

36 Letter from Henri Matisse to Father Couturier, 15 May 1949, Matisse, Couturier, Rayssiguier 1993, p. 188.

37 Journal of Father Couturier, 16 August 1949, in Matisse, Couturier, Rayssiguier 1993, p. 225; Ecrits 1972, p. 270.

38 Journal of Father Couturier, 16 August 1949, in Couturier 1962; Ecrits 1972, p. 270.

39 Recorded in Martin 1955; Ecrits, p. 274, note 18.

40 Conversation between Brother Rayssiguier and Henri Matisse, 12 April 1949, in Matisse, Couturier, Rayssiguier 1993, p. 175. See also *Etude de mains jointes,* 1949, charcoal on paper, Musée Matisse, Nice.

41 For example, *Christ Pantocrator*, icon, thirteenth century; Tretyakov Gallery, Moscow. Christ Pantocrator is a repeated theme in Byzantine art. The half-figure of Christ holds the Bible in his left hand, his right hand being raised in a gesture of preaching.

42 Journal of Father Couturier, December 1948, in Matisse, Couturier, Rayssiguier 1993, p. 123.

43 Matisse 1951; Ecrits 1972, p. 260.

44 Reproduced inside the cover fold of the catalogue to the exhibition *Paris* 2001.

45 Matisse 1951; Ecrits 1972, p. 260.

46 Matisse 1951; Ecrits 1972, p. 260.

47 Second station: Jesus Carries His Cross.

48 Fourth station: Jesus Meets His Mother.

49 Fifth station: Simon Helps Jesus.

50 Seventh station: Jesus Falls for the Second Time.

51 Ninth station: Jesus Falls for the Third Time.

52 Tenth station.

53 Eleventh station.

54 Twelfth station: Jesus Dies on the Cross.

55 Thirteenth station: The Descent from the Cross.

56 Fourteenth station: The Entombment.

57 Verdet 1970, p. 74; Ecrits 1972, p. 265.

58 *Femme à la chaise rouge*, oil on canvas; The Baltimore Museum of Art, The Cone Collection; Barr 1951, p. 476.

59 Ecrits 1972, p. 260.

60 Matisse 1951; Ecrits 1972, p. 260.

61 27 February 1950, Henri Matisse to Father Couturier, in Matisse, Couturier, Rayssiguier 1993, p. 309.

62 Peter Paul Rubens, *The Descent from the Cross*, 1612–14; Antwerp Cathedral.

63 27 February 1950, Henri Matisse to Father Couturier, in Matisse, Couturier, Rayssiguier 1993, p. 309.

64 Charbonnier 1960, vol. 2; Ecrits 1972, p. 266.

65 Jean Mouraille has written a book about Andrée Diesnis (1921–1981): *Andrée Diesnis: Sculpteur-céramiste*, Nice, 1988. The artist took her inspiration from religious subjects: faith, the family and the female form. 'I want to talk to people in everyday language' she said. Her pottery sculpture, often monumental in size, can be found in religious environments: the churches of Nice, the Oratory on the Col de Restefond in the French Alps, the children's hospital and Dominican chapel in Paris, the Church of St Joseph, the Chapel of the Seminary and Carmel in Avignon and the Roman Catholic church in Tehran, as well as the Chapel of the Rosary in Vence.

66 Matisse, Couturier, Rayssiguier 1993, p. 80.

67 Percheron, Brouder 2002, p. 139.

Chapter 3

1 Charbonnier 1960; Ecrits 1972, p. 267.

2 Matisse, Couturier, Rayssiguier 1993, p. 86.

3 Matisse, Couturier, Rayssiguier 1993, p. 84.

4 *Chapelle* 1951; Ecrits 1972, p. 258.

5 *Le Silence habité des maisons*, oil on canvas, private collection.

6 Verdet 1970, p. 115; Ecrits 1972, p. 251.

7 Matisse, Couturier, Rayssiguier 1993, p. 420; Ecrits 1972, p. 273.

8 Letter from Matisse to Henri Laurens, 4 November 1949, in Paris 1970, p. 58.

9 Matisse 1951; Ecrits 1972, p. 259.

10 Letter from Father Couturier to Henri Matisse, [15 April 1950], in Matisse, Couturier, Rayssiguier 1993, p. 327.

11 Comment elicited by R. Pernoud, *Le Courrier de l'UNESCO,* vol. VI, no. 10, October 1953; Ecrits 1972, p. 323.

12 On the differences of opinion between Matisse and the Dominican friar Brother Rayssiguier, see Percheron, Brouder 2002, p. 132.

13 Comment by Henri Matisse in Matisse 1951; Ecrits 1972, p. 259.

14 The Musée Matisse possesses two preparatory drawings for the *Tree of Life* stained-glass windows (1950, coloured glass, transparent and ground, set in lead). The cut-paper *maquette* for the *Tree of Life* window is now in the Collection of Modern Religious Art in the Vatican Museum.

15 Comment reported by R. Bernier, in Bernier 1949; Ecrits 1972, p. 262.

16 Matisse 1951; Ecrits 1972, p. 259.

17 Pernoud 1953; Ecrits 1972, p. 323.

18 Interview in Pernoud 1950; Ecrits 1972, p. 230.

19 Comment reported by R. Bernier, in Bernier 1949; Ecrits 1972, p. 262.

20 Comment by Sister Jacques-Marie in Percheron, Brouder 2002, p. 163.

21 Matisse 1947; Ecrits 1972, p. 237.

22 J. Cowart, in *Washington* 1977, p. 154.

23 Couturier 1962; Ecrits 1972, p. 269.

24 Comment by Henri Matisse, 8 September 1950, in Couturier 1984, p. 220.

25 Pernoud 1950; Ecrits 1972, p. 323.

26 Letter from Henri Matisse to Father Couturier, [early April 1950], accompanied by a sketch, in Matisse, Couturier, Rayssiguier 1993, p. 326.

27 Letter from Henri Matisse to Father Couturier, 23 November 1950, in Matisse, Couturier, Rayssiguier 1993, p. 378.

28 Verdet 1952; Ecrits 1972, p. 304, note 25.

29 Letter from Henri Matisse to Father Couturier, 31 October 1950, in Matisse, Couturier, Rayssiguier 1993, p. 373.

30 Letter from Father Couturier to Henri Matisse, 4 November 1950, in Matisse, Couturier, Rayssiguier 1993, p. 375.

31 Letter from Father Couturier to Henri Matisse, 12 November 1951, in Matisse, Couturier, Rayssiguier 1993, p. 409.

31 Collections: Musée Matisse, Nice; Musée Départemental Matisse, Le Cateau-Cambrésis; Musée National d'Art Modern, Centre Georges Pompidou, Paris; the Museum of Modern Art, New York; Museo del Vaticano, Rome.

32 Matisse's own remark, in Brassaï 1997, p. 313.

33 'L'exactitude n'est pas la vérité', 1947. Preface to the catalogue to *Liège* 1947; Ecrits 1972, p. 173.

34 The collection in the Musée Matisse in Nice includes five *maquettes* for chasubles, in white, green, violet, pink and black. A preliminary study on a white background, plus a pink chasuble bearing a Paschal lamb, complete the collection.

35 Matisse to André Verdet, in Verdet 1952, p. 43; Ecrits 1972, p. 148, note 9.

36 1948, Musée Matisse, Nice.

37 The design was later used to create a glass wall in a room in the infant school named after the artist in Matisse's birthplace. Matisse gave his permission Ernest Gaillard, the architect of the new school, for the *Bees* window to be created. The task was entrusted to the master glassmaker Paul Bony. The window was installed at the end of December 1954, soon after Matisse's death, and inaugurated on 2 May 1955. Intense and warm in colour, the design has been adapted to school use. Since 2001 it has been listed as a *Monument Historique*.

Conclusion

1 Conversation with Jacques Guenne, in Guenne 1925

2 Sister Jacques-Marie died in 2005 and is buried in the cemetery in Vence, in the tomb of the Dominican nuns.

3 Matisse 1951; Ecrits 1972, p. 259.

4 Letter from Matisse to Henri Laurens, 22 October 1949, in *Paris* 1970, p. 21; Ecrits 1972, p. 261.

5 Cut paper, Musée Matisse, Nice.

6 Verdet 1952, p. 53; Ecrits 1972, p. 265.

7 Message from Henri Matisse to his native town, Ecrits 1972, p. 320.

8 L. Aragon, 'Matisse-en-France', in Aragon 1971, i, p. 111 (Quarto Gallimard, 1998, p. 139).

9 Conversation with Léon Degand, in Degand 1945; Ecrits 1972, p. 304.

10 Message from Henri Matisse to his home town, Ecrits 1972, p. 320.

11 'Henri Matisse on Modernism and tradition', *The Studio*, IX, no. 50, May 1935. (Retranslated from English); Ecrits 1972, p. 133.

12 Matisse 1947; Ecrits 1972, p. 238.

Chronology

1 *Papeete-Tahiti*, 1935, Musée Matisse, Nice; and *Fenêtre à Tahiti II*, 1936, gouache on canvas, Musée Départemental Matisse, Le Cateau-Cambrésis.

Bibliography

Aragon 1971
Louis Aragon, *Henri Matisse: A Novel*, i–ii, Gallimard, Paris, 1971

Barr 1951
Alfred H. Barr, *Matisse: His Art and his Public*, The Museum of Modern Art, New York, 1951

Bernier 1949
Rosamond Bernier, 'Matisse Designs a New Church', *Vogue*, pp. 131–132, 15 February 1949

Billot 1993
Marcel Billot, 'Matisse et le sacré', introduction to Matisse, Couturier, Rayssiguier 1993, p. 10

Brassaï 1997
George Brassaï, *Conversations avec Picasso*, Gallimard, Paris, 1997

Champlitte 2005
Du génie à la spiritualité, exh. cat. (Musée départemental Albert et Félicie Demard, 28 May – 28 August 2005), Champlitte (Haute-Saône), 2005

Chapelle 1951
[Henri Matisse], *Chapelle du Rosaire des Dominicaines de Vence*, Vence, 1951

Charbonnier 1960
Georges Charbonnier, 'Entretien avec Henri Matisse', in *Le Monologue du peintre*, vol. 2, Julliard, Paris, 1960

Couturier 1962
Marie-Alain Couturier, *Se garder libre*, Cerf, Paris, 1962

Couturier 1984
Marie-Alain Couturier, *La vérité blessée*, Plon, Paris, 1984

Degand 1945
Léon Degand, 'Matisse à Paris', *Les Lettres Françaises*, no. 76, 6 October 1945

Diehl 1954
Gaston Diehl, *Henri Matisse*, Pierre Tisné, Paris, 1954

Ecrits 1972
Henri Matisse, Ecrits *et propos sur l'art*, text, notes and index by Dominique Fourcade, Hermann, Paris, 1972

Escholier 1956
Raymond Escholier, *Matisse, ce vivant*, Fayard, Paris, 1956

Finsen 2001
Matisse – Rouveyre: Correspondance, collected, annotated and edited by Hanne Finsen, Flammarion, Paris, 2001

Gillet 1943
Louis Gillet, 'L'Allongé-Une visite à Henri Matisse', *Candide*, 24 February 1943

Guenne 1925
Jacques Guenne, 'Entretien avec Henri Matisse', *L'Art vivant*, no. 18, 15 September 1925

Jacques-Marie 1993
Sœur Jacques-Marie, *Henri Matisse: La Chapelle de Vence*, Grégoire Gardette, Nice, 1993

Lejard 1951
André Lejard, 'Propos de Henri Matisse', *Amis de l'Art*, no. 2, October 1951

Liège 1947
Henri Matisse, dessins, exh. cat., A. P. I. A. W. (Association pour le Progrès Intellectuel et Artistique de Wallonie), Liège, 1947

Martin 1955
P. Martin, 'Il mio maestro Henri Matisse', *La Biennale di Venezia*, no. 26, December 1955

Matisse 1939
Henri Matisse, 'Notes d'un peintre sur son dessin', *Le Point*, no. 21, July 1939

Matisse 1943
Henri Matisse, *Dessins: Thèmes et Variations*, preceded by *Matisse-en-France*, by Louis Aragon, Martin Fabiani, Paris, 1943

Matisse 1947
Henri Matisse, *Jazz*, Tériade, Paris, 1947

Matisse 1948
Florilège des Amours de Ronsard, Albert Skira, Paris, [1948]

Matisse 1950
Poèmes by Charles d'Orléans, text and illustrations by Henri Matisse, Paris, Tériade, [1950]

Matisse 1951
Henri Matisse, 'La chapelle de Vence', *France Illustration*, Christmas issue, 1951

Matisse, Couturier, Rayssiguier 1993
Henri Matisse, Marie-Alain Couturier, Louis-Bertrand Rayssiguier, *La chapelle de Vence: Journal d'une création*, Cerf, Paris, 1993

Montherlant 1944
Henry de Montherlant, *Pasiphaé, Chant de Minos (Les Crétois)*, with original engravings by Henri Matisse, Martin Fabiani, Paris, [1944]

Mouraille 1988
Jean Mouraille, *Andrée Diesnis: sculpteur-céramiste*, Nice, 1988

Paris 1948
Henri Matisse: Les grandes gouaches découpées, Musée des arts décoratifs, Paris, 1961

Paris 1970
Henri Matisse: Exposition du Centenaire, exh. cat. (Grand Palais, Paris, April–September 1970), P. Schneider (ed.), Ministère d'Etat des Affaires Culturelles, Réunion des Musées Nationaux, Paris, 1970

Paris 2001
Henri Matisse: le Chemin de croix, Chapelle du Rosaire des dominicaines de Vence, Réunion des musées nationaux, Paris, 2001

Percheron, Brouder 2002
René Percheron, Christian Brouder, *Matisse, de la couleur à l'architecture*, Citadelle et Mazenod, Paris, 2002

Pernoud 1950
Régine Pernoud, 'Nous manquions d'un portrait de Charles d'Orléans ... Henri Matisse vient d'en composer un', *Le Figaro Littéraire*, 14 October 1950

Philadelphia 1948
Henri Matisse: Retrospective exhibition of paintings, drawings and sculpture organized in collaboration with the artist, Philadelphia Museum of Art, Philadelphia, 1948

Scritti 1979
Henri Matisse, *Scritti e pensieri sull'arte*, raccolti e annotati da D. Fourcade, traduzione di M.M. Lamberti, Einaudi, Turin, 1979

Tériade 1929
Tériade [S. Eleftheriades], 'Visite à Henri Matisse', *L'Intransigeant*, no. 14, 22 January 1929

Tériade 1930
Tériade [S. Eleftheriades], 'Entretien [de Matisse] avec Tériade', *L'Intransigeant*, 19, 20, 27 October 1930

Verdet 1952
André Verdet, *Prestiges de Matisse*, Emile-Paul, Paris, 1952

Verdet 1970
André Verdet, 'Les heures azuréennes', *xxᵉ Siècle*, special edition: *Hommage à Matisse*, Société internationale d'art XXᵉ siècle, Paris, 1970, pp. 114–115

Washington 1977
Henri Matisse: Paper Cut-Outs, exh. cat. (National Gallery of Art, Washington D.C., 10 September –23 October 1977; The Detroit Institute of Arts, 23 November 1977 – 8 January 1978; The St. Louis Art Museum, 29 January – 12 March 1978), Abrams, New York, 1977

General books

Jean-Pierre Dubois-Dumée, *Chemin de la croix*, Desclée de Brouwer, Paris, 1996

Sylvie Forestier, Marie-Thérèse Pulvenis de Séligny, *Matisse, le ciel découpé,* Citadelles & Mazenod, Paris, 2012

Xavier Girard, *La chapelle du Rosaire 1948–1951*, RMN, Paris, 1992

Jean Guichard-Maili, *Les gouaches découpées de Henri Matisse*, F. Hazan, Paris, 1983

Henri Matisse, *Chapelle du Rosaire des dominicaines de Vence*, Vence, 1951

Henri Matisse et la sensation d'espace: actes du colloque organisé les 10 et 11 octobre 2003 au Musée Matisse, Le Cateau-Cambrésis (*Henri Matisse and the feeling for space: Report of the conference held on 10 and 11 October 2003 at the Musée Matisse, Le Cateau-Cambrésis*), Eric Bonnet and Dominique Szymusiak (eds), Presses Universitaires, Valenciennes, 2005

Exhibition catalogues (in chronological order)

Henri Matisse: chapelle, peintures, dessins, sculptures, livret-expo, Maison de la pensée française, Paris, 1950

Henri Matisse: thèmes et variations, le rêve, la chapelle, Samlaren, Stockholm, 1951

Autour d'un chef-d'œuvre de Matisse: les trois version de la danse Barnes (1930–1933), essays by Suzanne Pagé, Richard H. Glandon, Jack Flam *et al.*, Musée d'art moderne de la ville de Paris, Paris, 1993

Matisse, la période niçoise, Musée des beaux-arts de Nantes, RMN, Paris, 2003

Matisse, 'Une fête en Cimmérie', représentation du visage dans l'œuvre de Matisse, essays by Claude Duthuit, Claudine Grammont, Marie-Thérèse Pulvenis de Séligny *et al.*, RMN, Paris, 2003

Du génie à la spiritualité, essays by Françoise Caussé and Hartwig Bischof, Conseil Général de Haute-Saône, Vesoul, 2005

Index of Names